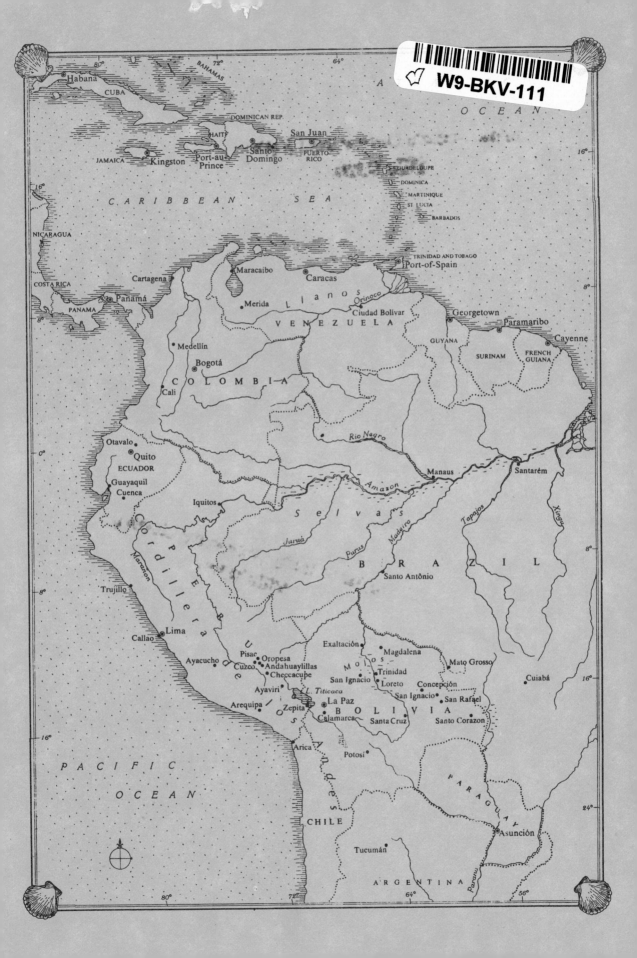

Vanishing Art
of the Americas

Vanishing Art of the Americas

Pál Kelemen

WALKER AND COMPANY
NEW YORK

FIRST PUBLISHED IN THE UNITED STATES OF AMERICA
IN 1977 BY THE WALKER PUBLISHING COMPANY, INC.
PUBLISHED SIMULTANEOUSLY IN CANADA BY
BEAVER BOOKS, LIMITED, PICKERING, ONTARIO
ISBN: 0-8027-0579-0
LIBRARY OF CONGRESS CATALOG CARD NUMBER: 77-77886
PRINTED IN THE UNITED STATES OF AMERICA

BOOK DESIGN BY JUDITH WORACEK MULLEN

10 9 8 7 6 5 4 3 2 1

to my wife

Contents

by the same author

BATTLEFIELD OF THE GODS
 ASPECTS OF MEXICAN HISTORY, ART AND EXPLORATION

MEDIEVAL AMERICAN ART
 MASTERPIECES OF THE NEW WORLD BEFORE COLUMBUS

BAROQUE AND ROCOCO IN LATIN AMERICA

STAUFFACHER'S WORLD ART HISTORY, VOL. V

EL GRECO REVISITED: HIS BYZANTINE HERITAGE

ART OF THE AMERICAS: ANCIENT AND HISPANIC
 WITH A COMPARATIVE CHAPTER ON THE PHILIPPINES

HUSSAR'S PICTURE BOOK

PERUVIAN COLONIAL PAINTING

FOLK BAROQUE IN MEXICO

BAROQUE PAINTING IN ANDEAN LANDS
 THE PAINTER IN EUROPE AND IN VICEREGAL SPANISH-AMERICA

"Here lie the dead.
Silent, they speak."
—SIR AUREL STEIN

A Wreath for the Indies

By the time Christopher Columbus walked on the mainland of the Western Hemisphere (1498), he must have realized it was neither China nor India nor any of the countries of Asia which were described in such tantalizing detail by Marco Polo two centuries before. But, although so many thousand miles from India, the island group in the Caribbean, which became so important in the advance of the Conquistadores, is called even today the West Indies, and the natives of the Western Hemisphere are Indians. In Madrid, the authority in charge of affairs of the New World functioned as the Council of the Indies. Their documents are stored in the elegant Renaissance palace in Seville known as the Archive of the Indies. The Chief Justice in colonial matters held the title Procurador de las Indias. And the laws referring to the Spanish colonial empire are known as Recopilación de las Leyes Indias, while even today a popular Spanish periodical bears the name *Revista de las Indias*. The word "America" refers generally to the United States. "Latins" call themselves Argentine . . . Bolivian . . . Mexican. . . .

1

The Indies is a world that for a time was allowed to sink almost beyond recall, as was its art. My interest came about naturally although quite fortuitously. I was born in the noble kingdom of Hungary, in the last decade of the last century–in a country that has brought forth three times as many luminaries in the humanities and sciences as the size of its population would warrant. I had twenty-eight years of benefit of that rare cultural humus which, after World War II, disappeared forever everywhere. I saw much of Europe, from Spain and Scotland to Poland and Macedonia. I was a rebel in a patrician family, writing and translating poetry, publishing essays on art and literature before my eighteenth birthday. For me the over-lauded Greco-Roman ideal of beauty was unexciting; Post-Impressionist painting had been absorbed. But the art of the Migration Period, which brought so much new in art and technique to Europe from the Middle and Far East, spoke to me. This was the movement of nomadic nations that swept the continent–Scythians, Huns, Avars, Magyars. Many settled, at least for a time, on the great Hungarian plain. From graves that were being excavated when I was a young man–tombs in which chieftains were buried with wives and horses–came forth gold and silver and the paraphernalia of pagan riders. The style was fresh and powerful and had nothing to do with Western Europe that adopted so much from it–and forgot to give credit.

With my American wife, whom I had met and married in Europe, I came to the United States on what was intended as a family visit (1932). While here we conscientiously visited museums and libraries in and around Washington, New York and Boston. At Harvard's Peabody Museum I was arrested by the sight of pre-Columbian objects lined up on dull shelves as in a lost and found department. I knew something of this civilization, of which so much was now in fragments; but never before had it come to me with such force that here was another art about which very little was known either in Europe or America. I spoke with Dr. Alfred M. Tozzer, the Chairman of American Archaeology there, urging that an illustrated survey be written from the standpoint of its art. He persuaded me to undertake the pioneering work that I had suggested for an American scholar, saying that the task needed someone of my background.

Our first experience in the "field" was in Yucatan, where Carnegie Institution was working on the Temple of the Warriors at Chichén Itzá (1933). My wife and I slept in a Maya hut where chickens ran in and out on the tamped floor–and we sat alone in the moonlight on the temple steps of the Ball Court. It was then that I decided to see as many of the sites as

2

possible about which I intended to write. For one can judge safely only with some knowledge of the ambience.

Already in Yucatan I realized that here a highly developed pagan civilization was confronted by a European Christianity, and by force and persuasion was coerced into a new pattern of life. This is the only continent in which–in contrast to Asia and Africa–Christianity was successfully transplanted.

Four more crossings of the ocean were undertaken to gather material also from European museums. I lectured in some countries. Memorable was an afternoon tea in Budapest with Sir Aurel Stein, a compatriot, famous for his explorations in Mongolia and obscure parts of Asia. The great archaeologist bolstered my feeling that the academe sometimes hinders the dispersal of new information, that anthropology often overlooks the point where art could be emphasized, and art history–lost in "scientific" jargon–can turn into autopsy of art. Our hostess, the distinguished author Countess Teleki, had tactfully left us alone for hours. As we parted, she remarked pensively, "And there two Hungarians go away–one to Asia, the other to America..."

In more than forty-five years of activity, my wife and I made nineteen extended trips, from our Southwest to Bolivia, to study, record and photograph. We consulted local historians, afficionados, connoisseurs. We made notes, collected publications, my wife photographed where no pictures were available. We published books on the subjects which have gone into seven languages and ten countries, and we still have voluminous unpublished notes and pictures in our archive. The ancient and contemporary arts of the Americas are now in fashion. With the great exhibition in Düsseldorf, West Germany (1976-77), of "Barocke Malerei aus den Anden"–Baroque Painting from the Andes–showing 122 paintings from collections in Colombia, Ecuador, Peru, Bolivia and the United States, ground for the appreciation of Spanish colonial art has been broken also in Europe.

Time and indifference are not the only causes of destruction. Awakening interest has led to the gutting of archaeological sites by greedy foragers, the dressing-up of colonial buildings in the interest of turismo with little regard to their original styles. We have seen paintings "restored" with modern pigments until not one square inch was left of the original surface, statues stripped of their colorful estofado and covered with cheap glaring gold, building façades "strengthened" either by stripping away the decoration or making a cover of cement as a butcher might carry through a face-lift.

Saddened and with growing dismay we observed the debacle—how modern technology obliterates a unique heritage to which three hundred years of artistic talent contributed.

The more we traveled in Spanish America, the more we realized that here is an art which can be understood only by observing also a certain amount of its cultural heritage. I have followed bypaths that lead to wider perspectives. In instances, I have included personal episodes to give a sharper focus and more immediacy to a subject which might appear too alien to some readers.

Like the previous ones, this book is planned for the general reader, with as many illustrations as possible—for, one picture tells more than paragraphs of text. It is concerned with fascinating examples of the arts that lie, little or not at all explored, on the geographical and historical periphery and that are rapidly vanishing, if not already lost. In these studies we offer, from the fading wreath, a few flowers that once grew in the gardens of the Indies.

Andean Village Churches

The Pacific wind travels relentlessly over the Peruvian shore. It moves the sand in such quantity that every so often hitherto unsuspected ancient tombs are uncovered. When we drove north from Lima, American snowplows were moving up and down the narrow hard-topped Pan American Highway, clearing the road. Despite stiff regulations, the Indian graves were being robbed of their gold, silver and other valuables by daylight. The slanting rays of the setting sun made the holes in the arid landscape look from a distance like trepanned skulls. Broken pottery and bits of fabric lay scattered, bones shone white, bleached by the heat of the day. Grave robbery is such an open profession even today that scientific excavation is handicapped. Ninety percent of Indian antiquities now on the market came into the traffic through those unscrupulous hands.

The coastal plain extends inland as much as forty to fifty miles. Arid waterless stretches alternate with rivers and rivulets that bring water from the Andean snows, furnishing irrigation to sugar plantations on their shores. Fishing villages make their meager living along the coast. Beyond, to the

east, the wall of the Andes seems to rise straight up, blocking half the sky. Numberless streams originate in the high plateaux of the central and eastern Andes and form large rivers which, like the Marañon, finish their run in the Amazon and flow into the Atlantic on the far side of the continent.

These valleys, at altitudes that vary from 6,000 to 12,000 feet, were the center of the Indian world when the Spaniards came to South America. At that time the Inca Empire was so extensive that the ruins of Ingapirca in Ecuador show the mark of Incan craftsmanship in masterly shaped and laid stones. Inca roads moved along the high plateaux, seldom lower than 5,000 feet. The mountain towns and villages with their well-organized communications system were invaluable to the Spaniards in their conquest.

One is apt to visualize the land at such high altitudes as a barren, windswept region, inhabited by a stubborn and starving people. A quite different picture unfolds for the traveler on his way to Cuzco, as he traverses the fertile valley of the Vilcanota River through fields of yellowing grain and patches of green pasture. The llama and alpaca grazed here before European animals were imported. The villages of the valley, populated by the Quechua, an energetic and cheerful people, lie near streams, and well-watered terraces of cultivated land run up the steep mountainsides.

The Spaniards early recognized not only the richness of the region but also the sturdy character of its folk. Indeed, the "pacification" of the natives was never completely accomplished. Crazed by the abundance of gold with which these people honored their gods, many a military captain, many a civil authority from Spain strove to gather a share of the loot. Turmoil and infighting resulted, as well as cruel persecution of the Indians, and lasted nearly into the last quarter of the sixteenth century. Then, Philip II appointed as his viceroy in control of that vast region Francisco de Toledo y Figueroa (ruled 1569-81). He was the third son of the Count and Countess of Oropesa, knight commander of the Order of Alcántara, major domo to His Majesty. Toledo proved one of the ablest–and among the most ruthless–of the colony's rulers. With a firm hand, he consolidated his authority over all branches of the administration. To control the Indians, he had them rounded up as far as possible and forced them to settle in towns designed after Spanish plans and provided with churches and clergy. Though in theory this might have brought about a Christianized community with echoes of ancient Inca paternalism, in practice the tendency was to provide serfs for the thriving *encomiendas* ceded to Spanish feudal lords.

Checacupe, one such village about sixty miles from Cuzco, goes back into

6

prehistoric times–according to some sources, to before the Inca regime. Besides the Quechua, its population counts members of the Aymara nation, who are numerous in the Lake Titicaca region and present-day Bolivia. Francisco Pizarro resided in this village at different times; his second will was dated there on June 22, 1539. Some of his captains married into Inca nobility. By royal grant Viceroy Toledo presented the village and surrounding territory as an encomienda to the widow of a good friend. In colonial times a prosperous gold mine was worked nearby; and even in Checacupe today the dance of the Tucumanos commemorates the mule trains that kept this region in contact with silver-rich Bolivia and the flourishing province of Tucumán in northern Argentina, whence the mules and their drivers came. The famous explorer and archeologist of the nineteenth century, E. George Squier, remarked on the fertility of the mountain-locked valleys and the number of extensive haciendas with their comfortable houses enclosed within heavy walls.

Checacupe's parochial church mirrors the rising prosperity of the region. The building lies with its long side on the main plaza [1.1].* Its barn shape and walls of adobe–brick or slabs of sun-dried clay–betoken an early date. The unobtrusive portal is of stone, with simple columns and no figural decoration, its lines half obliterated by repeated whitewashing. In front of it, in an ample atrium closed off by an adobe wall, stands a tall cross, memento of the one first planted by pioneering missionaries. The bell tower stands separate, an arrangement not unusual in this region.

All the more striking is the richness of the interior. The walls of the nave are covered with immense murals in tempera. Near the entrance door is a picture of Santiago in battle with the Moors [1.2]. Santiago Matamoros, the Apostle St. James the Greater, was the patron of Spanish knighthood. Each newly anointed member of the Order received a parchment decorated in colorful miniature technique, bearing the figure of the saint. The large mural at Checacupe follows the scene which, on a smaller or larger scale, usually ornamented such a patent of nobility. Spanish lancers can be seen led by the saint who sits a white charger, flourishing his sword. To the right are the fleeing Moors and in the foreground a group of the fallen enemy. A bit of empty surface in the background is filled with a lonely rider, placed against the little landscape with houses; and on clouds in the sky another miniature shows Christ holding the Cross, and at his feet the suppliant Virgin Mary.

*The related illustrations immediately follow the text of each section.

The frame around the piece is painted in the local tradition of fine dadoes; and the beam ends above, belonging to the choir loft, show how harmoniously designed was the decoration. The mural probably dates from as early as the last quarter of the sixteenth century, at which time the whole interior–walls, ceiling and painted beams–was executed.

The tray ceiling of the apse would also seem to survive from this early period [1.3]. It is covered with textile fastened to a reed base, the whole smoothed with gesso and painted with figures that have the character of enlarged book illustrations. A series of the Apostles occupies the lower row and above, the monograms of Jesus and Mary in elaborate heraldic frames alternate with the heads of sibyls. The beams, with their open interlacing, adhere to the Moorish tradition but carry decorative portrait medallions in the center. The exquisitely wrought pendants in the center display the same effective mixture of style.

A refurbishment is recorded about 1690-1700. Side altars from that time cover some of the original decoration, as can be seen at the right of the Santiago mural.

The pulpit, which also dates from that time, hangs suspended from the wall like an oriel, and is entered from a passage through the masonry [1.4]. Unusually rich and varied, its carving relates to that of the retable–note the grape-wound columns–but does not overpower the serene figures of saints on the balustrade. Its corbel has the form of a bowl from which jut four remarkably expressive, grotesque heads, each different from the other. Stylistically this work shows similarities to the better-known pulpit in the church of San Blas in Cuzco which dates before 1696. The Indian Juan Tomás Tuyru Tupac, whose name is linked with the San Blas pulpit, was born in a small village in the vicinity of Checacupe, and a Quechua family of that name is still living there. Contemporary documents name him as an architect and master carpenter, as well as a sculptor and a specialist in "hydraulic works," which probably included organs.

The main retable was replaced by the one standing there today [1.5]. Garlands of grapes, heavy and protruding, entwine its columns. Variety and an upward movement is gained by the placement of the statues, within deep niches in the first order, and in the second, on corbels against an intricate golden grillework with crownlike baldachins above them. Paintings on fabric make up the final tier of the composition.

The communion rail again presents the figures of the Apostles in a poignant reminder of their presence at the Eucharist. In some medieval

churches, as at the cathedral at Torcello near Venice, the Apostles were depicted on the screen before the sanctuary; and they still appear thus on the iconostasis of Greek Orthodoxy. Apparently these figures were often placed on the communion rail in European churches until the Renaissance supplanted the wood railings with bronze and marble balustrades. The full series of Apostles on the altar rail of the church at Checacupe is probably a unique survival. Mark with his identifying lion is depicted in the center right, and beside him Andrew with his cross. On the left panel–the gate opening into the sanctuary–is the figure of St. Paul, who sometimes replaces Judas in representations of the Twelve. The figures all sit in shell-roofed niches. Poses and coloring are varied. Traces of the polychrome have survived the centuries.

While my wife was photographing the altar, she heard a woman from the village complain to the priest: ''These people are planning to take away our treasures.'' She broke in to explain that her husband was an historian, interested only in recording such beautiful art works and making them more widely appreciated. ''Then,'' replied the woman, ''someone else will come at night with a truck and take them away.'' To that there was no answer.

The parish church in Andahuaylillas, about thirty miles from Cuzco, was founded in 1580 on the ruins of an Inca temple. The traveler feels the strange atmosphere of this region. In the photograph [1.6], taken more than a generation ago, one sees the fountain of pure water–always a focal point of village life–and, in the open atrium, a brick pyramid with all three crosses of Golgotha. Snakes are carved on the pedestals of the crosses.

The church, dedicated to St. Peter, is constructed with adobe walls and a pitched roof of cane and timber. It has a second-story gallery accessible from the choir loft–a type found in other widely scattered mission territories. Traces of murals can be seen on the brick portal and in the recessed gallery. The adjacent bell tower is built of stone. Inside the barn-shaped building, the ceiling follows the slope of the roof, its surface plastered over and painted with a tapestrylike design [1.7]. Enormous paintings, mounted in lavishly gilded frames with crests that reach into the ceiling, cover the walls of the nave. There are two pulpits, both in considerable disrepair, that bear texts in Quechua.

A large mural, to the left as one enters, was apparently derived from a book illustration [1.8]. It shows a man of mature age reluctantly turning away from a banquet table where his companions are feasting–note the planked fish, the fruit pie, the wine, a fork as well as knives. He seems about

to pass through the narrow gate to enter the Mansion of the Lord. Angels are assisting souls over the final hazardous bridge, even performing last-minute rescues, while three young men exactly alike–a symbol of the Trinity–lean from their high rampart to encourage the newcomers. The Apostles and Mary watch from windows below them. Letters of the alphabet are strewn over the composition as in didactic books, where various figures are explained in the text.

The inscription quotes from the Psalms: "The Lord looketh from Heaven; He beholdeth all the sons of men..." (Ps. 33, v. 13, in the King James Version) and, "Whoso is wise and will observe these things..." The verse continues: "even they shall understand the loving kindness of the Lord." (Ps. 107, v. 43). The rest has been rubbed into illegibility by centuries of passing hands and shoulders.

In the adjacent wall, the entrance to the baptistry bears the text: "I baptize thee in the name of the Father and of the Son and of the Holy Ghost, Amen"–in Latin, in the medallion held by angels; in Spanish, across the painted frieze and in Quechua, over the arch [1.9]. An excellent statue of Peter stands beside the door. Like nearly all of the statues at Andahuaylillas, it is an armature figure, modeled from the pulp of the maguey, smoothed over with plaster and dressed in starched and painted textiles.

Much more weather beaten is the doorway opposite [1.10]. The panels show a flower design, and there is a fragment of a mural and a prayer wheel with bells–a rarity. Notable is the colonial rug covering the altar steps. Its big flowery pattern is characteristic of the late seventeenth or early eighteenth century. It was probably cut from a larger rug that covered the floor of the sanctuary. These were once general in the Andean highlands. Where the temperature ranges from freezing at night to the burning sun at midday, the priest at early morning Mass must have been very cold in the unheated church, when icy winds swept through from the snow fields.

The rugs and tapestry hangings of the Andes have a special place in the history of colonial art. They were usually woven in the ancient tradition, of wool on a cotton warp. The local weaver's manipulation of pattern shows that he had absorbed much from imported samples. This *mestizaje,* or blending of Indian and European methods and motifs, is characteristic of the art of those centuries.

Very large rugs, few of which survive, were produced for the palaces of viceroys and archbishops and for important state apartments, and became fashionable among rich hacienda owners. As a goodly number of recently

10

arrived Spaniards in those early days were of noble lineage, it was natural that hangings with their coats of arms should be in order. The central panel was ideal for the display of an heraldic device. Whether a Knight of Santiago, a member of the Military Order of Calatrava or of the *Templarios de Jerusalén,* each possessed a patent of nobility emblazoned on parchment seldom larger than a college diploma. The native weaver was required to enlarge the impressive colored shield, sometimes as much as tenfold. Small wonder that considerable distortion occurred. Such frequently used heraldic animals as the lion, the griffin and other mythological beasts were strange to America. Their translation into tapestry produced fantasy figures that went on living in the weaver's repertoire. Having no frame of reference for the highly conventionalized units of armorial bearings, he loosened the outlines. A medieval helmet may be recognized, but the plumes have turned into flowers. On the flowing ribbon of the phylacterium, the motto of a family may appear as a row of dots, the weaver being illiterate. Characteristic of this work is the scattering of birds and small animals throughout the field, and even little human figures can be seen, out of proportion with other motifs, as if copied from a book.

Music and the dance had an important role in pre-Columbian ceremonies. The Indians fashioned trumpets of shell and clay, flutes and panpipes of pottery and reed, drums of many types. The missionaries made good use of this musical talent in bringing Christian rites nearer to the neophyte. Prayers and responses were more easily learned when set to some simple chant. Choirs were taught part singing, an accompanying orchestra could be assembled, and the dance became an integral part of some celebrations.

Doubtless early organs were brought into the New World from Spain, where Flemish organ-builders and organists had a notable influence. But soon Indians, working with the new tools furnished by their conquerors, were able to construct their own instruments under the instruction of the missionaries. Of the two famous organs of the Mexican cathedral, just as those in Cuzco, one was imported in its entirety, while the other seems to have been a local copy executed after the model in the church.

Andahuaylillas has two organs, placed in the arms of the U-shaped choir loft. One of these shows an orchestra of angels on its folded wings [1.11]. The native *charango* and portable harp are prominent, with a fiddle that seems an invention of fantasy. On the other wing, the bass viol, the lute and the little drum are all realistically depicted. The organ opposite [1.12]

carries paintings of David with his harp and St. Cecelia at the organ. The two levers at the right are still connected with the ancient bellows, pumped by hand. Both instruments appear to have been touched up by less skilled hands at a later date.

M. A. Vente, a Dutch authority on ancient organs, believes that these instruments date within the first half of the seventeenth century, calling attention to the few trackers and the small number of keys as well as their primitive construction. Also, the tall center section of the narrow case shows an early type of pipe arrangement, with the longer pipes placed in the middle. As was usual in Spanish organs, there are no pedals.

The adjacent walls were tapestried with decorative murals of *angelitos*, vases and swags of flowers. More than once, cracks and water damage have been roughly repaired. In such poverty-stricken communities, the concern of the local priest for the condition of his ancient buildings is understandable, and if one of the more affluent of his parishioners offers to spruce up the damaged walls with fresh plaster and an insipid, cheery stencil like a provincial hotel corridor, who can blame him for accepting?

The sanctuary of this church is somewhat raised and is set off from the nave by a wide arch, embellished on the altar side with clusters and swags of fruit. A broad crack down the middle is evidence of the endangered condition of the entire edifice. A splendid ceiling, *mudéjar* in construction, covers the apse [1.13]. It is painted in the clear tones that characterize the decoration throughout this building and is liberally gilded. Especially striking is the shell where the ceiling ribs converge to form a baldachin above the main retable.

The retable itself shows signs of considerable addition and subtraction, though it remains splendidly homogeneous [1.14]. Interesting are the many carved baskets holding three thistlelike blossoms. Small silvery squares of mirror form a glittering arch about the doll figure of the Virgin and a crownlike canopy above her. In the pediment, Mary kneels before the Trinity, her hands folded in prayer. At the very top of the retable a huge sunlike gloria encloses the figure of the Lamb of God resting on the Book.

According to a painted tablet, the sanctuary arch was decorated in 1631 at the expense of the parish priest, Juan Pérez de Bocanegra. A great linguist, Bocanegra published a dictionary of the Quechua language—which may account for the several inscriptions in that tongue. Probably the beginnings of the rich interior date from this period. The earthquake which devastated Cuzco in 1650 must have caused damage here also and necessitated consid-

erable repair. Some of the silver objects in the church are dated 1765, and the carved wooden screen behind the Coronation group at the top of the altar is inscribed "Through the veneration of an Indian devotee 1843."

These two churches present samples of the early colonial style–lavish, pleasing to the eye and often highly original. Too bad that such interiors are becoming more and more difficult to find, partly due to neglect and the destruction of time, but mainly from the deterioration of taste that has brought about the importation of mass-produced objects and ideas.

With the reconstruction of Cuzco after the earthquake of 1650, the architectural style of churches in the Andean Highlands becomes more uniform, definitely influenced by the buildings which went up on the Plaza de Armas. Characteristic are the use of stone as material, the two well-paired towers, graceful finials and numerous minor decorations that prove what excellent masons and carvers were at hand. Magnificent barrel vaulting survives in some abandoned buildings, though many, towering above the huts of the surrounding village, fell victim to lightning in the fierce mountain storms.

Oropesa, a rural town some 20 miles from Cuzco, bears the name of Viceroy Toledo's family, mine owners and great landholders since his time. Besides its centrally located parish church, there is an enticing little hermitage outside the town dated 1685 [1.18]. In Spanish America, such a secluded "retreat" was usually in the care of religious confraternities. The statues and paraphernalia of the Holy Week and other religious processions were often stored in the building.

From a distance, the Hermitage of Oropesa, with its well-proportioned twin towers of evenly laid stone, is an echo of Cuzco, with an elegance reflecting that of the dominant family. On nearer approach, the carved portal shows the typical Andean Indian style of stone carving, shallow yet with clearly defined motifs–a scheme which developed only here and is recognizable as such among other native work. Two guardian angels in the spandrels are executed with the charming simplicity of honey-cake sculpture. Smooth columns rise like candles from leafy bases, and puma masks are carved in the blocks above the capitals. Although the variety of motifs is limited, the effect is balanced and harmonious.

Squier, on his trip of exploration in 1875, found the principal quarries of the Incas still in use near Oropesa. They were the source of the reddish stone so characteristic of Cuzco building. Immense stone blocks of every size and in every state of processing were scattered over an area of more

than half a square mile. Close by stood the rough stone huts of the workers and a more pretentious building that doubtless had housed the overseer.

There are churches on the rim of Lake Titicaca that have their own unique style, independent of Cuzco. One such gem of originality survives at San Pedro Zepita, close to the Bolivian border. As we approach, the massive body of the structure with its noble tower looms over the reed-thatched roofs of the small settlement [1.15]. It is set with the long side on a sloping grass-grown plaza– one of several buildings so placed in this region. From the low, stepped platform from which it rises there is a superb view of the broad expanse of the lake. Though the climate is harsh, the place was once thickly settled and rich in cattle that grazed on the treeless plain.

The church tower is built of smooth laid stone with little ornament except for the finials at the top. Rougher masonry characterizes the building proper. Additions at the sides bolster the shallow dome and give the structure the shape of a cross. A tiled roof over the nave outlines the curve of the impressive barrel vaulting within.

Little care was spent on the portal at the nave's end. The wood of the ironbound door is tattered and weather streaked. On the other hand, the side entrance which faces the plaza is rich in carved detail [1.16]. It stands under a shallow arch that makes it appear recessed. Technical mastery is evident in the carving. The effect is not so much that of a retable as of a *mampara*, the ornate screen that closes off the nave at the entrance of many large Latin American churches.

Peter occupies the niche at the left, Paul stands opposite. The dense, deep-carved decoration on the columns and broad cornices is accentuated by heavy shadows. Grotesque masks peep out of intricate strapwork. Peter's keys and other religious symbols blend into a mass of flowers on the doorposts. Angelitos and cherub heads appear everywhere. Vases, top heavy with bouquets, make up the finials. One is amazed to find such an exotic and individual stone exterior orphaned in such a location.

When we saw it, the interior was utter dilapidation [1.17]. The splintered wood of the doorway let through rays of the sun on a vast empty space. A narrow masonry bench ran along the walls. The stone vaulting, though water stained, was intact. It terminated in massive corbels decorated with a leafy pattern, now cruelly whitewashed. A trace of a painted frieze could be seen just below the cornice. There was no furniture except for an elaborate retable, which stood lonely but intact at the apse end of the barnlike nave. A few paintings, some without frames, were hung at random on the dusty

walls. It was there that we photographed and subsequently published an archangel musketeer–a subject up to that time neglected, and discussed at length in a later chapter of this book.

According to a letter from the bishop of La Paz dated 1788, the church of San Pedro Zepita was finished in 1765 after many years of work.

Perhaps nowhere else in Spanish America can one find such individuality of decoration as in the church façades around Lake Titicaca, which reflect two disparate stylistic origins blended to picturesque effect. As seen at Zepita, the niches are usually filled with the figures of saints. Their classical stance, with tranquil gestures and quiet drapery, only serves to emphasize the richness of the ornamentation about them. Some motifs are derived from native plants and animals. Others, such as the almost-unique strapwork in the columns at Zepita, seem suggested by the ornate title pages of imported books.

Ayaviri, on the north rim of Lake Titicaca, belongs to the Department of Puno and has been the capital of its district since colonial times, as the spread of the village indicates. Its present population numbers around 4,000. The gold mines of the region reached their apex between 1680 and 1720 but are still being worked periodically.

The Dominicans were the first to acquire this area for evangelization. With the arrival of the Jesuits, the task was divided between the two rival orders. And if there is any sight that demonstrates the dominating power of the Church and the discipline that emanated from it in those days, it is that of the structure at Ayaviri, standing in majesty in a bleak landscape that seems as remote as a plain on the moon [1.19].

The nave of the church measures some 55 feet long and nearly 30 wide. Influence of Cuzco is evident in the fine proportions of the twin towers, built of smooth-cut, pale pink stone, and in the heavy vertical buttresses and the many finials. A dome set over the crossing enhances the dignity of the structure. The rough walls of the building proper present a considerable contrast to the sophisticated façade [1.20]. Here a rubblelike fill, reminding us of old-fashioned cobblestones, is laid in uneven rows in thick mortar. The apse of a church was always the first to be built–the date on the main portal usually records when the building was finished, sometimes many years later. Time has left its mark on the church at Ayaviri–buttresses had to be shored up, additions were made and demolished, the apse end reconstructed. Iron covers most of the roof, but when the picture was taken (in the 1940's) there were remnants of red and green tiles.

15

The windows, placed at random, show the thickness of the walls. Windows in that region were in general small, for technical and seismic reasons. Peru had no glass factory until late colonial times, and thin translucent slabs of alabaster or the oiled skin of animals were often used to cover the openings, giving a diffused but adequate light. A much-eroded mud wall still encloses the back of the building.

The group of village folk at the fountain, some with their bicycles leaned against the wall, presents a contrast to the elegance of colonial times–a glimpse of the present-day life of these hardy folk.

Ayaviri's church is also outstanding for its interior. As often in those great stone structures of the Andes, the vaults over the apse and transepts are Gothic in construction, and barrel vaulting covers the nave. The retable [1.21] is rich in detail and rather reserved in total impression. As prosperity rose in the place, the whole central section was apparently renewed with a silver altar frontal and *sagrario*. The mirrors, already noted at Andahuaylillas, are characteristic of the area.

Many Indian churches in rural regions still have tamped earthen floors, where the congregation stands or kneels. If some higher dignitary should come for a visit, a chair or bench would be placed diagonally near the altar. In the not-too-distant past, one could observe a lady entering with her maid servant, who would lay a rug or sometimes set a chair for the mistress, who would follow the services from her specially isolated position. At Ayaviri, benches were installed in the nineteenth century and the floor was tiled.

At Tiobamba, another unusual edifice stands melancholy amid barren fields not far from Pisac. Two broad, open bell walls flank the entrance, which is thus recessed. The façade is delapidated, with signs of having been redone in relatively modern times. On the other hand, the tile roof is still in good condition. Fine, evenly cut stones enclose a little atrium before the entrance, with crosses on the corner posts. The side walls are chiefly of rubble [1.22], although some Inca stone can be seen in the construction. What makes this building different from the others we saw are the striking bell walls. Although highly effective, they are not organically related to the design and appear to occupy part of foundations that were planned to carry larger towers.

With little or no population about, a priest will seldom visit this place. The crosses of the abandoned cemetery epitomize the solitude. As an old saying goes, "The Holy Ghost comes here only to rest."

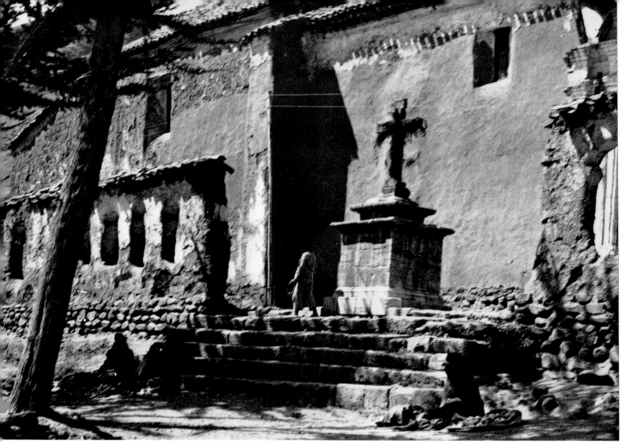

[1.1] Parochial church. Checacupe, Peru.

[1.2] Mural of Santiago Matamoros.

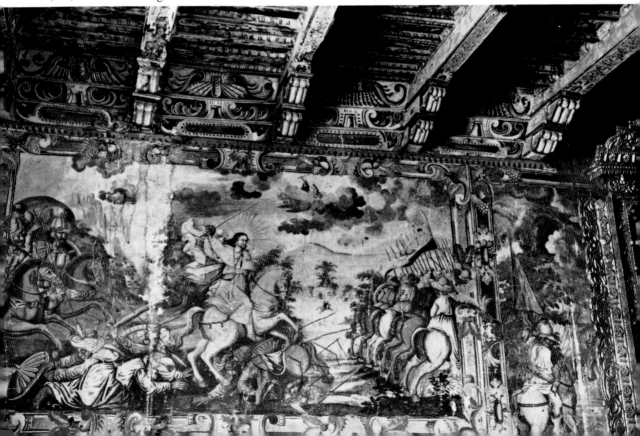

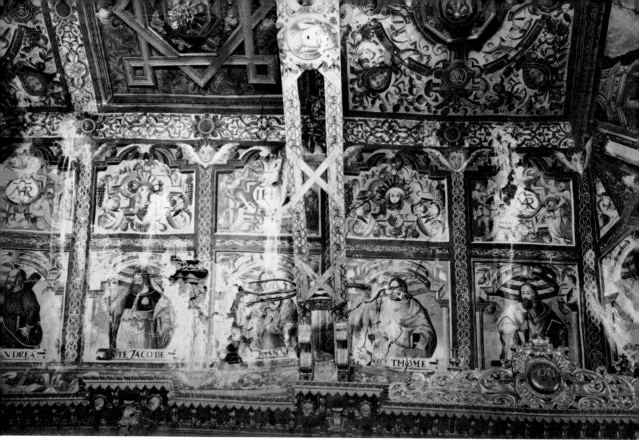

[1.3] Ceiling in sanctuary. Checacupe, Peru.

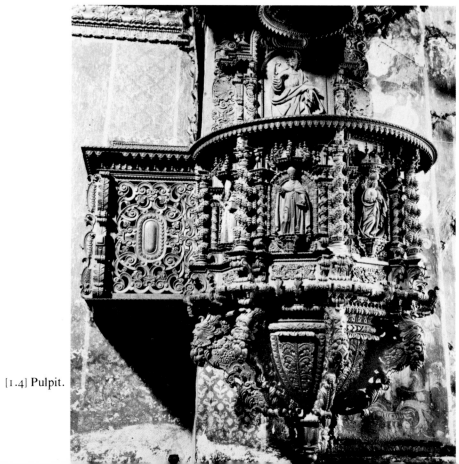

[1.4] Pulpit.

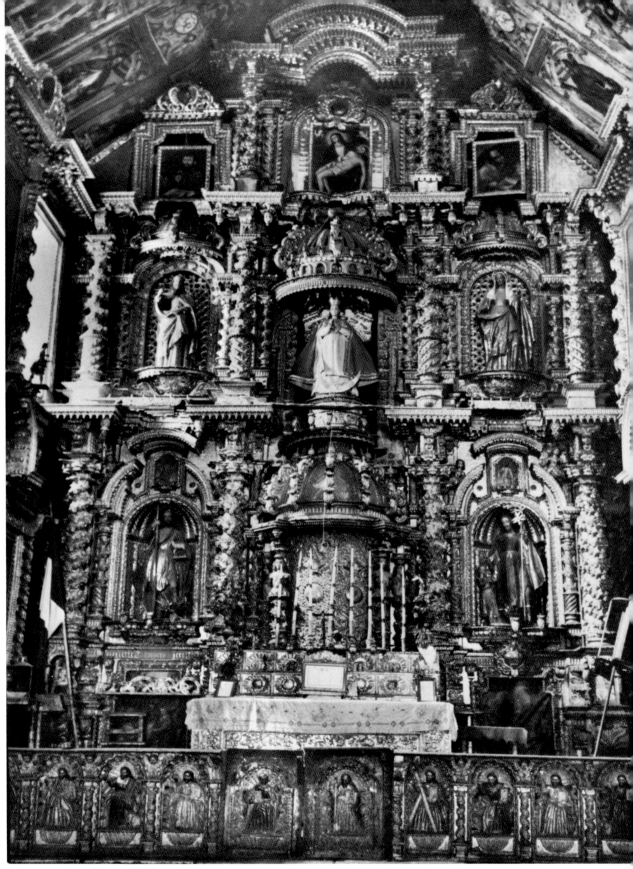

[1.5] Main retable.

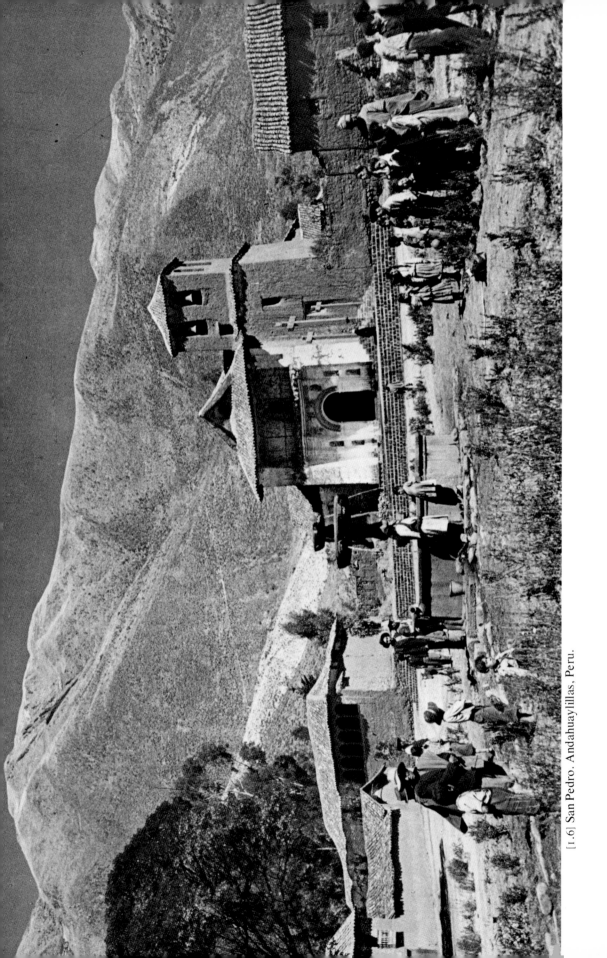

[1.6] San Pedro. Andahuaylillas, Peru.

[1.7] Interior.

[1.8] Mural, entrance wall.

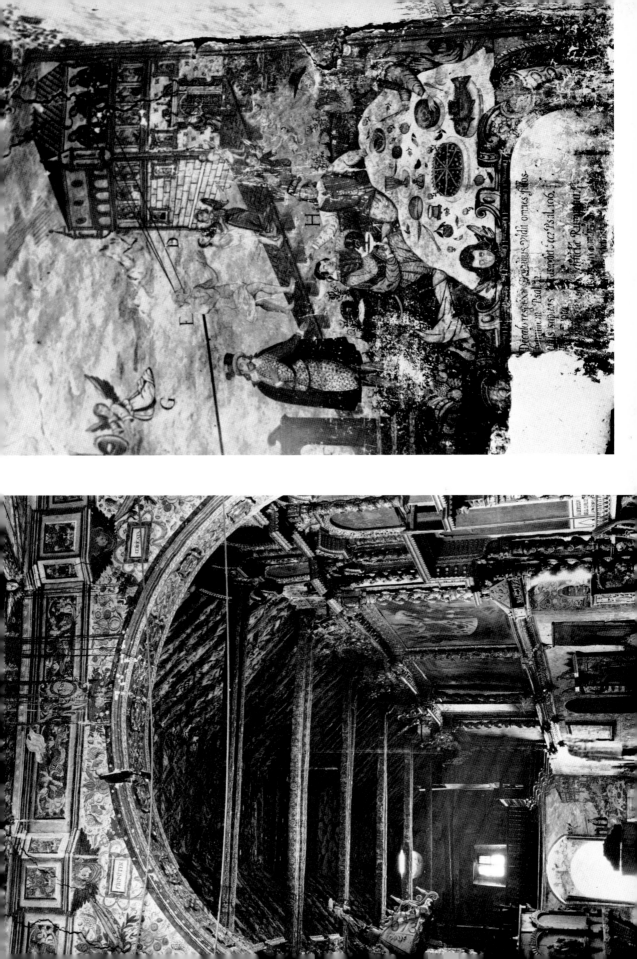

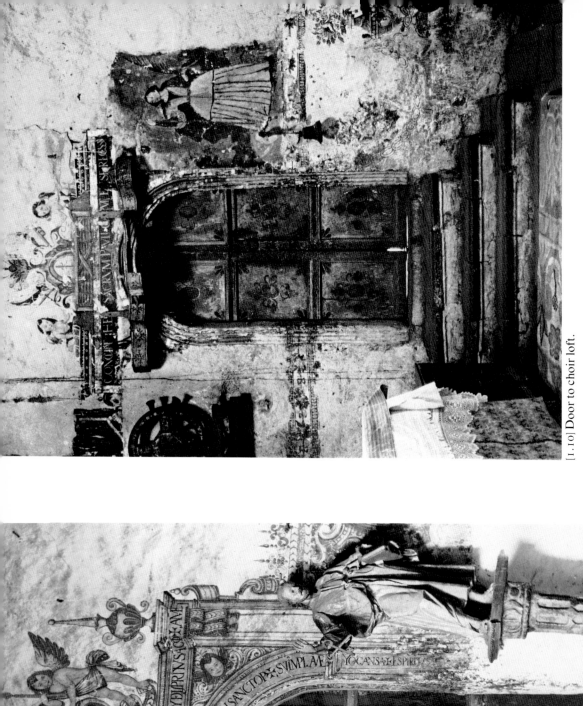

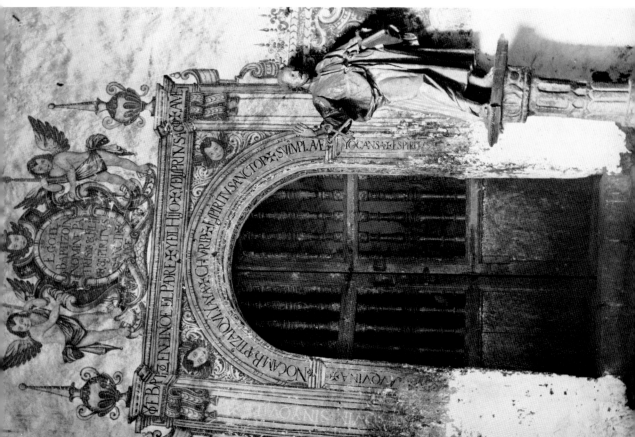

[1.10] Door to choir loft.

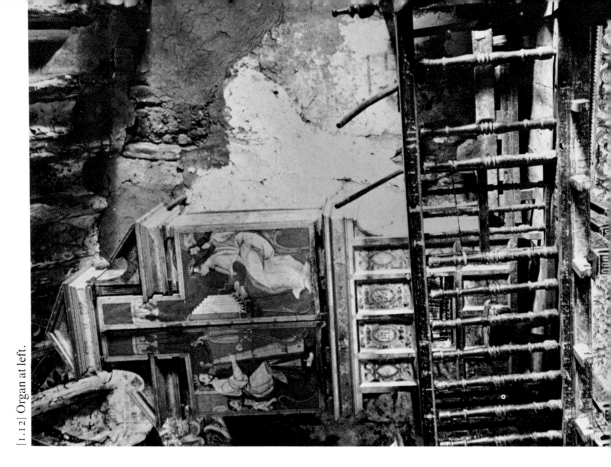

[1.9] Door to baptistry. Andahuaylillas. Peru.

[1.11] Organ at right.

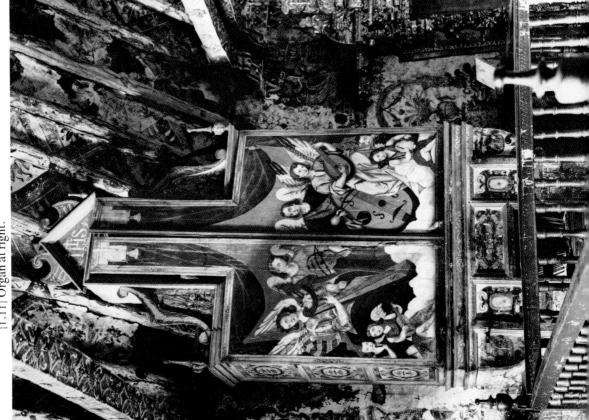

[1.12] Organ at left.

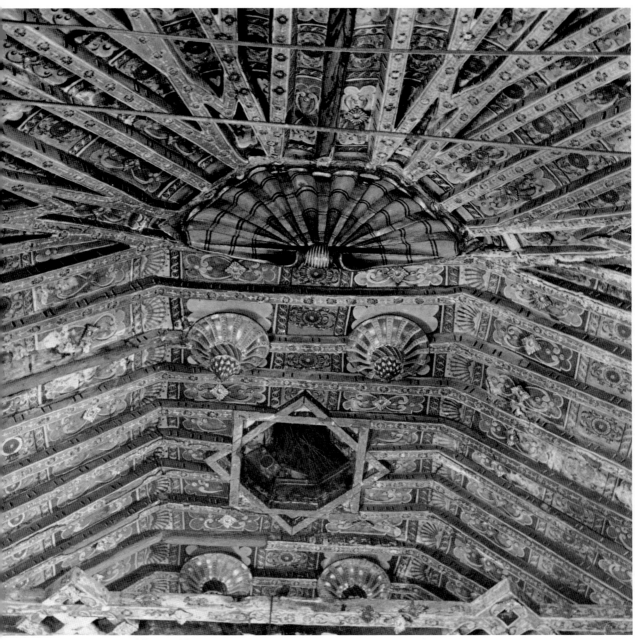

[1.13] Silver ceiling, sanctuary. Andahuaylillas, Peru.

[1.14] Detail of main retable.

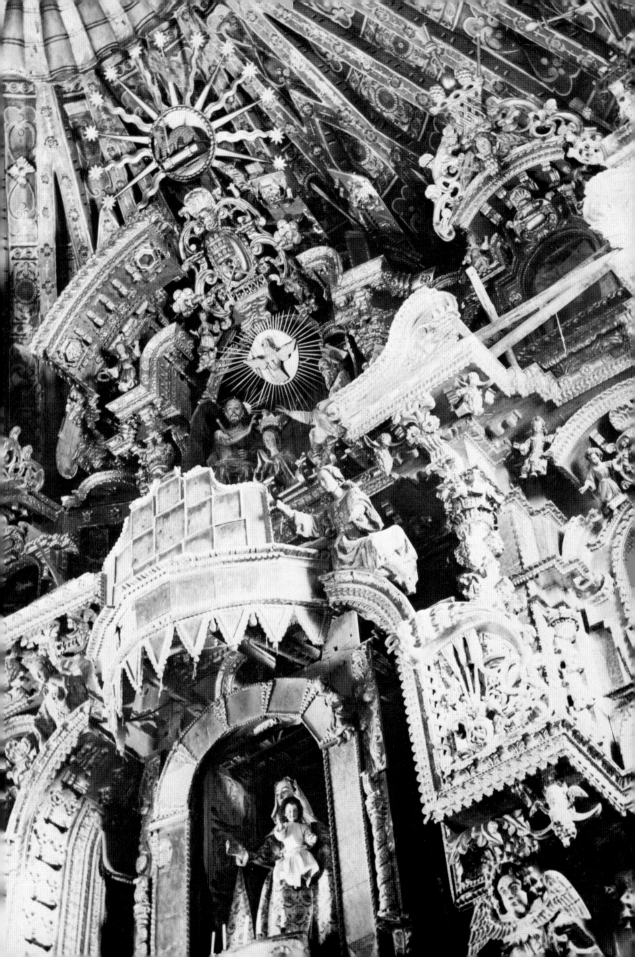

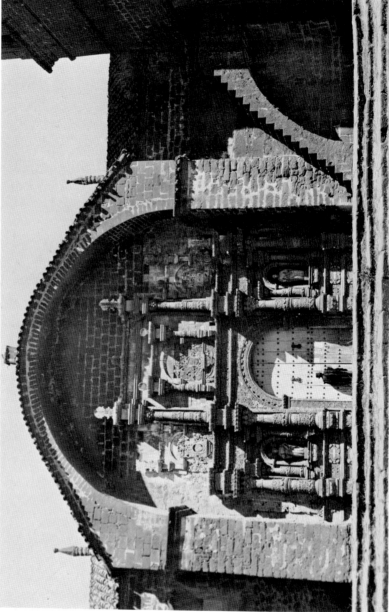

[1.16] Side portal.

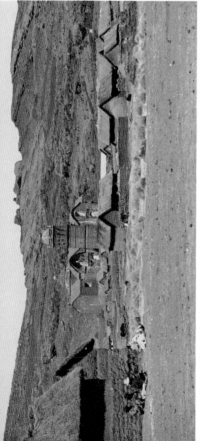

[1.15] From a distance.

SAN PEDRO. ZEPITA, PERU.

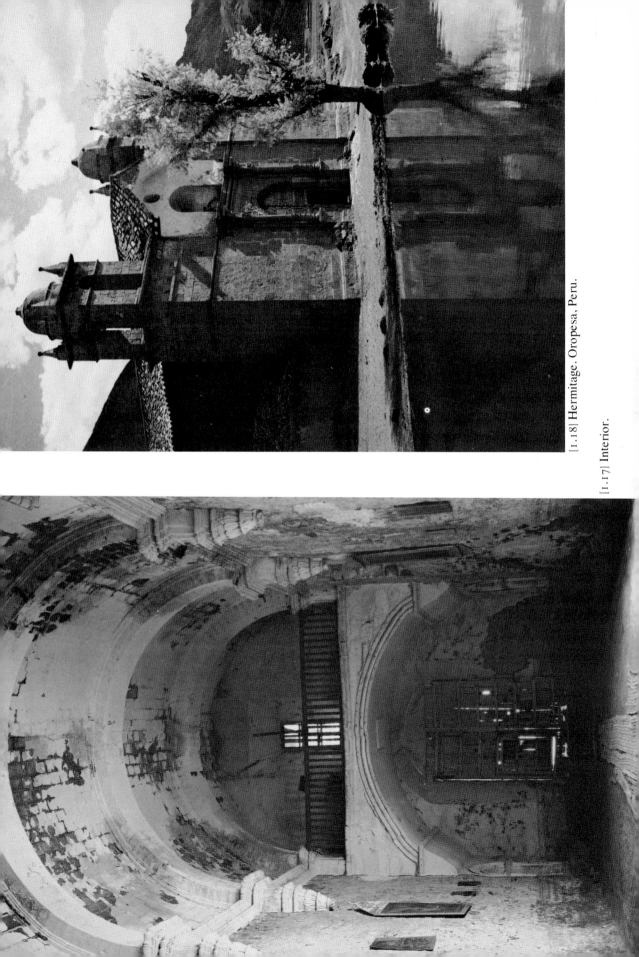

[1.18] Hermitage. Oropesa, Peru.

[1.17] Interior.

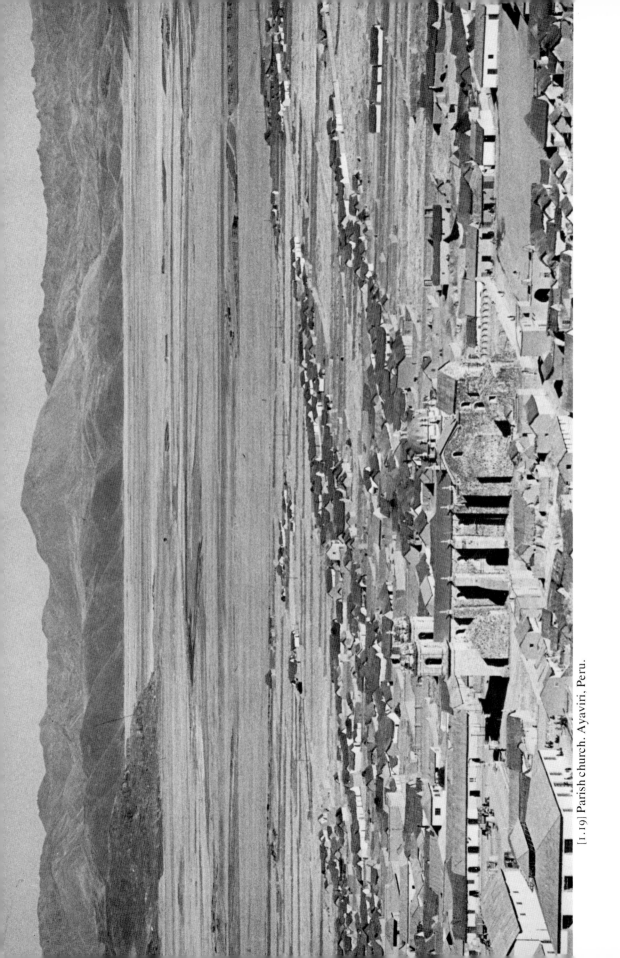

[1.19] Parish church. Ayaviri, Peru.

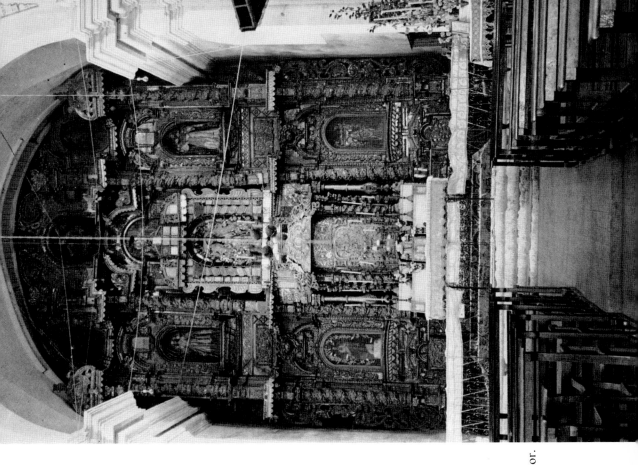

[1.21] Interior.

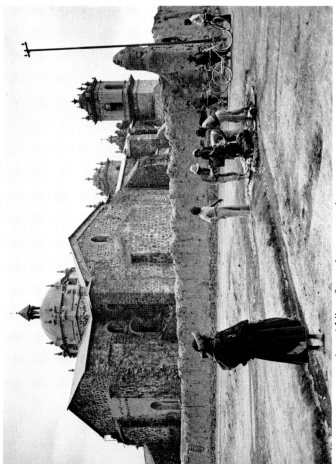

[1.20] View from the apse end.

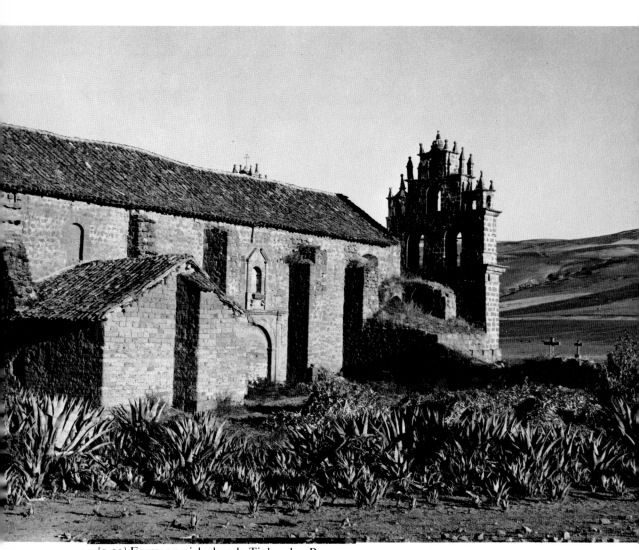

[1.22] Former parish church. Tiobamba, Peru.

2

A Mexican Colonial Catafalque

A catafalque (from the Italian for "scaffold") is a temporary construction covered with a pall, erected for funeral ceremonies. In the case of an important personage, the body of the deceased rests on a pedestal and his decorations and other insignia of honor are displayed on a velvet cushion. Lighted candles are placed around the catafalque, flower tributes are laid at its base, and sometimes soldiers stand as an honor guard. When a Requiem Mass is said at memorial services, a catafalque with simulated casket is placed outside the communion rail at the crossing in a church. Such was the custom in provincial towns upon the death of a member of the royal family or a high ecclesiastical dignitary in past centuries, when princes, dukes, kings and emperors ruled from Russia to Spain and from Prussia to Sicily. Giuseppe Verdi wrote his Requiem Mass for his idol, Alessandro Manzoni, to be sung at a memorial service in Milan several years after the death of the Italian patriot, novelist and poet.

The custom of offering last homage to the dead goes back into prehistoric times. Homer described the funeral pyre on which the body of Patroclus

was laid as being one hundred feet square, constructed of wooden beams, and surrounded by amphoras of honey and oil. It burned throughout the night. Inspired by the Classic, the Renaissance revived the custom. *Horatii Emblemata,* a book by Otho Venius, printed in Antwerp in 1607, shows a Renaissance interpretation of classical funerary rites. The illustration reproduced is entitled *Virtus immortalis* and is accompanied by a text from Seneca [2.1]. In the foreground one sees the stump of a tree, symbol of terminated life, and a stream suggesting the River Styx. Poised on a globe is an allegorical trio of Fortitude, Law and Might. The pyre in the background is being put to fire by two draped, weeping women (Fates?) with flaming torches, while a man with upraised arms seems to deliver a eulogy. On top of the pyre where the body lies, a phoenix starts toward Heaven carrying a nude human figure, symbol of the soul of the deceased. According to the ancient bestiaries, the phoenix, a symbol of immortal life, lives upward of five centuries, then destroys itself by flying close to the sun. After nine days it arises from its own ashes. In the iconography of Greek Orthodox Church, an angel bears the soul of Mary heavenward in the form of a newborn infant. El Greco is the only painter of his epoch who carried this iconographical device into Western painting in his *Burial of the Count of Orgaz.* It is notable that in the Spanish language a catafalque is often called *pira* (pyre) as well as *tumulo* (tomb), among other expressions, and also *apparato funeral* and *cenotafio.*

Like the triumphal arch, which was also revived from the Classic, the catafalque–*castrum doloris*–became an elaborate structure, often many-tiered, with painted and sculptured decorations. Such artists as Dürer, Palladio, Tintoretto and Rubens designed and executed catafalques and/or arches of triumph. The Spanish architect José Churriguera (1650-1723), after whom an architectural style is named, rose from obscurity with his design for a resplendent catafalque for the wife of Charles II of Spain. Sometimes such a monument remained an elaborate sketch, submitted to the authorities but not carried out, to be distributed as a print for the benefit of posterity. In the latter category belongs Dürer's vast drawing of a triumphal arch for the Emperor Maximilian, with its more than a hundred scenes. El Greco and his studio furnished the design and decoration for a triumphal arch in 1587, when the bones of the martyred St. Leocadia were returned to her native Toledo. He also contracted to do a catafalque for memorial services in the Toledo cathedral in honor of Philip III's wife, who died in 1611. Painted on wood to simulate stone, the catafalque contained allegori-

cal statues, portraits of kings, coats of arms, and as the culmination of an impressive architectural build-up, a dome and a lantern with an angel ten feet high holding the imperial crown. An inventory of the contents of El Greco's studio made a few days after his death by his natural son Jorge Manuel mentions several canvases remaining "from the triumphal arches" and the funeral ceremonies, as well as "fables" or "legends" (allegories?) and a painted royal coat of arms.

Rulers and feudal lords, patrons of the church, were usually buried in the crypt or under the floor of a church or chapel. When space grew scarce, the walled-in holy ground around the church was used. (The German word *Friedhof* means a courtyard where peace rules.) In more modest cases, where such a place of honor was not possible or relevant, an *epitaphium* was in order. This might sketch the story of the family, with various religious or martial allusions. It was usually painted on wood and placed in a decorative frame on a church wall, where everyone who visited the place was reminded of the importance of the deceased and family. The story-telling quality of such works brings to mind the *milagros* which, especially in Mexico, record miraculous healings through faith or escapes from danger or catastrophe. As time passed and church interiors were refurbished with whitewash or paint, such mementos became besmirched and still more often, with new landowners, lost their significance and were discarded.

The illustration [2.2] shows a seventeenth-century *epitaphium* from the distinguished Berzeviczy family of Zineskál, North Hungary. Husband and children–even dead babies, marked with a cross–together with several relatives, mourn the loss of the mother, and the visitor who reads the Latin inscription is admonished to weep with them at their bereavement. They seem to be kneeling in a chapel, in the apse of which stands an altar with lighted candles and a painting of the Resurrection. In the upper half of the panel the Triumph of the Saviour is depicted, in the company of the seven kings of Israel–the harp identifies David. The four Evangelists constitute the wheels of the chariot, which is drawn by two haloed sheep (Apostles?) and driven by a little angel away from the grinning jaws of hell. Christ carries the flag of Resurrection and holds captive the skeleton of Death and the devil of Sin chained behind him.

A catafalque from immediately after the Conquest of Mexico is recorded in the New World. In the spring of 1522, news spread through the Mexican capital that the conquistador Hernán Cortés was dead. Funeral processions

were organized, masses for his soul were said, and a catafalque was erected in the first parochial church on the Zocalo. Actually, Cortés was exploring Western Mexico in good health and, returning to the capital, soon gave the lie to the false report.

In 1560, a *"tumulo imperial de la gran ciudad de Mexico"* was constructed for the Holy Roman Emperor Charles V, two years after his death. The catafalque proper with its architectural ambience is reproduced and described in a booklet. Among the 22 painted scenes, a goddess is shown taking a garland from Ulysses and placing it on the emperor's brow, while sad Indians stand around with mourning veils in their hands; Cortés stands before his liege lord with unsheathed sword, announcing the Conquest; the City of Mexico is depicted in its lagoon, with many idols broken and burning, and Charles receives the skeletal figure of Death with welcoming open arms and a joyful expression.

The accounts of these memorial services frequently record the eulogies spoken by various dignitaries and give the poems and epigrams contributed to the occasion, some of which adorned the walls of the monument itself.

News of the death of Charles II, the last of the Spanish Habsburgs, reached Vera Cruz on the first of November, 1700. One hundred and twenty-six days later, on the 6th of March, 1701, the viceroy notified all civil and ecclesiastical authorities to celebrate the sad event "in a dignified and appropriate manner." At once the cost of black baize cloth and other mourning stuffs rose to such heights that the viceroy had to set an official price. The funerary procession in the Mexican capital left the Town Hall in the morning, led by trumpets and kettledrums, the players dressed in mourning clothes with sable streamers flying from their muffled instruments. There followed on horseback the mayor and his secretary, three submayors and the municipal council, all in mourning garb, their hats wound with sable bands, their horses decked with black trappings. The procession reached the palace of the viceroy, who then officially announced the death of the monarch to the assembled notables. Thereupon, the bells commenced their solemn tolling–first the great major bell of the cathedral with two hundred strokes, after which all the bells of the 71 churches of the capital and the suburbs joined in. A second public proclamation took place at the archbishop's palace, a third at the Palace of the Inquisition, and a fourth at the Town Hall. The tolling of the bells lasted until eight in the evening, "and as if Heaven wished to express its sorrow, the sky was covered entirely with clouds." Funeral solemnities were held in the cathedral on the 26th and 27th of April, before a catafalque, bedecked with

laudatory inscriptions, erected in memory of the dead monarch. The following morning in all religious orders, a Requiem Mass was celebrated. It is recorded that the Inquisition put up its own catafalque for the occasion in the church of Santo Domingo, at a cost of 1,420 silver pesos. An Indian village near Puebla paid its homage to the dead king with a catafalque replete with skeletons, skulls and crossbones, some of the details harking back to the pre-Columbian epoch.

Part of the woven cloth for the covering of a catafalque survives from Peru. The fragment is framed with a broad flower garland and, in separated fields, two upright skeletons stand, flanked by two attendants, each of whom is partly skeletal, partly attired. One principal figure wears a crown and carries a scepter [2.3], while the other wears the papal tiara and carries the pontifical cross [2.4]. Each of the attendants holds a spear in one hand and a cross in the other. Allegedly the piece comes from the mortuary chapel in Juli on Lake Titicaca. The fact that the warp is of cotton and the weft of natural brown alpaca wool bespeaks its origin in the highlands of Peru. It has been suggested that the tapestry was woven for a memorial service for King Philip III of Spain and Pope Paul V, both of whom died in 1621. However, it may commemorate a similar coincidence that occurred when Pope Innocent XIII died in 1724, the same year as the youthful Louis I of Spain after a brief reign.

In Mexico, the celebration of All Souls Day, November 2nd, is still a major event both as a religious holiday and as an Indian fiesta. It is celebrated in all communities, large and small. Cemeteries are illuminated with tapers and candles; new flowers are laid on the graves; the market displays skulls made of pastry dough and hard candies, or of wax in which candles can be lit. Toy-size skeletons turn up, such as an orchestra of skeletons fashioned of clay strengthened with wire, playing violin, guitar, viola da gamba, and drum. Although many of these excesses have long been forbidden, they continue to entertain the population for whom this fiesta is full of fantasy, mystery and tradition. On this occasion, as in Europe, catafalques with simulated coffins appear in the churches in memory of the dead, and three memorial masses are offered within the 24 hours.

Prints and memorial books that go back into the earliest time of the colonies show us funerary monuments with their historical, allegorical and symbolic scenes. Sometimes the accompanying text is limited to description and the enumeration of those who participated; at other times, the craftsmen and artists who took part in the *mise en scène* are named. Admirable is the intellectual standard which supposed that religious sym-

bolism and classical mottoes could be understood in a country that was still fighting barbarous Indians on its periphery. The expenses of these monuments often ran high, as we see in some cases where we have detailed accounts of what was paid to the merchants of raw material for paint, gesso or to carpenters for labor. Thus there are instances in which parts of a catafalque used on a previous occasion were taken out of storage and used again for reasons of economy. Although all of these monuments exist merely as designs and descriptions on paper, this author came upon an actual four-tiered catafalque in respectable condition in the Mexican town of Toluca.

Toluca lies even higher than Mexico City, dominated by the snow-crowned peak of the Nevada de Toluca. Early in the seventeenth century a visiting Carmelite missionary, Antonio Vásquez de Espinosa, wrote that "the famous town of Toluca belonging to the Marqués de Valle (descendants of Cortés) contains over two hundred Spanish residents with a fine Franciscan convent. The town is a busy trading center. They make the best ham and bacon there in all New Spain and great quantities of soap. The town and the whole valley have a cold climate; it is full of cattle ranches and farms and the whole region is prolific and healthy. . . ."

Toluca benefited from the fact that it lay on the main road from the Mexican capital to Valladolid (today, Morelia). It was in the vicinity of great mines whose riches were early exploited. At Tlalpujahua and El Oro de Hidalgo, mining centers to the north, are preserved monumental churches, substantial living quarters for the miners and signs of more recent prosperity. Toluca boasted an efficient militia, the Toluca Infantry, which was sometimes called into action in other regions. With Independence, the city became the capital of the state of Mexico. Its colonial monuments suffered, perhaps more than those of most other cities, in the ensuing upheavals and revolutions. Growing prosperity also effected changes. The cathedral has a cold neoclassic style, and even this has been "renovated." The Franciscan establishment mentioned by Vásquez was replaced in the seventeenth century by an imposing monastic complex, which in turn was partly demolished in the late nineteenth century to make room for another church. However, some remnants from earlier times survived and show the good taste in which the artists and artisans performed. A statue of St. Francis of Assisi stood in a niche on one side of the portal surrounded by friendly leafy garlands [2.16]. A cowl frames his head, his eyes are cast downward, the stigma shows on his right hand. An aura of asceticism and humility, touching even the unbeliever, emanates from the figure. One is reminded of the

widely reproduced statue of St. Francis by Pedro de Mena in the Treasury of the cathedral at Toledo, Spain. The Spanish sculptor is well known and honored; but who was the person, who, without ever seeing the Mena work, could give Toluca such a dramatic rendering of this beloved saint? Today, even this detail has vanished.

Among the few buildings that still show the dignity of the viceregal period are the church of El Carmen and the adjoining former Carmelite monastery. The brothers of the Order of Mary on Mount Carmel claim descent from the hermits who lived on that mountain in the Holy Land, whence, according to tradition, Elijah ascended to Heaven in a fiery chariot. The arrival of the Crusaders revitalized the order, which transferred to Sicily and spread throughout Europe as the so-called White Friars. Teresa of Avila (1515-1582) founded a reformed Carmelite nunnery in Spain in 1562 under a very severe rule. In the tenets of her reform and its heritage from the contemplative life of the early hermits in the Near East, the vanity of all worldly possessions, the mortality of man and the contemplation of death were given special emphasis.

Franciscans, Augustinians and Dominicans were the first to come as missionaries to the New World. The arrival of the Carmelites was somewhat delayed. This was partly owing to a vitriolic quarrel with the Jesuits, the youngest of the religious orders, over the Carmelite claim to historical priority. But after the reform, the Barefoot Carmelites became very active throughout Spanish America. It appears that their first monastery was founded toward the end of the sixteenth century with a small hermitage in the Mexican capital. In 1606, another establishment on the road to Toluca is recorded. It was known as the *Desierto de los Leones,* so-called from the hermits' traditional withdrawal into the "wilderness."

The Carmelites, in their expanding activities, reached Toluca in the last years of the seventeenth century. Their *real cédula* (royal patent) dates from 1697, and their church was consecrated in 1711, though the tower with its three bells was not finished until a century later. With its broad, tree-shaded atrium, the sumptuous church still contains large paintings by Francisco Martínez (active between 1718-1755), who was also a gilder of altars and a notary of the Inquisition, and works by the still better-known artists Juan Rodríguez (1675-1728) and Nicolas Rodríguez Juárez (1667-1734). In the eighteenth century, the establishment also boasted a spacious two-story monastery, with ample patio as well as nearby flower and vegetable gardens and grazing land.

The catafalque stands today in a stark back room of the former Carmelite

monastery, now the Municipal Museum [2.5]. The four-tiered structure rises to a height of ten and one half feet. On the lowest row, the paintings–all of which are on cloth–measure 3 feet high by 10½ feet long, while those on the three tiers above it grow proportionately smaller. Although dulled by age, the colors cover a broad range. All the paintings are framed with an elaborate *passementerie* of blossoms, shells and tassels painted in shades of yellow to simulate gilding. Each panel carries a Latin motto, and on each a pertinent poem in Spanish is set in a floral frame topped by the insignia of the Carmelite order. On the bottom row, a fourteen-line *soneto* appears, then successively *décima, octava, quintilla,* and, at the top, *terceto.*

The dead king [2.6] wears the costume of the late seventeenth century, with lace ruffles around the neck and at the wrists. His broad red cloak bears the emblem of Castile on the right shoulder and is lined with ermine, the fur of royalty. The boots are unusually high, again a prerogative of the select. A regulation from the end of the sixteenth century decreed that, except for nobility, boots taller than two handbreadths ("the turning of a hand...") were subject to tax. The wide cuffs and the skirt of the coat show lavish embroidery. In his right hand, the king holds the royal scepter, and his crown is a somewhat simplified version of that of a Spanish monarch, with a globe and a small cross at the top, symbol of an apostolic ruler. On the left in the painting, a Carmelite hermit raises his hands as if to express the Latin words on the streamer: *Quo peregrine...?* "Whither, pilgrim, goeth thou forth?" (The Latin word *peregrine* connotes "stranger.") The man at the right, whom the hermit is addressing, wears the emblem of St. James the Greater, suggesting pilgrimage to the famous shrine of Santiago di Compostela in Spain. The accompanying sonnet, translated freely, warns the stranger who has unwittingly stumbled upon this somber scene to turn back lest he behold Death enthroned, reflected in the crowns of deceased monarchs–for Light must be dissipated in darkness, Life must fall trophy to Death, and Fire dissolve in ashes.

On the three other sides of the lowest row of the catafalque, a pope, a cardinal, and a bishop are laid out in the same manner. In somewhat similar vein, the Latin motto and the sonnet that accompany the dead pope [2.7] admonish the heedless cavalier (only the upper classes were permitted to ride horseback) to halt his swift pace and ponder, so that at this gigantic pyre, seeing the greatest luminary rendered to shadow, the *pontifice sumo* himself subject to death, he may achieve vision for his blindness, light to his ignorance, reproach for his arrogance.

The pope is depicted in lively colors with triple tiara and a jeweled pectoral. The large floral pattern of his cope, picked out with metal threads, and the deep lace edging of his alb are rendered in detail. His crozier is painted so that those parts which would have obstructed the face are omitted. Of the cardinal [2.8], the import of the Latin text is that like lightning or a meteor, at the height of his glory he vanishes. And in the sonnet, a Voice from the Abyss warns the reader that in his progress toward the stars, he too will end on the bier.

In contrast to the previous personalities, the bishop [2.9] lies with his hands in a praying gesture. He is in full ecclesiastical vestments, with miter, braided and brocaded chasuble, a maniple over his arm, and embroidered gloves on his hands. His pastoral staff lies across his breast. This is the only case among the high authorities depicted on the catafalque where Death appears as a skeletal figure and is named *Muerte* in the sonnet. In the others he is "Fate," "Force of Destiny," etc. Here Death stands at the bishop's feet firing a cannon over his dead body at a fortress, the walls of which are partly shot away, with pieces flying through the air. The motto announces: "What Heaven has given me remains," and the sonnet carries out the lesson of the picture–that Death lays siege even to miters; that the most accurate hits are nothing to Death's scythe, and Heaven allows him to seal the fate even of bishops.

In the second row of the catafalque, in exact illustration of the Latin text, Death lingers in the bedchamber and Amor abides on the "sepulcher"–a tiered catafalque painted with skulls and crossbones [2.10]. Amor is blindfolded, has double dragonfly wings, and holds his quiver in his right hand. The bedchamber is suggested by a canopied, columned structure with a tasseled dome. The burning candles on the table have a manifold meaning–the most obvious, the evanescence of love as well as of life. Death rests on a blanket of unmistakable Indian design. Thus classical elements from the Old World are mixed with folk art of the New.

While the sonnets for king and ecclesiastics are written in a solemn, high-flown style, abstruse in content and complex in phraseology, in the manner of the famous poet Luis de Góngora (1561-1627), the remaining verses are epigrammatic, more fluent and straightforward. More than one hand can be perceived in the lettering. Here the somewhat puzzling gestures of the two figures are explained in the eight-line poem, the *octava:* Death and Amor exchange weapons; death is the wages of Cupid, and Amor reduces all to oblivion.

To the right of this panel, on the side, the most complex scene of the catafalque is partly visible in the photograph of the total. It represents the triumphal chariot of Death [2.11]. Its motto: *nemini parcit,* "He spares no one," is a quote from Ovid in a letter to Livy. It was used in a book of emblems from 1669*, and doubtless in various other works concerned with "reminders of death" which were popular in that period. Death is enthroned in the triumphal car, wearing the laurel wreath of victory. In his left hand is a mirror with a faintly reflected picture catching the passing image of life, and in his right, what appears to be an empty spindle, the thread of life having run out. the chariot is drawn by a lion and an eagle, heraldic emblems of temporal and spiritual authority, both looking back at their driver in apparent fear. A lady and a gentleman, well designed, their elegant Rococo dress depicted in detail, are also attached as captives to the car by a golden beaded chain which frames the composition, holding it together. The poem gives the moral: No one can escape cruel Destiny, neither the rational nor the brute, neither old man nor maid; Death's triumphal car is hung with spoils from life–scepters, staves of authority, tiaras, cardinal's hats, miters and banners–all of which appear in the picture.

Also in this second tier is the painting of a "sprightly beauty of youthful age," in noble silks, seated in an elaborate pavilion in a garden sparkling with flowers. Her heart is pierced by a long arrow that flew in from a dark tunnel-like cave on the left [2.12]. The motto says succinctly: She dies, suddenly pierced through.

In the third row, Death turns a spinning wheel with his right hand and with his left, draws a thread from the heart of a nun in Carmelite garb [2.13]. The motto, "On a thread, life is held," underlines the message of the *quintilla:* Live always mindful of the fateful spinner. In this case only, opposite the nun, Death is decently dressed in bodice and dark skirt, albeit in rags.

In the same row, again seen at the right in the picture as whole, is the scene, *Time Racing with Death* [2.14]. Time, a chronometer in his left hand, has wings and the rich dress of an archangel, but also the winged helmet and boots of Mercury. Death hobbles along, bent and leaning on his staff. But as the *quintilla* brings out, no matter how great the odds, Death will leave Time behind him.

In this tier is a scene with the streamer: *In ictu oculi . . .*, a phrase from Paul's First Epistle to the Corinthians (15:52), ". . . in the twinkling of an eye,

Mondo Simbolico, ampliato dell' Abbate Picinelli. Milano, 1669.

at the last trump; for the trumpet shall sound, and the dead shall be raised incorruptible, and we shall be changed." Death is seated before a table writing with a quill pen in the Book of Evidence where the deeds of each life are totted up [2.15]. In his left hand, he holds high a large hourglass, marking the passing time to a young man of gentle bearing who raises both hands as if in protest or surprise, though behind his ear a trumpet is visible. As the Spanish text proclaims, the *trompeta* will call you to give an account of your life.

On the uppermost and smallest of the canvases (27 x 52 inches), all that survives on this tier, is the only scene with a suggestion of consolation [2.5]. A warrior in helmet and breastplate lifts a honeycomb from the mouth of a dead lion, about which the bees are still buzzing. The quotation, "Corpse of lion, honeycomb sweetness," refers to Samson's finding of honey in the very mouth of the dread lion of Timnah (Judges 14:8). Thus the topmost picture presents an allegory of Christ's triumph over Death. One is impressed by the book-learning of those friars, who, as Carmelites, especially and continuously meditated upon death.

The dress of the youthful king would suggest the turn of the century. However, the material, the cut and ornaments of the ladies' and gentlemen's costumes on the smaller canvases and the styling of their wigs would place them in the mid-eighteenth century or somewhat later. One must give or take a decade or so in consideration of the time-lag which frequently occurs in colonial modes.

Due to the weathered condition of the paintings, their coloristic quality can be judged only approximately. Where grime and dust were wiped away, before these photographs were taken, lively if tired coloring could be enjoyed. As happens often in colonial work, the grounding was inferior and tended to darken with time. Thus only the whites, the light yellows and reds have life in them, while many complementary shades are dulled and out of harmony. Some of the final highlights, some poses and movements of the figures, some facial expressions evidence good craftsmanship. Certain of the streamers may have been repainted, for they seem pressed into the composition and out of proportion. On none of the thirteen existing scenes could a signature be found. It would appear that the Carmelite order kept this catafalque on hand and erected it on All Saints Days and other occasions of public mourning. It could be variously decorated with fabrics, candelabra and flowers as suitable for the different events.

After secularization, the former monastery of Toluca served various purposes. Finally, one section was assigned to a primary school, another to

an art school, and some of the most spacious rooms became a modest museum. The director of the museum, scouting for exhibition material, found in a storeroom of the parochial church–once part of the monastic complex–paintings sagging on their stretchers among pieces of religious paraphernalia, broken candlesticks, discarded vases, shabby artificial flowers and fragments of dusty rugs. The director, himself a painter, showed interest in acquiring the neglected paintings, but the priest protested his intrusion. On the decision of the governor of the state, however, the colonial paintings were transferred to the museum as state property and assembled there, revealing their original purpose.

How general was the custom of erecting such funerary monuments is illustrated by a catafalque from what was really *ultra mar*, the Philippine Islands. It was raised in honor of Charles III's queen, Maria Amelia, in 1762, in the Augustinian church of Manila, two years after her death [2.17]. Charles III (1716-1788) is often called the greatest of the Spanish Bourbons. Although a sincere Roman Catholic he is notable for ordering the expulsion of the Jesuits from Spain and her overseas provinces, thus rendering the Inquisition ineffectual. Expenses for the magnificently canopied catafalque were paid for by Don Francisco X. Salgado, the governor and captain general. "Laur. Atlas" is named as the engraver on the left lower edge of the memorial print which is preserved in the Archive of the Indies in Seville. The royal crown rests on the simulated coffin and appears also at the top of the whole composition. As in so many colonial monuments of this type, skeletons represent Death. Here two are seen standing on columns, the left one with a scythe, the right, with an hourglass, flanked by half-skeletal, half-dressed attendants, as in the Peruvian tapestry. Allegorical figures of the four continents occupy larger pedestals, and heraldic emblems of the royal family and the colony are displayed in the center.

Whether this elaborate construction in distant Manila was executed in all its detail cannot be ascertained. The fact remains that as far as this writer could establish from his own experience and inquiries here and abroad, the only actual catafalque surviving from these centuries is the one in Toluca. Perhaps somewhere in Latin America, in the Escorial in Spain, in Mafra in Portugal, or in some remote provincial establishment in Europe, such monuments really exist, if only discarded or unrecognized in fragments, and will come to light with time. It would be important not only to the history of art, but also as a memento of a cultural climate in which youth is not pursued and glorified as paramount, and the inevitability of death is faced with philosophy and dignity.

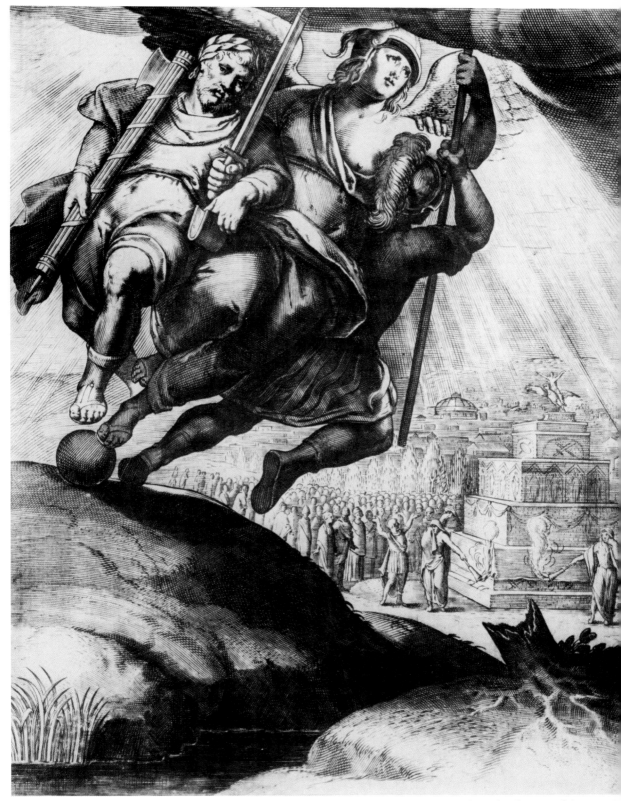

[2.1] Ancient catafalque.

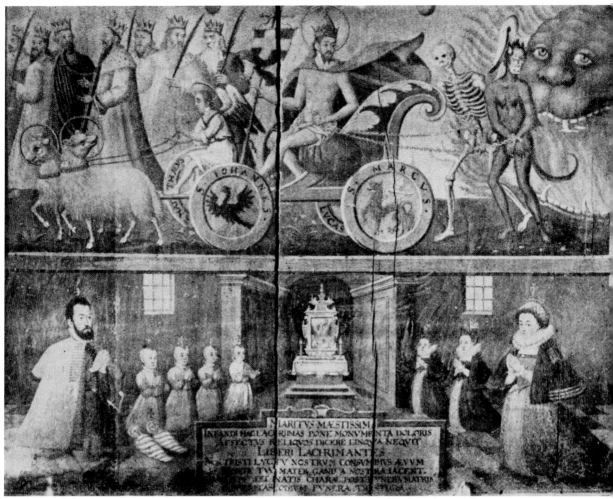

[2.2] Hungarian *epitaphium*. Seventeenth century.

DETAILS OF CATAFALQUE COVER. PUNO, PERU.

[2.3] The dead emperor.

[2.4] The dead pope.

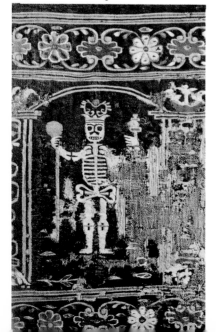

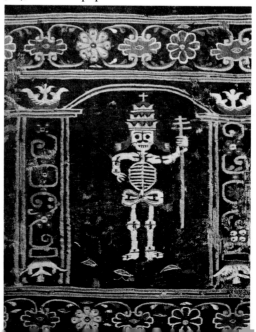

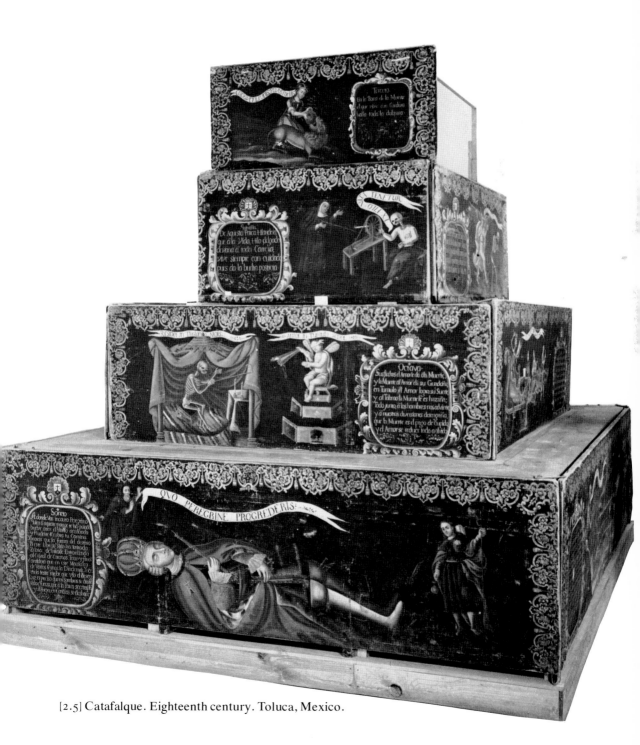

[2.5] Catafalque. Eighteenth century. Toluca, Mexico.

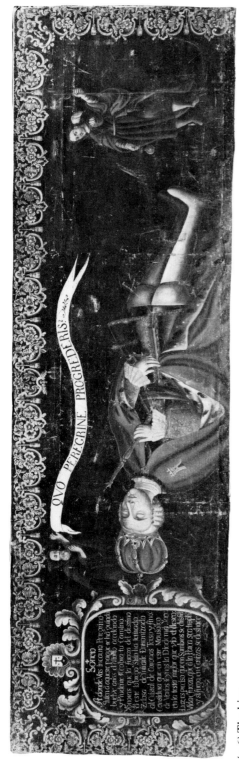

[2.6] The king.

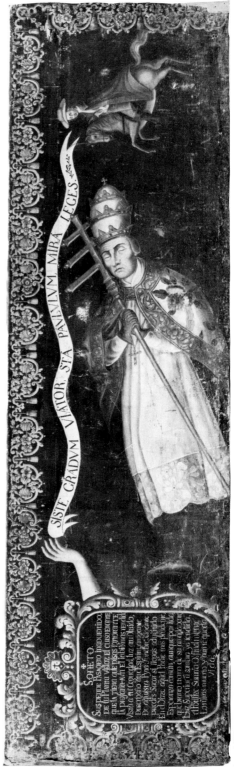

[2.7] The pope.

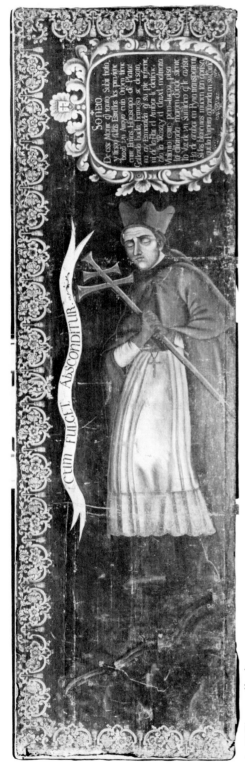

[2.8] The cardinal.

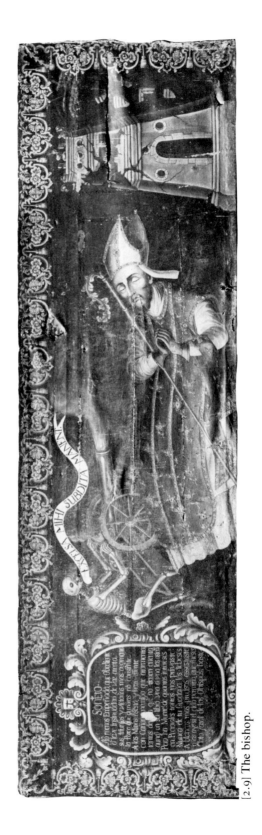

[2.9] The bishop.

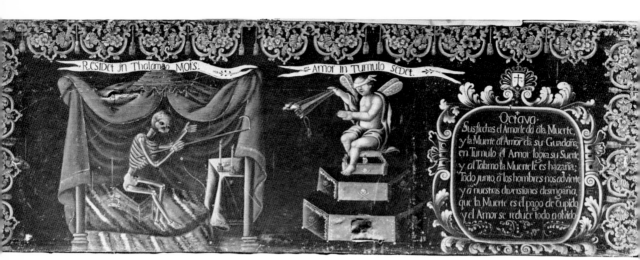

[2.10] Amor and Death.

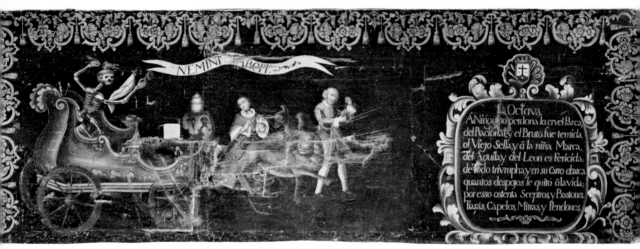

[2.11] The triumphal chariot of Death.

[2.12] Death and the Maiden.

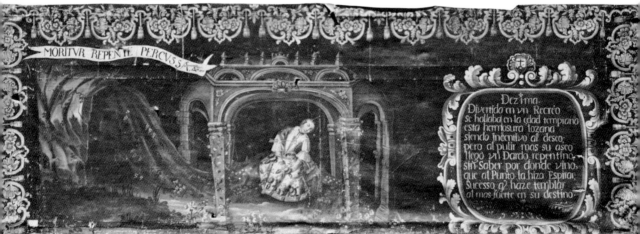

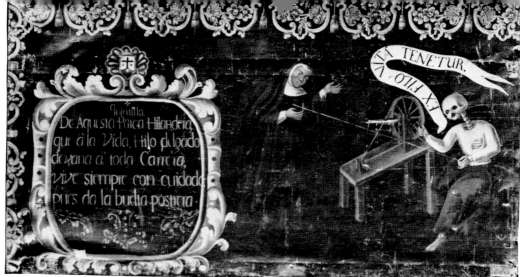

[2.13] Death, the spinner.

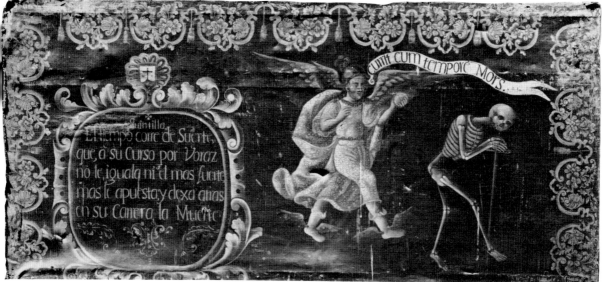

[2.14] Time races with Death.

[2.15] The Last Trumpet.

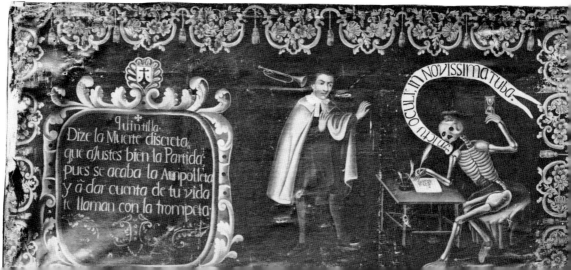

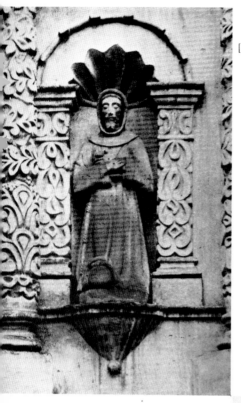

[2.16] St. Francis of Assisi. Toluca, Mexico.

[2.17] Philippine catafalque. Engraving.

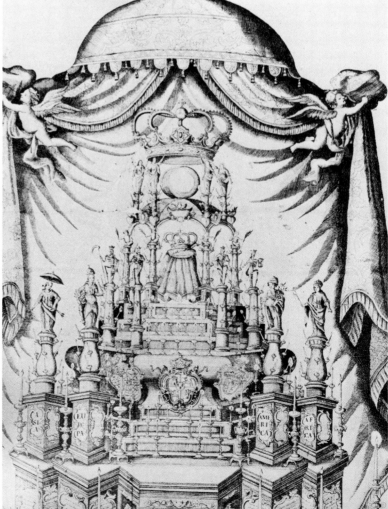

Of Adobe, Wood and Stone in New Mexico

Arid high plateaux cut through by wide canyons and rimmed with heavily forested mountain slopes comprise the landscape of New Mexico. Very few parts of the United States have such an early and varied history. Here clashed and mingled three different civilizations–the ancient Indian, the Spanish colonial, and the "Anglo" or North American. In the history of the stone retable of Santa Fe are mirrored the various racial and artistic strains which contribute a unique vigor to this region.

Arizona and New Mexico, northern edges of the Spanish colonial empire, lay on the border of unconquered territory, vulnerable to unexpected movement from many quarters. By the mid-seventeenth century it was clear that the golden cities of Cíbola were not to be found there. Santa Fe; founded in 1609 and named The Royal City of the Holy Faith of St. Francis, remained the northernmost outpost of Spanish control. Franciscan missionaries, supported by the Spanish Crown, set about converting the Indians, not only along the easily accessible Rio Grande but also in remote mountain valleys. The small colony was beset by Indian revolt and murder-

ous forays by savage Indian nomads, and in 1680 Santa Fe was practically wiped out. But within a decade, Diego José de Vargas, the newly appointed governor and captain general of the region, was able to put the community on a firmer footing. He had a thorough search made in every Indian pueblo for looted church property, and from his list, it is clear that at that time the ritual objects were not made locally but had been brought in by the missionaries.

Communication was maintained and stores replenished by wagon trains that plied every three years from Mexico City, the viceregal capital over 1,500 miles to the south. With each group came soldiers, colonists and friars, who carried with them the bare necessities for life and the performance of their services. Bad weather, impassable roads and attacks by Indians often disrupted the traffic, and the shortage of basic utilitarian items wrought grave hardship on the striving little community.

While the parish priest and missionary received some subvention from the Crown for their work, the religious personnel suffered perhaps even more than the civilians in the great intervals between the arrivals of supplies. The bishop of Durango who ruled over this increasingly vast territory seldom visited his domain. Because of the great distances and the shortage of clerics, *visitas* had to be established, where the priest, arriving sometimes after an interval of several years, performed mass marriages, baptismals and burial services. There were no schools. Most people were illiterate. Much of the religion was kept alive by word of mouth. All of this led to alterations and additions in standard religious practice and art which can be confusing to present-day students and artists. In vain had Indian raids destroyed chapels and churches. They were gradually rebuilt and decorated. There was a need for Bibles and utensils for the Mass, for candles and candlesticks, vestments and altar covers. The replacements, when they did arrive, were often inadequate and of very mixed quality. More and more of such requisites came to be made by local craftsmen.

The buildings in that arid and sunburned region were constructed of adobe–bricks and slabs of sun-dried clay–with walls sometimes almost a yard thick, after the manner of the terraced houses of the Pueblo Indians in pre-Columbian times [3.1]. Not only were the materials at hand different even from those available in Mexico but also the local craftsman had very little artistic tradition. He made retables of wooden panels on which a local painter sketched out and then colored the figures of locally popular saints [3.2]. Altar cloths were embroidered with motifs that were often more worldly than religious; wall hangings were painted on deer, elk and buffalo skin. Production of church furniture–confessionals, pulpits, benches–

grew into a local industry. The priest wrote his own registers of birth, death and marriage, decorating the title pages as far as his artistic impulse led, and bound them in buckskin and rawhide. It was natural that the interior as well as the outside of buildings came to be stamped with a distinctive New Mexican style.

Sheep raising and other animal husbandry improved yearly. Agriculture developed as far as labor was obtainable. The ancient systems of irrigation and dry farming were applied to advantage. In the beginning, many of the Indians proved recalcitrant and had to be forced to work. It should be mentioned here that in few parts of the Spanish viceroyalty did so many Spaniards or Spanish descendants work with their hands and take an active part in the development of their land. The Indian was at the bottom of the social list; then came the mestizo. The Negro had a special place, because he represented the investment of money. However, the Creole, born of "pure" Spanish blood in the Americas, was less socially honored than the native of Spain who, although he may have come recently from the mother country and claimed an ancestry which often was impossible to trace, nevertheless lorded it over the impressionable and strongly provincial population.

Thus, on one side, the religious personnel and some of the farming population lived in poverty, while the gentry enjoyed the benefits of affluence–each class differentiated by its costume. The Spanish New Mexican *hacendado* wore a broad hat with a feather and a short circular cape edged with gold fringe. His breeches showed a row of silver buttons down the side and often a ruffle of lace, and his horse boasted splendid trappings. The officers of the garrison were similarly garbed in fine material, decorated when possible with gold and lace. The itinerant field judge also held an important post. He was charged with the settlement of borders and water rights, and with the investigation of theft and other crimes committed in his districts. He was also the supreme authority when it came to military parades and rodeos. Although his uniform was practical of necessity, it sported silver braid and buttons. His stirrups might be of silver, and the sword of authority hung at his side.

The pioneer woman wore the sturdy clothing of a peasant; but with prosperity and the growing exchange of merchandise, silks and velvets appeared, with laces and jewelry sometimes imported from Europe–and several years underway. Chinese porcelain cups from the early eighteenth century were found among the ruins of early mission stations. The absence of handles proves that they were not made for export to Europe, but originated on the Asian mainland and came via the Philippine trade.

A map of Santa Fe from the mid-eighteenth century records a "palace" for the governor, a church and monastery dedicated to St. Francis and another to San Miguel [3.1]. There were several chapels besides—one at the end of the governor's palace for the service of officials and leading members of society; a special chapel for the use of the garrison stationed in the town, and one for the Indians. The map shows a *barrio*, or quarter, called Analco where Tlaxcalan Indians, who had accompanied the first Spanish settlers, were settled. It was the practice that members of this friendly tribe, who enjoyed certain privileges because of their early alliance with Cortés, should function as a connecting link between the Spanish population and the unsubdued Indians of the locality.

In 1754, Francisco Antón Marin del Valle became governor and captain general of the remote province. As the old garrison chapel had fallen into disrepair, he ordered the construction of a new and more elaborate one, dedicated to Nuestra Señora de la Luz, "Our Lady of Light," and generally known as *castrense*—that is, belonging to the military. Pedro Tamarón, then bishop of Durango, visited Santa Fe about that time and praised the building in his report. For this chapel, the stone retable illustrated here was carved; it is unique in New Mexico in its material and sculptural variety [3.9]. The names of del Valle and his wife appear as donors at the base of the piece with the date 1761.

By the end of the century, trade with the United States was growing more and more lively. According to some historians, the customs and ideas which the Yankee brought into the Spanish colony were a significant cause of the movement toward independence from the Spanish motherland. In vain did the Spanish authorities forbid dealing with the North Americans. Wagon trains on the hazardous Santa Fe Trail brought manufactured goods that were eagerly exchanged for the heavy silver peso of Spanish minting and for produce and materials valuable to the northerners. Trading licenses gained great importance.

In 1846, the area above the Rio Grande became United States territory. After the dissolution of the Spanish colonial regime, Mexico was struggling for the firm establishment of a republic. Hostile Indians were rampant on both sides of the border. Protestants from the north had moved in, and the religious zeal of the Roman church slackened, still ruled as it was by the bishop of Durango some 1,000 miles away. The creation of a separate bishopric for the territory above the Rio Grande had been in travail for decades, even in colonial times, but had met with indignant objection from the Mexican hierarchy. Under the American regime, the territories com-

54

prising New Mexico, Arizona and Colorado were withdrawn from the jurisdiction of Durango, and a French missionary priest, Jean Baptiste Lamy, was appointed bishop of the huge new diocese. He arrived in Santa Fe, his capital, in 1849, accompanied by a lifelong friend as his vicar.

Lamy was born in 1814 in Lampdes, province of Auvergne, in a clay-plastered house on an unpaved street; pigs and chickens ran about the muddy courtyard. As a member of a family of many children, he was early destined for the priesthood. The rector of the seminary he attended encouraged his interest in missionary work, and at the age of 24, Lamy sailed for the United States. Stationed at Cincinnati–already a lively commercial center where waterways and highroads converged–he served Roman Catholic missions in farming communities of Kentucky and Indiana for some ten years.

Although brought up in a poverty-stricken village, Bishop Lamy knew the medieval monuments of central France and had lived for some time in the prosperous Midwest. He must have been shocked at the sight of his new see. The buildings were mud colored like the endless landscape. Though American occupied, the place had kept its Mexican look. Indians, Mexicans, American traders, sheep ranchers, trappers and prospectors produced a dizzying human mélange in their variety of dress and type. The simple folk traveled by burro; the more affluent rode on horseback with high-heeled boots, broad hats and *sarapes*, practical for riding in the blazing sun. The women wore long *rebozos* draped over their heads and shoulders, even over their faces. These people were ignorant, quick minded and hot tempered. Whatever education they had was received at home. Lamy found four Protestant ministers already in the region working to establish schools. The resident Roman priest was a Creole, suspicious of his new "foreign" superiors, especially since Lamy spoke no Spanish–and indeed always remained rather weak in that language.

Lamy set out as soon as possible by muleback for Durango–a trip that took him nearly a year–to verify his authority with the Mexican bishop. Then, secure in his new post, he chose the church of St. Francis, the largest in Santa Fe as his parish church and cathedral, and made his own census: 68,000 Catholics, 2,000 "heretics" and some 40,000 "infidels." Within four years, he had opened a convent school, with ten boarders and 22 day students. He visited each of his parishes, condemning some buildings as unfit for religious service, encouraging the refurbishing of others, replacing the old religious objects as fast as could be afforded.

For a priest graduated in Europe, it must have been disturbing indeed to

walk into such a church as Cordova's, which mirrored the religious imagination and iconographical concepts of those who had built and decorated it in year-long isolation [3.2]. Our eyes, accustomed to expressionistic art, are not repelled by the holy images of the region. One can recognize in them the unswerving faith which inspired the local craftsmen. The *santo* of the Merced in her modish hat is painted on cottonwood with all superfluous ornamentation left aside [3.3]. In her right hand she extends the symbolic purse of charity–originally, of ransom for enslaved Christian captives. In her left, is not the standard lily but a flower of the desert with three buds. St. Christopher's halo is fixed to his head, as is usual in a statue [3.5]. On his shoulder, the Child Jesus, holding the orb of sovereignty, is fully dressed, while the saint wears only a wide loincloth and sandals. His staff is a stalk of cactus. Broken horizontal lines make the flowing stream credible. In the *bulto,* or carved figure, the Christ of the Column leans on a slender conventionalized pillar suggesting a plant [3.4]. His hands are bound, his large eyes open but unseeing. Ribs and wounds are exaggerated. The whole sculpture evokes compassion. Yet how could Lamy, who had no knowledge even of the lachrymose and highly dramatic images of Spain, find any religious focus or point of reference in such works, accustomed as he was to the saccharine mass-productions common in the mid-nineteenth century.

Like anyone moving to an alien land from his own culture, Lamy brought with him his own ideals. Educated in a small French seminary, he looked upon his diocese as a French missionary enterprise. His standard was a French colony with French religious administration, that drew sustenance and financial aid from France and was influenced by his European experiences. When he turned to the construction of a worthy cathedral, he chose a French architect–perforce using local materials–so as to echo as closely as possible the cathedral at Clermont, near the place of his birth. But the alternating blacks and whites of the windows and the dwarf twin towers of the cathedral at Santa Fe lack the grace and spontaneity of the old-country architecture [3.6]. The result is as much like the Romanesque and Gothic of France as the faded rose pressed into her prayer book is like the bouquet which a young girl carried to the ball. However, Lamy had early expressed an admiration for the stone retable in the Castrense and had made a special effort to keep the building in good condition. When further repair of the chapel was found impracticable, the site was sold, and the great stone retable of N.S. de la Luz was set up in the cathedral building, still under construction, replacing the original "tinsel" altar there (1859).

In 1875, Lamy was named archbishop. He retired ten years later and died in 1888, his dream project still incomplete, and was buried beneath the cathedral's main altar. His successor, Pierre Salpointe, a practical and sober man–also French–recognized the impossibility of carrying out Lamy's original plan. All that he could do was to appeal to France for enough funds to complete the façade and connect the old and new sections of the building. The stone retable was concealed behind a curtain of canvas and a more "modern" one placed before it. When we saw it in 1936, it was walled into such a narrow space that it was almost impossible to study it. Many visitors did not even know of its existence.

Early in 1939, the Anglo community, with the approval of the diocese, transferred the stone retable to a new building, known as Cristo el Rey, "Christ the King." It is in the pueblo style, which is not only autochthonous but also, through its tasteful proportions, a worthy shelter for the unique eighteenth-century carving [3.7].

In comparing this retable with contemporaneous European work, a certain disregard for architectural organization is notable in the placement of the ornament–trademark of the folkloristic [3.9]. At the top, semicircular sections in very flat relief each contain a human head surmounted by an ornate composition of flowers and fruit. The second tier is flanked by a related scheme of great tendriled vines and tasseled cords. *Estipites* (inverted obelisks) serve as inner pilasters, surmounted by human heads and figures. Eucharistic grapes are featured everywhere. The basket carriers and the flowery vases are motifs that are found in delightful regional variations from the frontiers of New Mexico to the Bolivian highlands. Despite neglect and mishandling, patches of brown, blue and white are still visible, revealing a lively sense of contrast. The retable must once have been the pride of all believers. It is interesting to remark that at a time when the Baroque in Mexico was at its most ebullient, the figures in this retable show an amazing serenity, almost aloofness, dominating the proliferation of ornament–another argument for its local production.

Like more ambitious compositions, the stone retable of Santa Fe is divided into three tiers. The Apostle St. James the Greater holds a predominant place in the center of the second tier. He is represented in the aspect popular throughout colonial America, mounted on his white charger leading Spanish troops to victory. The placement of the figure within an octagonal frame is effective, echoing the larger, more elaborate niche below him.

The image of God the Father occupies the uppermost place. He wears the

papal tiara and in His left hand holds the orb, symbol of sovereignty; His right is raised in the gesture of benediction. The panel below this presents Our Lady of Valvanera, department of Lograno in northern Spain. This version of the Virgin Mary can be traced back into the tenth century, when, according to legend, her miraculous image was found in a tree. In the original Romanesque statuette, she rests on four eagles. Hers is said to have been the first picture to arrive in the New World, brought by Christopher Columbus on his first voyage. A striking representation of this figure is now in the Museo de Américas in Madrid. It is a rather small painting, some 18 by 13 inches, signed by one Juan Gonzáles [3.8]. Here Mary sits with the Child in the hollow of a tree, a cavalier kneeling before her. The figures are encrusted with seashells and lacquer in brilliant colors, a technique practiced with picturesque effect in the exotic materials of the New World.

On the Santa Fe panel, also, the Virgin sits in a tree; the eagle's head can be seen at the right and its tail at the left, as if she were enthroned upon the creature, symbol of majesty. It is evident that the entire upper section of the retable was once framed by a pediment, perhaps with a bevy of little angels so beloved in folk sculpture.

Likewise in the tradition of the regional artist is the left panel of the second tier, showing St. Joseph with the Infant Christ and with the flowering staff associated with his figure. In the art of Europe, Joseph is usually represented as "a person very far advanced in years." In the Spanish colonies, he became a rather youthful figure with dark beard and upright carriage, as shown here. Below this panel, Ignatius Loyola, founder of the Jesuit order, stands on two globes, carrying a standard and a book inscribed with the motto of his order: *Ad Majorem Dei Gloriam,* "for the greater glory of God."

Thus far, holy figures have been seen that can be encountered universally. The three remaining panels introduce a new note. The saint on the right of the first tier is the Franciscan Francis Solano (1549-1610), known as the Apostle of South America. His left hand holds aloft a crucifix, while the right extends a shell, symbol of baptism, above a group of half-naked Indians, some of whom are wearing feathered headdresses. Solano worked for twenty years among the natives, beloved by them for his command of their various dialects. He died in Lima and was canonized in 1726, only 35 years before the conclusion of the military chapel in Santa Fe. It is notable that in this panel other figures and a tropical landscape appear.

Above this relief is John of Nepomuk, patron of Bohemia and protector of the Jesuit order. He wears clerical robes and carries a crucifix and the palm of martyrdom, for he was cast from the bridge at Prague into the Moldau

River in 1393 because of his refusal to reveal the secrets of the confessional to the Bohemian king. Some of the arches of the bridge are visible in the carving. John of Nepomuk was venerated locally from the time of his death but was not canonized until 1729, three years after Solano.

The cult of the Holy Mother of Light, subject of the striking central panel in the first tier, is closely linked with missionary work [3.10]. Portuguese Franciscans founded a mission in her honor in India in 1516. Some 25 years later the Jesuit missionary, Francis Xavier, and his companions enrolled in a religious society dedicated to her before setting out for the Far East. In the early eighteenth century, the cult gained impetus in Sicily, then a viceroyalty of Spain, following an apparition of the Virgin. A painting of this vision was made in Palermo and later accompanied the Jesuit Guiseppe María Genovesi when he went as missionary to Mexico in 1707. Soon various Jesuit establishments in Mexico were vying with one another for its possession. It was given to León in the northern part of that country and is enshrined there in the cathedral [3.11].

The canvas, only about three feet high, shows Mary carrying the Child on her left arm, while with her right she lifts a soul in the form of a terrified human being out of the gaping jaws of the Devil, a writhing dragon. The Infant holds a flaming heart in each hand, symbol of Christian devotion, which he has selected from–perhaps is placing in–a basket proffered by an angel. Two smaller angels float above the Virgin's head holding a large crown, and cherubs dot the clouds about her and are grouped beneath her feet. The text on the phylacterium of the original is in Italian: "La Madre SS: del Lume" (*lume* means light in the Sicilian dialect). Spanish or colonial reproductions of this figure, however exactly copied, always bear the text in Spanish: "Madre SS de la Luz" or "N. S. de la Luz."

In Europe, the writer found no traces of this version of Mother and Child except in Sicily. In the parish church of Avola, a town on the eastern part of the island, on a side altar dedicated to her, the dramatic scene is depicted in polychromed wood [3.12]. The priest there expressed amazement at our interest. Pointing to the bare, unused altar, he said they were considering scrapping the statue because, to quote him, *Come devozione e morta*–"As a cult she is dead." A claim that it possesses the original painting of Madre Santissima del Lume is made by the parish church of the ancient tiny fishing village of Porticello, whence, legend has it, Father Genovesi departed for his missionary work in the New World. In this place, as we observed, the image is painted on a slab of slate and is nearest in style to the painting venerated in Mexico. It would appear that this dramatic version of the Virgin originated in Sicily and came to especial popularity in the New World

through missionary activities for which its symbolism held the significance of actuality.

In Quito, Ecuador, a teeming missionary center famed for its art work in colonial times, an enormous painting of the subject exists, as well as an exquisite statuette group by the famous Indian sculptor Caspicara. In Puebla, Mexico, about the same time, a church was dedicated to Our Lady of Light and a panel on the façade depicts the scene using that city's well-known tile work. Tepotzotlán, great center of Jesuit teachings, possesses a lovely half-lifesize statue, excellently preserved. In Texas, a mission bore her name, and we saw a small high relief of the figure in a private collection in New Mexico. In Zacatecas, northern Mexico, the group, as life-size polychrome wooden statues dressed in textiles, stands on a side altar of the church of Santo Domingo, once Jesuit property [3.13]. And in the town of Guadalupe nearby, there are a number of paintings of the figures, interestingly varied in style and costume according to their date. All of these various representations in Old and New Worlds date from the eighteenth century. It is remarkable that a small picture could inspire not only large and small paintings but well-balanced reliefs and three-dimensional statues, where the originally mild and demure figure becomes a dramatic protagonist of the cult.

A book on the cult of Our Lady of Light was published in Palermo in 1733, and a Mexican edition appeared four years later. By that time, Mexico had a flourishing production of books, well illustrated with woodcuts and engravings. In 1766, Governor del Valle of New Mexico founded a religious brotherhood, the Cofradía de la Congregación de N. S. de la Luz, and had the constitution and bylaws printed in the Mexican capital. Its frontispiece is a woodcut that follows, within the limitations of the medium, the original Italian canvas [3.14].

The Santa Fe stone panel is carved with economy of line. The figures have been fitted with dexterity into the octagonal composition. Although it is evident that the panel was executed for the same complex and by the same artist who carved the retable, yet it does not seem originally intended for the place it now occupies. The corner pieces with their carved rosettes prove that the relief was designed to go into an upright rectangular space. Further, it is too short to fit into the central niche of the retable so that a broad band of different material had to be added to fill the gap. An officer of the United States Army, in describing the military chapel at Santa Fe as he saw it in 1846, states that a large rectangular slab showing Nuestra Señora de la Luz occupied a place on the façade above the central portal. The Puebla example has already been mentioned and there are a number of others in which this

60

tradition survives. That the central panel is dark and weathered, as against the retable where traces of coloring are still clear, was noted by the architect who built the modern church. Also, there is evidence that when the retable was stored in the cathedral, a statue filled the central niche, bearing out the tradition that the panel was originally designed to stand elsewhere. Nevertheless, in the absence of any contemporary group, the placement of the relief where it now stands is eminently fitting.

The selection of saints to adorn the Santa Fe retable gives it especial individuality: saints revered through the ages stand beside those canonized only a short time before it was designed; a representation of the Virgin, of most ancient tradition, is juxtaposed with one of the latest cults. Being carved of stone, the retable is unique in New Mexico. Most New Mexican churches had retables of wood or of brick and adobe. Bishop Tamerón reported that the material for this piece was quarried about eight leagues, that is some twenty miles, from the city and was of very fine white texture. A recent finding of stone chips in the courtyard of the former Castrense corroborates his statement.

The visitor who, like this writer, returns to Santa Fe after some decades will find a number of added attractions to the cityscape. Victorian façades on the main plaza, which once seemed utterly incongruous, have taken on a certain historical perspective. And, fortunately, more and more new structures are being built in the Pueblo style. In the church of Cristo Rey, erected according to plans by the architect John Gaw Meem, modern and colonial Santa Fe meet most impressively [3.7]. The enshrinement of the colonial retable in a modern church epitomizes the maturity of artistic and historical appreciation. This edifice, built in the shape of a cross, incorporates architectural features of several regional churches of the colonial period. It is one of the largest adobe structures now in use in the United States, with walls that vary from two to seven feet in thickness. Two massive towers flank the entrance. Between them–a favorite feature–a second-story wooden gallery opens from the choir. Its railing and bold overhead beams bring a pleasing contrast in texture and color to the adobe walls. Wood also adds a livening hue to the side wall, where the heavy beam ends protrude in old Pueblo tradition. An open corridor along the first floor at the left produces a plastic effect. Inside, the whitewashed wall, the wooden floor and the carved corbels also are in keeping with tradition. Small windows bring in a diffused light. Two-hundred-year-old patina shrouds the unmoving stone figures. Outside, a youth in an open blood-red auto dashes, roaring, past.

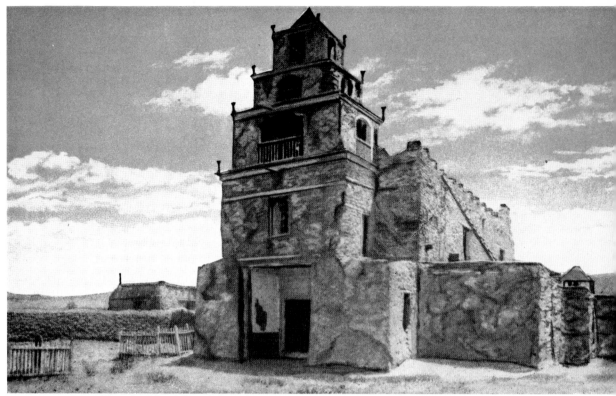

[3.1] Church of San Miguel. Santa Fe, New Mexico.

[3.2] Church interior. Cordova, New Mexico.

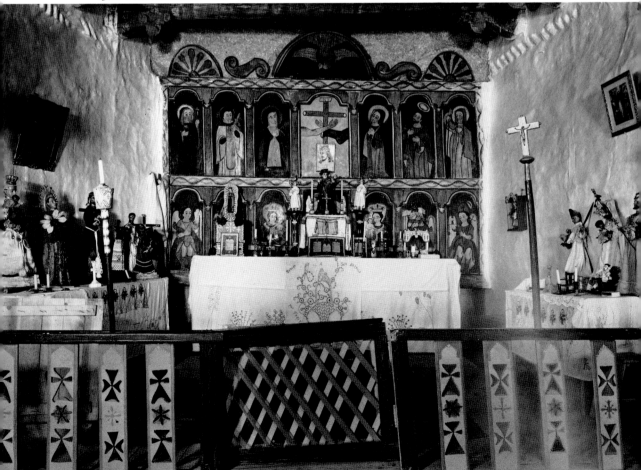

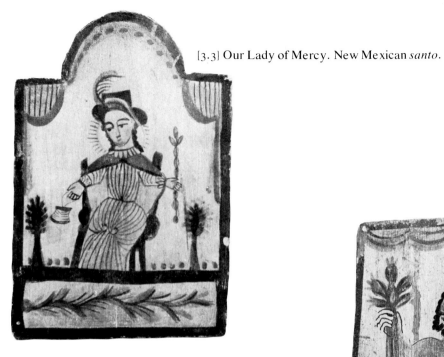

[3.3] Our Lady of Mercy. New Mexican *santo*.

[3.5] St. Christopher. New Mexican *santo*.

[3.4] Christ at the Column. New Mexican *bulto*.

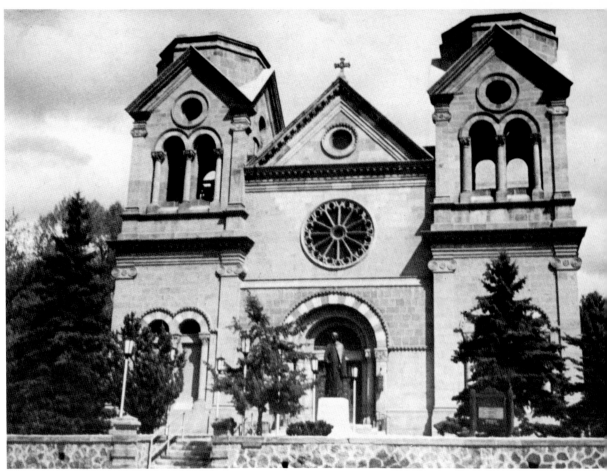

[3.6] Cathedral. Santa Fe, New Mexico.

[3.7] Church of Christ the King. Santa Fe, New Mexico.

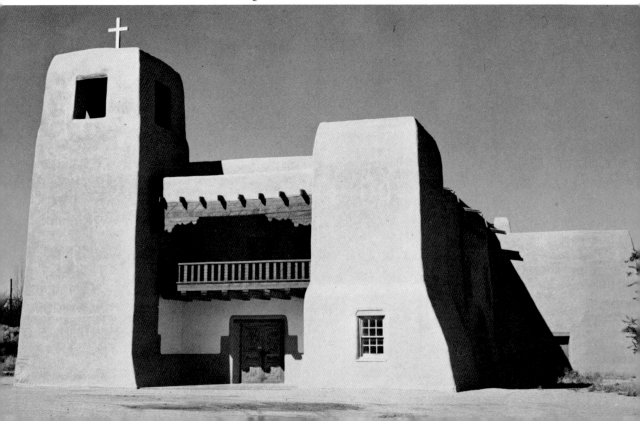

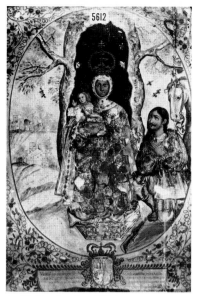

[3.8] Our Lady of Valvanera.

[3.9] Stone retable. Church of Christ the King. Santa Fe, New Mexico.

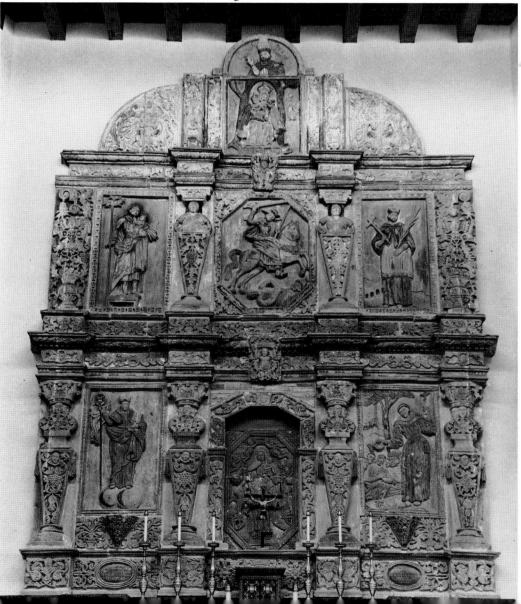

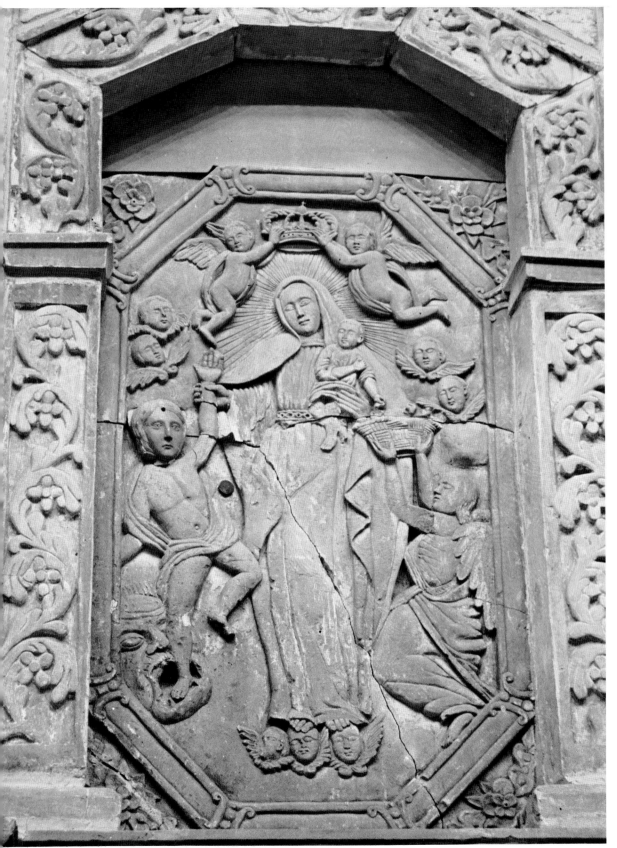

[3.10] Our Lady of Light. Church of Christ the King. Santa Fe, New Mexico.

[3.11] Original painting. Cathedral. León, Mexico.

[3.12] Parish church. Avola, Sicily.

OUR LADY OF LIGHT.

[3.13] Santo Domingo. Zacatecas, Mexico.

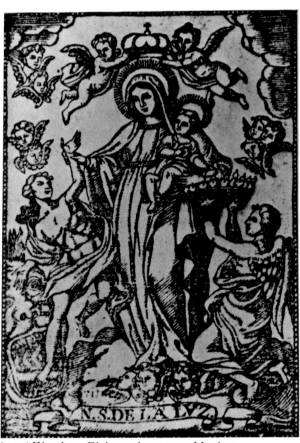

[3.14] Woodcut. Eighteenth century. Mexico.

4

A Calvary Scene in the Bolivian Wilderness

An ancient tomb chamber was discovered in the Nazca Valley of Peru roofed over with wooden beams and in good enough condition to reveal fragments of large painted cotton hangings draping the walls. For coloring the fabrics, dyes were used that did not seep through to the back. The designs were outlined in black, which prevented the paint from spreading into empty spaces, then filled in with color. Chiefly brown and yellow remain, with traces of red, blue and black.

The conquerors found many uses for the Indians' technical skills in their civilian life. As well as taking a great role in the building of dwellings and churches, the natives furnished textiles, from wall hangings to table covers and clothing. Considerable comfort, even luxury, developed early along the route of the silver pack trains. Inca roads, which followed the Altiplano from south to north, could be utilized. However, travel at best was rough, and many areas of lesser importance remained practically inaccessible. Even the ancient Inca road which continues into Ecuador leads off to a dead-end branch toward the east. This was a wild region from the points of

view both of population and landscape. Maps of the sixteenth, seventeenth and eighteenth centuries show a vast uncharted area, not connected with the pulsing life of the highways–and darkness hangs over it when it comes to history.

The Jesuits were comparative late-comers to the New World. By the time they reached the viceroyalty of Peru, the older religious orders had put their claim on much of the more easily accessible lands. The Jesuits considered themselves a military order in the service of the Lord and, as quasi-commandos, were willing to take over various missionary territories in dangerous peripheral areas, such as northern Mexico and tropical South America. In 1671, the Provincial of Lima ordered the evangelization of the province of Mojos.

This was the *oriente,* an area on the borders of Peru and Bolivia, where the ground falls rapidly from the freezing high plateaux to jungle forest less than a thousand feet above sea level and only five degrees below the Equator. Far from any civilization, communication was practically impossible during the rainy season from September to April. Even maps of the present day show a blank area, streaked through with veins of water alternating with swamps and bogs, and paths that in colonial times were often known only to the Indians. No gold or silver was to be mined there. The natives lived in widely scattered tropical forest villages as farmers, hunters and fishermen. The most powerful and culturally advanced of the tribes were the Mojos and the Chiquitos. In the mid-seventeenth century, the Mojos counted some 6,000, scattered in seventy localities. The Spaniards describe the men as wearing long togalike garments of printed cotton and nose rings of silver and other metal [4.2]. They were expert with bow and arrow. The women wrapped themselves in straight untailored lengths of cotton cloth.

By the end of the century, the Jesuits had gathered as many as 20,000 Indians in fifteen well-organized *reducciones.* "Reduced" from their former wild state and settled about the mission, they formed a closed circle with as few outside influences as possible. In many of these communities, no Spaniard or Creole was permitted even to spend a night. This change in the entire life style of the natives was drastic. As they were illiterate in matters of religion, the events of the Bible and the principles of the dogma had to be brought before their eyes, whether on the walls of the church or with printed illustrations. Reports state repeatedly that the Mojos and Chiquitos showed superior talent in music and in handicrafts. They eagerly took part in the sumptuous services of the church and participated with

70

music and dancing in the various ceremonies. They constructed pipes of different lengths from reed or light bamboolike wood, on which they played with the effect of an organ–which later they were able to build [4.1].

A native cotton which has relative strength grew in this region and could be woven on standing or horizontal looms into a durable cloth of considerable breadth known as *tucuyo*. It was said to take six days to spin one pound of the cotton thread and eight days more to weave one yard of tucuyo. The manufacture of this heavy cotton cloth was a characteristic industry of the Mojos–and the designs were painted like the pre-Columbian fabrics excavated in Peru with dyes that do not bleed through the reverse side.

It was natural that the Jesuits made use of the Indians' skill at weaving. A painted cloth of uncertain purpose from that region is now in an East German museum collected early in this century [4.13]. The design is divided into several fields. A little orchestra is represented in the upper row playing a viol, a *charango* and a harp, and at the right, a trumpet. On the lower and larger section, soldiers in eighteenth-century uniform stand at attention to right and left, emphasizing the solemnity of the middle scene. Here the details are garbled. The scene might represent the ritual biblical sacrifice of a ram, or, as the presence of the large bird suggests, Elijah miraculously attended in exile. What gives this hanging especial interest is that the Lenten curtain of the Descent from the Cross [4.4] is framed with a nearly identical wavy pattern enlivened at the sides with a thorny or saw-toothed motif. Although the similarity of the borders is not a proof that the pieces were done by the same hand or even come from the same village, it shows that this was a popular decorative element in those missionary regions. The same sinuous motif also occurs in a somewhat less organized form in the leafy pattern framing in Figure 4.5. It appears that the three curtains illustrated here are of the same material and the same general provenience. In subject matter, they are connected with the ritual of Holy Week.

Dramatic presentation of religious events was long practiced in Europe. The Holy Week processions in Spain are famous. Even today on Good Friday some church interiors are draped totally in black, tomblike, emphasizing the tragedy of the Crucifixion, obliterating the worldly pomp usually on display. Transplanted to the New World colonies, the drama was soon embroidered with touches of native fervor at fiestas in which all the surrounding communities took part.

In our nearly four and one-half decades of surveys in Latin America, covering the land from Mexico to Bolivia, it has happened repeatedly that on entering a church to take notes and photographs, we found the main

retable curtained away–*tapada*. This was always at Lent, in preparation for an enactment of the great biblical drama, the Passion of Christ. The main altar is veiled as early as Passion Sunday, a week before Palm Sunday, though the solemn procession does not take place until Good Friday before Easter. Then the statues are carried out on litters studded with silver and bedecked with flowers–Christ bearing the Cross, Mary as the mourning Dolorosa, followed by John the Evangelist, weeping. It is regarded as a special service to help bear these heavy burdens. Pancho Fierro (1802-1879), mulatto artist of Lima, has immortalized such a Holy Week procession, showing floats of Christ's entry into Jerusalem, the Last Supper, and Christ before Pilate surrounded by Roman soldiers.

We have a description of the moving ceremony at the church of San Felipe Neri in Oaxaca on Good Friday of 1970. Two black curtains veiled the sanctuary, a single lighted candle in front of them evoked a sepuchral atmosphere. When the priest mounted the pulpit for his sermon on the Seven Last Words, these curtains were drawn aside, revealing a life-size Crucifix planted in the sanctuary floor. The *Descendimiento* took place later the same afternoon. A man in a long white robe mounted a ladder placed against the Cross and removed the sign INRI, the Crown of Thorns, and the nails from the statue, using white napkins handed up by two white-clad attendants so that the objects should not be touched by human hands. When the first nail was drawn, he let the arm, hinged at the shoulder, fall gently to the figure's side, to uncannily dramatic effect. The body, when freed, was lowered by means of a wide band of white cloth and laid into a glass-walled coffin. A life-size image of the Virgin stood on the altar as if witnessing the whole procedure. When the time came for the funeral procession, this figure was whisked away and replaced by the black-clad Virgin of the Seven Sorrows. Women with candles formed a lighted passageway, and the procession wound through the church, the Dolorosa following until the coffin was set to rest in front of the altar.

In Santiago Atitlán, Guatemala, we have seen the elders of a fraternity reverently washing the figure of the recumbent Christ and preparing it for the grave (1940). In Morelia, Mexico, the women of a sodality, in dark clothes with their scapularies about their necks, held a wake at the side of an open casket in which Christ's figure lay wrapped in white linen (1947).

After the sad days of the tragedy, Easter Sunday brought triumphant processions of the Risen Christ marching through the city streets, sometimes to the music of a military band, in smaller places to that of the amateur orchestra of the town. In Quetzaltenango, "Indian capital" of Guatemala,

the nearly life size statue of Mary was carried in early morning by a select group of women in the colorful garb of their region, ostensibly on the way to the "tomb" (1940). An Indian girl walked in front of the statue, her hair in long shining plaits, holding a bowl of copal incense high on her open palm. The powerful perfume formed a mild cloud into which the figure advanced. We had heard the tune of the "Beer-Barrel Polka" played at the pace of a funeral march in the Good Friday procession; on Sunday noon it was performed by the same band in a lively tempo with rhythmic flourishes.

Monday, after the celebrations, the statues are put away, to be taken out the next Eastertide. In some places where a Calvary chapel exists or the Stations of the Cross are marked by pavilions, as in Brazil, the figures or mannikins are stored there. In Querétaro, Mexico, the participants of the Last Supper occupy an unused altar in the church. The decoration of the various groups on the floats have to be refreshed from time to time, causing rivalry among members of the various fraternities and sodalities as to who will be granted this honor.

Embroidered scenes of the Passion appear on the Lenten curtain that veiled the altar in the church of Santa Teresa, Ayacucho, Peru [4.3]. On the cross-shaped medallion in the center, one can make out the Washing of the Apostles' Feet and the Last Supper; at the center is the Crucifixion, surmounted by the Entombment; and at the top, the Risen Christ. The curtain is dated 1727 and was in use as late as the 1940's, when this photograph was made.

The three painted hangings from the Mojos region illustrated here represent the Descent from the Cross. The center of all three compositions [4.4-4.8] is the Crucifix. Christ's head leans toward the left; his body shows drops of blood, sometimes to a degree that suggests a fetish. Mary and John the Evangelist stand at the foot of the Cross. Mary Magdalen appears in two of the paintings clasping its base.

It is clear that these curtains, with all their considerable differences, relate the whole Passion story in a condensed form. In the background one can find the two cruets of the Eucharist. The larger urn suggests the pitcher and basin that Pilate used to wash his hands of responsibility. The Cup of Gethsemane is shown as a chalice in some of the paintings. The staves of the mob at Gethsemane are there, the sword, and the ear which Peter cut off with it; the head of Judas appears with his moneybag—in two cases it is significantly tied with a rope around his neck. The reed put into Jesus's hand when He was mocked, and the hand that struck Him; the scourge and the column, together with the cock that crowed upon Peter's denial of his Lord,

can be recognized. The dark robe at the upper right is the purple one put on Jesus when He was mocked as King of the Jews; the one on the other side represents the seamless garment for which the Roman soldiers cast dice–which are also depicted. An axe or hammer, the three nails and the pliers for removing them are present, and the sponge and lance can be seen beside or behind the Cross. In the upper corners, the darkened sun and moon bear mournful witness–in one hanging the sun is weeping [4.4]–and in the upper center of two of the curtains, the veil of Veronica carries the face of the Lord. The three overlapping faces representing the Trinity [4.6] stand in direct contradiction to the tenets of the Council of Trent.

The two thieves appear in all three representations, one turning toward Christ, the other, at the right, looking away, while the Devil lurks nearby waiting for his impenitent soul. The Devil has the spotted tail of a jaguar in Figure 4.4. Certain elements of one version [4.5] seem to have been painted in reverse, as if copied from a tracing. Judas is seen at the left, as is John with the Chalice. On the right, quite similar to John in dress and outline, stands the Virgin Mary, her heart seemingly pierced with a machete rather than a rapier. Interesting is the decorative use of stripes on the various robes.

Drum, drumsticks, furled flag and trumpet can be recognized in a frieze at the bottom of the representations. These too doubtless carry symbolism, as well as the reminder of military might. A broken branch symbolizes life cut off, a furled flag is funereal, the trumpet reminds of the Last Judgment; the name Golgotha signifies "place of the skull." In one piece, drumsticks and crossbones have blended [4.4].

No doubt the most outstandingly dramatic depiction and also the most detailed from the iconographical point of view is the hanging in Figure 4.6, which measures 13 feet 4 inches high by 9 feet 11 inches wide. Drum, trumpet and flag are clearly represented. The many symbols of the Passion seem to float in space and, with stars sprinkled over the free surfaces, the effect is that of a tapestry. The composition is balanced and full of movement. Here alone there is action; in the others every object stands posed as if frozen in time.

Near the frame on the right, a crouching skeleton suggests the limbo which the good thief escaped. In the lower right corner sits an elegant young man in eighteenth-century attire, at ease with knees crossed, as if observing the scene [4.7]. With his fine cut of coat, the elegant buttons and silver buckles, he might be a sponsor or an *hidalgo* bystander. But the horns and the spurred heels identify him as the Devil, however great the contrast with the other representations–as if a warning that he is always present, cleverly disguised, awaiting his victims. Behind him, the reed put into Jesus's hand

at the Mocking, the pillar of the Flagellation, and the cock marking Peter's denial are strikingly grouped.

Although they all record the drama of the Passion, these hangings are obviously done by different hands. All are painted with dyes in the pre-Columbian technique–the figures outlined in black and filled in with mild colors.

It was not until the time of Dürer in the early sixteenth century, as woodcuts and engravings proliferated, and especially around Rubens (1577-1640), that representations of the Descent from the Cross populated with many figures became favored. Ruben's famous painting in the Antwerp Cathedral presents three women and five men near the Cross–two workmen stand on ladders leaned against it, while two ancients in flowing biblical robes receive the body of Christ as it is lowered. An earlier representation, strongly Gothic, brings a Descent in which Joseph of Arimathea and Nicodemus in rich robes stand on the ladders and, with white linen cloths in their hands, themselves take down the body of Christ [4.9]. In Mexico, numerous *Descendimientos* exist, mainly as sculptured groups. Such a *tableau mort* from Peru [4.10] is especially relevant since it comes from Juli on Lake Titicaca, where the Jesuit order was powerful. The scene is staged three-dimensionally. The personages are all in biblical garb as tradition dictates, including the two figures who take the body of Christ from the Cross. Here the story is still more graphically presented, because the *Cristo yacente,* Christ laid out for burial, is visible in a painting immediately under the sculptured scene.

No doubt, somewhere a prototype existed in print or on canvas from which inspiration for our painted Mojos curtains was drawn. But en route, much was changed, added and omitted. The most remarkable difference is in the two figures on the ladders leaned against the Cross. They are two Jesuit priests, unmistakable from their characteristic pointed birettas, with long lace-edged surplices and regulation stoles. Here no one assists from the ground. Each holds a large white cloth [4.8, detail] with which the priest on the right reverently removes the Crown of Thorns, recalling the ceremony in Oaxaca previously described. In the other paintings, they stand passive, in prayerful attitude.

The inclusion of two Jesuits in their well-known priestly garb is highly unusual and far from the accepted tradition which the Council of Trent has regulated and the Inquisition endeavored to control. However, in the last third of the seventeenth century, at the zenith of Jesuit power and before the Jansenists challenged their hegemony, the Holy See granted the privilege that Jesuits could be portrayed as participants in biblical events. Such

assertiveness might be one reason why the Order aroused so much antagonism. While the three Mojos curtains show variations in details, it is clear that the two Jesuits belong to the composition.

In itself, the Lenten curtain is not only a missionary custom–it appears in large churches of the Roman rite; even the Anglican church drapes the crosses with a mourning veil on Good Friday. Most Latin American churches we have seen use purple hangings. Painted curtains done on ordinary cotton cloth are reported to have been quite general in villages of southern Mexico. Such a curtain showing the Crucifixion once hung over the altar of the church of Xoxo near Oaxaca during the *Santa Semana*. A native called Urbano Olivera is recorded in Ixtlan, Oaxaca, at the end of the last century, who was a specialist in painting enormous *manteas* (a Mexican expression for coarse cotton cloth) that covered the entire retable, on which were painted *tres cruces grandes*. They were hung from the ceiling and used exclusively on Good Friday. In Mexico such a piece had the name of *lienzo del Calvario*–Calvary curtain. While the composition was in its main content related to those reproduced from Mojos, Peru, in the state of Oaxaca where the Dominicans dominated, no Jesuit figures would have been suffered.

The three Lenten curtains with the symbols of the Passion represent a very different folk art, both in origin and decorative effect, from the European. In the Austrian Alps, the lace edging on the altar cloth of a roadside shrine displays a Persian tulip. A crucifix covered with a tin roof at the edge of a sunny Hungarian wheatfield has carved crossbeams that recall a Turkish window grille. In Europe, these details were absorbed by rustic talent rooted in Christianity since early centuries. In America, Christianity had to make concessions to the completely alien temperament and imagination of the Indian–and even to a certain degree, of the mestizo and Creole who grew up in such a different ambience. Only scattered records can be found of these remote missions. This is partly to be explained by the devastation and decay that occurred after the Jesuits were expelled in 1767, when the reducciones were broken up and the converts slowly returned to semicivilized life.

Recently, from very different but equally obscure sources, descriptions have become available that show the immense contrasts in the life in viceregal Peru. While the missionary was working in semiwilderness, another, glamorous Peru can be envisioned from a diary covering the years 1640 to 1697. Don Josephe de Mugaburu y Honton was born in Spain of Basque ancestry and made his career in Peru, attaining the post of captain of the Viceregal Guard. An early entry in his copious diary describes the

arrival of the new viceroy, Count of Salvatierra, in 1648, riding under a canopy carried by the city's aldermen. The chief magistrates of the capital held the bridle of the viceroy's horse. In Mercaderes Street a triumphal arch had been erected, where he was showered with flowers and silver, and all that area was paved with silver ingots to the number of 300.

Even more detailed is the account of the entrance of the viceroy, Count of Castellar, in 1674. He rode a white horse with silver trappings, and magistrates clothed in crimson velvet walked at his horse's bridle. Companies of Spanish soldiers and military units of costumed Indians lined the route of the parade, and a number of triumphal arches stood at various street intersections. Again a section of Mercaderes Street was paved with silver ingots, each weighing more than a hundred pounds—the sight of which seemed pleasing to His Excellency's eyes. The cortege included 24 pages, 24 mulatto lackeys, three muledrawn carriages for his family, each with six attendants in liveries of red, blue and silver. There followed 24 mules led by Indians. The animals had silken ropes and halters and were covered with silk cloth on which were embroidered the arms of the family. Each bore silver baskets, heaped with sweetmeats.

But in all Mugaburu's pages, there is not one line on the interest or beauty of an architectural or artistic monument—the so unbelievably varied achievements of local artists and craftsmen. Although the Indians comprised the majority of the population and undoubtedly presented an exotic element to European eyes, Mugaburu generally ignored them and wrote practically nothing about any but Spaniards in Peru. His diary is an example of a rigid class structure, the poisonous fruits of which are still being harvested.

As pleasant as it was to stay in high positions in the larger cities, so full of hardship and danger was the life of the missionary who was ordered into the wildernesses of northwest Mexico or southeast Peru. Life was below any civilized level to which an educated European was accustomed, and many of them suffered martyrdom. In the beginning, the Society of Jesus accepted only Spanish nationals and those of related nations into their seminaries, but later this changed because of the great need for workers. For those who came from Spain or one of the other viceroyalties, the shock of the new life was not so strong as for Central Europeans—Austrians, Bavarians, Bohemians, Hungarians, Poles—who had very little knowledge in the beginning even of the Spanish language. Sometimes they had to wait a year in Cadiz before they finally found a ship to take them across the ocean, and they often spent the year learning crafts and the languages which would be useful in their new positions. Most of those who came in the early decades

are buried in America, but a number who arrived in the first half of the eighteenth century and were strong enough to withstand the suffering and privation of their task and the final indignities of the expulsion, have left memoirs. In many cases the collected notes were confiscated in the brutal deportation of 1767, when the Jesuits were herded together, shipped off without human consideration and unloaded in Cadiz. There were enough empty buildings there, formerly ecclesiastical, where they could be kept in detention. However, while the Spanish, Mexican, and Peruvian subjects of Spain languished in Cadiz for years–for nobody claimed them–the Habsburg Empress Maria Teresa, whose power spread over half of Europe, used her influence to free her subjects as fast as possible.

One such freed Jesuit was Ferenc X. Éder, born in north Hungary in 1727, who on graduating from the mission school was sent to South America at the age of 22. His permanent position was in Mojos, that jungle-filled flatland in the eastern part of Peru and Bolivia. The imperial pressure brought Éder back to his native land, to a sylvan region in north Hungary where he became the town parson in a rich mining town, Besztercebánya. There he put down his memoirs in Latin, calligraphically written on 289 legal-size sheets of paper, which today would amount to over 600 typed pages.

Éder, too, describes the luxurious life of the upper classes in Lima, but also the misery of the natives, whether in the fields or in the mines. Coming from a country with rich, well-organized agriculture and animal husbandry, he is amazed that in neighboring Paraguay wild horses and mules roamed without the administration having an idea of their numbers. He observes that the Indians have no knifelike tool, for they seldom have hard meat, and fish and their other food items can be eaten with a forklike spiked implement and a spoon. He mentions that there are still *tampus* here and there, those overnight stations built by the Incas, where the traveler can spend a night– some of them still well kept, with roofs overhead, fireplaces in order and even tools, though others have been vandalized and robbed of all their contents.

With a certain nostalgia, he writes of the tropical flowers and fruits, the birds and animals unknown overseas. He calls the potato "a most delicious new vegetable" which could find a profitable distribution in Europe. He admits that he finds *chicha,* a drink made of fermented maize which is stored in cool places, like beer, very successful in quenching the thirst after a dusty, tiring trip.

It is interesting to note that the monkey, chinchilla, puma, and hum-mingbird, as well as maize, the papaya, avocado, pineapple and *chirimoya* appear as decorative motifs in certain churches even in the Peruvian

Altiplano—proof of the exchange of skillful craftsmen from the lowlands. As for the *chirimoya*, "it grows on trees, its color is green, its taste is between sour and sweet—the riper the sweeter and more juicy." He thinks it must have originated in Paradise.

On the other hand, Éder also describes the human and animal filth of the settlements, the rain-washed garbage running in open drains in the middle of the streets. It was only on a few great holidays that the Indians cleaned the streets with brushes and, in some places, even strew them with flowers when the high ecclesiastics and members of the feudal class went on foot to the church in a demonstration of sham humility. Otherwise gentlemen of importance rode on horseback; the ladies were transported in sedan chairs or palanquins or in carriages and coaches so that their elegant attire should not be soiled.

Éder, free from his former Jesuit discipline, had too many bitter memories of his forced American experiences not to express harshly and openly a sympathy for the incredibly misused natives. He deplored the lack of appreciation and reward that might well wither the creative impulse of such a talented people.

The expulsion of the Jesuits did not mean that in their missions religious life ceased abruptly. A goodly number of communities in that area retain the names the Jesuits gave them—San Javier, Santa Ana, San Ignacio, San Miguel, San Rafael, among others. And many of the ingrained, familiar rites continued. The best method of bringing to the heathen Indian the ideology of the new faith was by making it visual. The prototype of the Lenten curtains illustrated here, probably stems from the time when the priest demonstrated the basic stories and symbols of the Bible, and the converts took part in their reenactment.

Nineteenth-century travelers through the abandoned Jesuit missions in Bolivia describe how the Indians celebrated Corpus Christi Day for themselves around 1870. Rich carpets, banners and standards were on display, flowers and green branches decorated the house fronts. Where once had been a large library at the church, only a few written prayers remained which were seemingly in usage. Scores of the *missa cantada* were still on hand, and violins, cellos, flutes, harps were in evidence, all made at the mission—even a trombone of palm leaves skillfully pasted together. The local production of musical instruments exists even in our day. In the village of Cherán, Michoacán, the writer found a number of simple houses where the inhabitants were engaged in making violins, mandolins and guitars from the fine woods of the nearby forest.

The semi-abandoned Mojos missions continued to live a religious life

though it may have been only a frayed shadow of former practices. The religious tradition still held, but the guiding hand was lacking, and the art works which had to be replaced as time went by, turned more and more into folk art. However, loyalty or discipline or fear—or perhaps all these together—did not permit the omission of the two Jesuit priests on the Cross. In the passing decades, other decorative elements appear or disappear on the Lenten curtain, but the figures of the two priests remain in the composition, even rising above the head of Christ.

Bringing us still nearer to the present time are photographs taken in the late 1930's, before oil was discovered in the Santa Cruz Department of Bolivia, which includes the Mojos territory. The modern technical age has since introduced incongruous taste, and it is lucky that even a series of such pictures survives. The church reproduced here stood in the former Jesuit mission settlement of San Ignacio de Velasco [4.11]. Juan de Velasco's name appears appended to a number of local missions. He was a notable Jesuit historian (1727-1819), working in Quito, who wrote numerous books and served as inspiration, a veritable paragon to missionaries in the wilderness.

The building's façade impresses with its ingenious use of wood—which was still abundant when these missions were established. The entrance wall is white stucco, its niches and portal framed in modeled decoration. An outside stairway leads to the choir loft with its balcony and wooden railing. The vast wooden roof, supported by enormous tree trunks some 35-40 feet tall, shelters the walls like an umbrella, leaving the space open along the sides for ventilation.

Inside, we are struck by eighteen evenly matched columns carved and set in stucco bases, each pillar a single tree trunk [4.12]. Stucco decorations enliven the walls. Wooden arches with heavy draperylike dentation break the height.

The last photograph [4.14] comes from San Rafael, another mission in the same department. It pictures a violin and bow lying on some sheets of handwritten music. Recent discoveries in the former Jesuit reducciones of Brazil reveal that musical scores were not only copied out for use locally, but were also locally composed. All three items shown here were made at the mission. They doubtless had a part in the orchestral accompaniment when the *missa cantada* was performed. What solemnity there must have been. How much would we give if a sound camera could have recorded the service. But silent, they still speak—with a music that might touch even a skeptic.

80

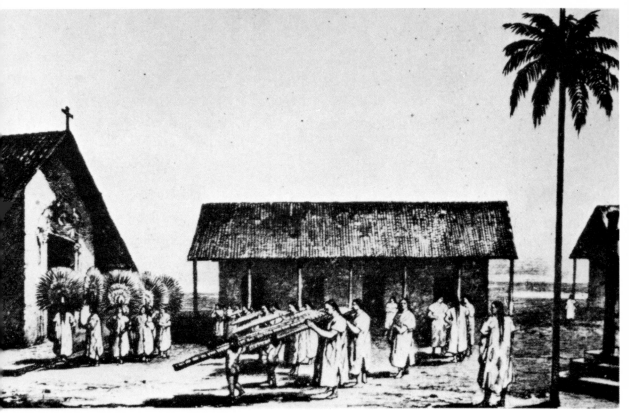

[4.1] Religious music and dancing.

Mojos region, Bolivia.

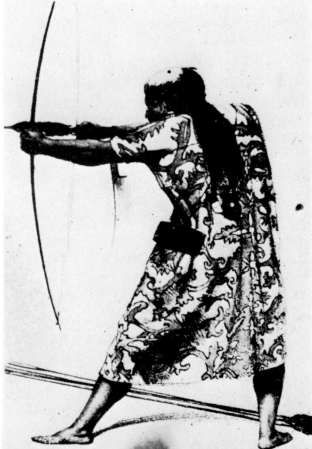

[4.2] Native costume of the Jesuit period.

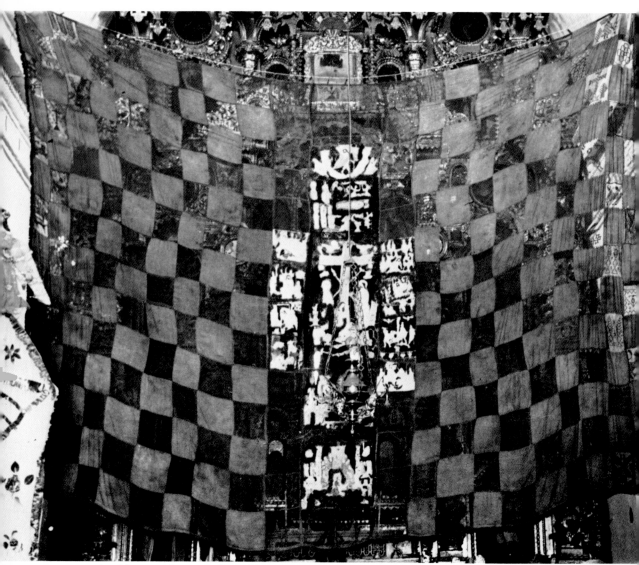

[4.3] Lenten altar veil. Santa Teresa. Ayacucho, Peru.

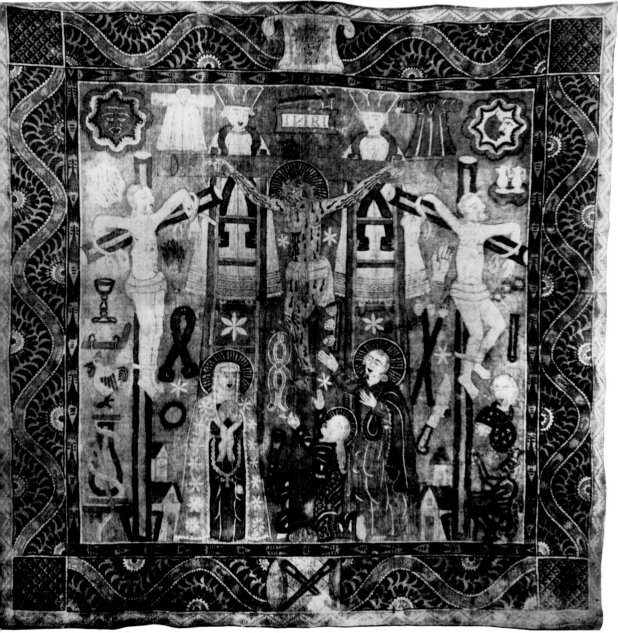

[4.4] Descent from the Cross. Lenten Curtain. Bolivia.

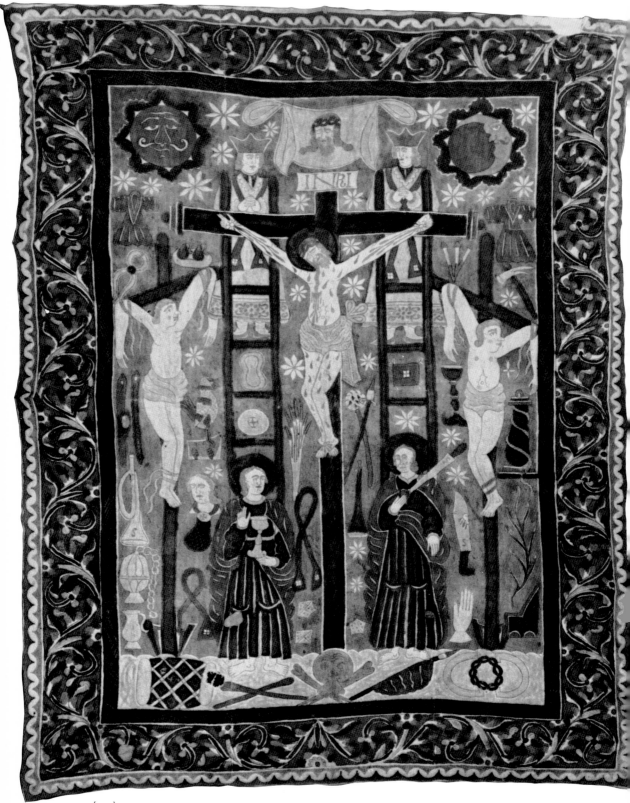

[4·5]

DESCENT FROM THE CROSS. LENTEN CURTAINS. BOLIVIA.

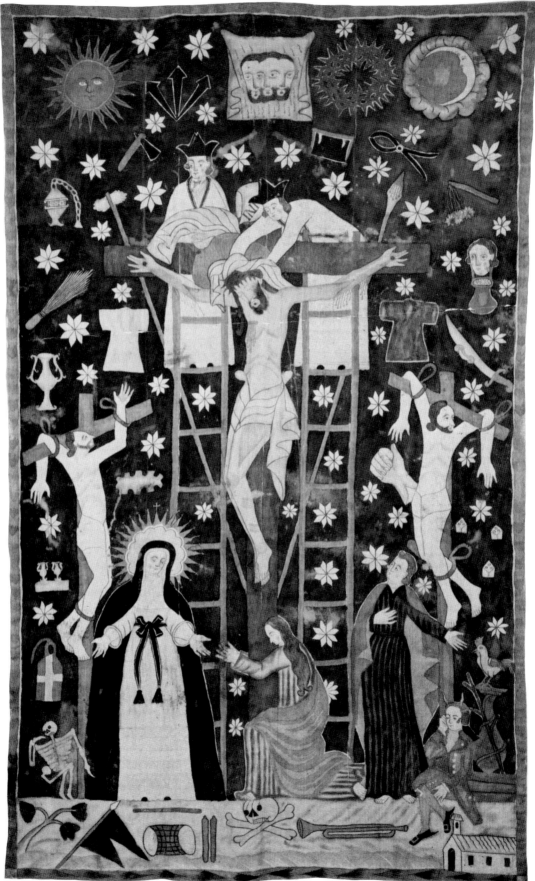

[4.6]

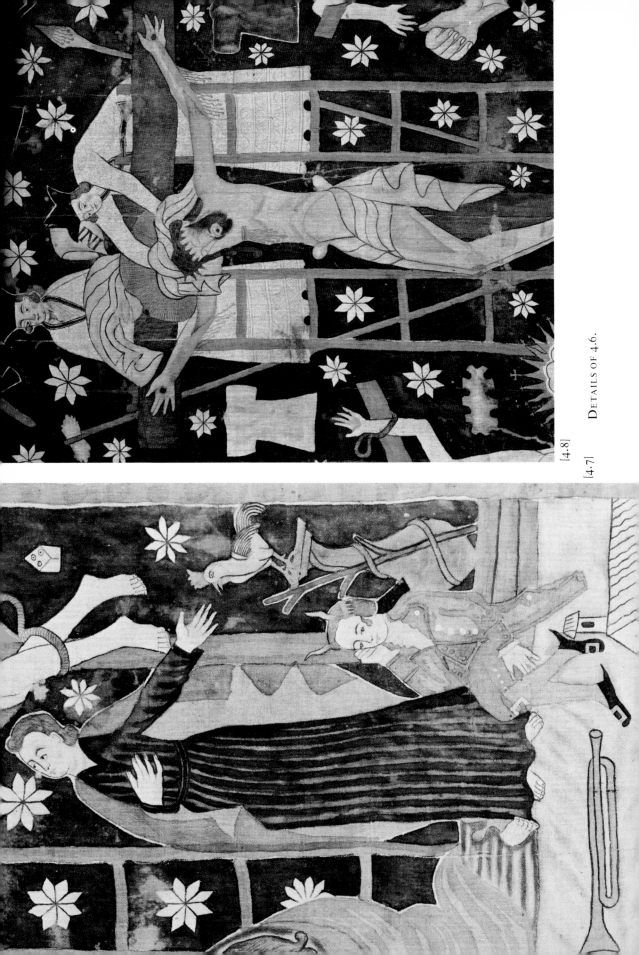

[4.10] Retable. San Juan. Juli. Peru.

[4.9] Flemish painting. Cologne. Germany.

DESCENT FROM THE CROSS.

[4.11] Parish church. San Juan de Velasco, Bolivia.

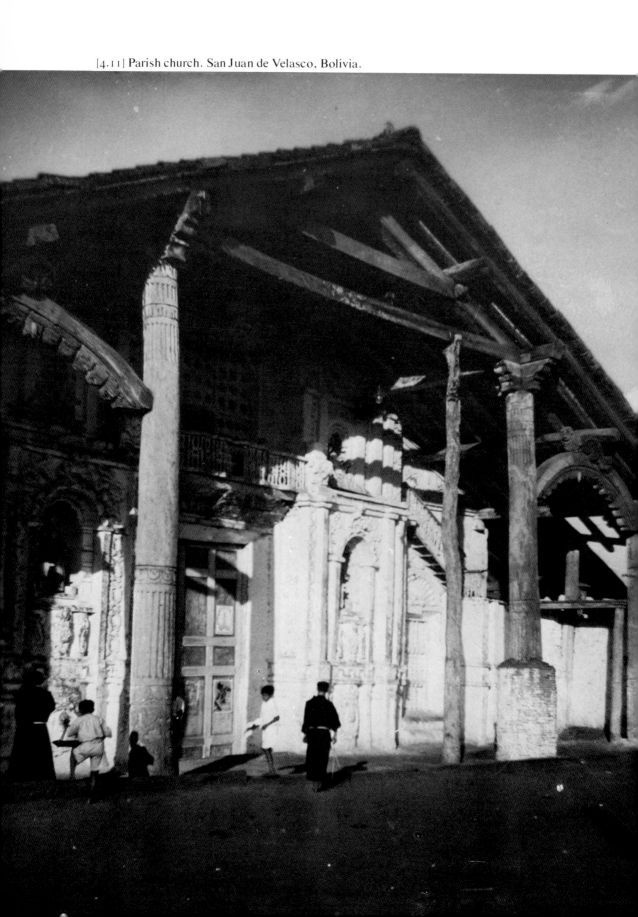

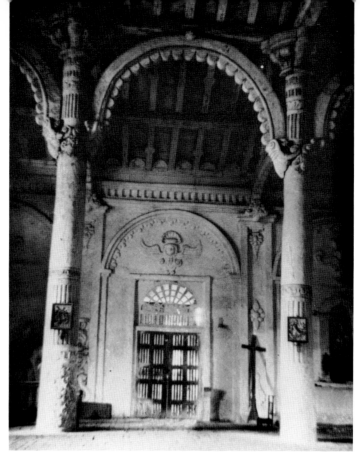

[4.12] Interior.

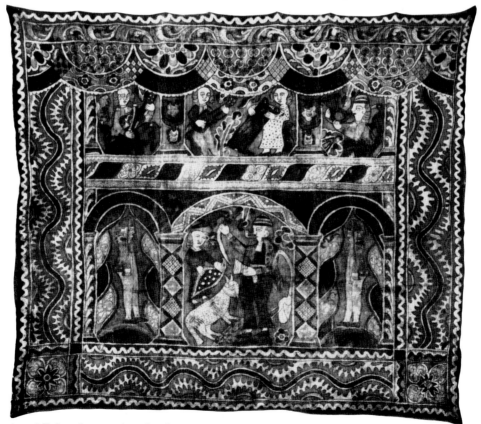

[4.13] Painted cotton hanging from the Mojos region. Leipzig, Germany.

[4.14] Musical coda from Mojos. San Rafael de Velasco, Bolivia.

5

Mines and Missions

Before the disintegration of the Roman Empire, Europe was threaded through with roads communicating with the far-flung outposts. Garrisons were grouped along the Danube, the Rhine and other salient points; stone and wooden watchtowers stood guard against barbarian invaders; and towns developed around many of them. Agriculture, animal husbandry and craftsmanship thrived. One might say the orchestra was there and needed only a new conductor and new scores for the concert of the new religion, a new civilization.

In the New World, except for a few great Indian centers, there was little city life that could be remodeled for Spanish purposes. Bishopric, mine, hacienda had to be created from nothing. The plan of colonization was uniform, but each region bears the mark of individuality. Though dependent on those who gave the orders, colonial life developed in many ways according to the talent and inclination of the natives who carried them out.

By a fortunate fluke of nature, broad belts of mineral deposits are buried in the spectacular mountain ranges of Mexico, comprising an area that stands alone in the history of silver mining. Although our times are not

propitious for writing an epos, nobody who knows the works, the suffering and eventual martyrdom of the missionaries throughout the viceregal period can forget what Spanish America owes them. Sometimes the adventurer searching for gold and silver reached uncharted territory ahead of the missionary. But in numberless cases it was the solitary friar, winding his way with sparse equipment along the courses of rivers and Indian trails, who, through his friendly attitude toward the natives, established the first tentative foothold that opened up a vast territory for evangelization and economic exploitation. From the beginning, there was gold to be panned from riverbeds. Rich veins of silver were discovered as far north as the Rio Grande at an astonishingly early date, although it was some time before it was possible to work many of them on a large scale.

The farther north the extension of Spanish claims, the more trouble arose with wild, marauding Indians, for whom the Spaniards used the general term "Chichimecas." Actually, the tribes were so diverse that a padre who had mastered the language of one group could not communicate with another group nearby. Armed expeditions were of little avail against these nomads. They would withdraw only to descend on some seemingly quiet village, setting fire to the thatched or wood-roofed cottages with flaming arrows, slaughtering the panicked inhabitants and disappearing again with booty of food, arms and animals.

Meanwhile, the Franciscan missionaries pursued their policy of peace and the Word of God. In the last decade of the sixteenth century, they persuaded a group of 400 Tlaxcalan Indian families from Central Mexico (altogether some 1,500 people), to push with them into new homes at the very borders of enemy territory. The Tlaxcalans were a highly intelligent people, accustomed to sedentary village life even in pre-Columbian times. Christianized, they had adjusted more or less to Spanish rule.

In some regions, the Chichimecas accepted the Tlaxcalan newcomers fairly peacefully. In turn, both groups were plentifully rewarded with gifts of food, clothing, tools and agricultural implements–all at the expense of the viceregal government. Chiefs were honored with cloaks, hats, boots and swords of the hidalgo, sometimes were even given permission to ride horses. However, raids on ranches and, above all, on the traffic that moved through the mountain passes to and from the burgeoning northern mines, never ceased entirely.

The chain of Silver Cities in the north produced not only fantastic wealth, but also a building activity that shows great individuality. Examples have been selected here from less publicized sites.

Starting our survey of these northern regions of Mexico, Monterrey lies toward the east in a mountain-ringed valley about 150 miles from the present United States border. It is first mentioned in history in 1560–green with vegetation and covered with valuable timber. Then came the discovery of silver, and with the centuries the landscape turned into a sandy, deforested area. Monterrey had its own missions extending into Texas, which was then still part of Spain's northern holdings. It was also an outpost of entrepreneurs who reached out until they encountered French and English possessions. When the Rio Grande became the border between two very different countries, Monterrey grew prosperous from the business and industry accruing from contact with its neighbor.

With the fluctuating fortunes, Monterrey's cathedral, begun as a parochial church in 1630, remained unfinished until 1800, and was not dedicated officially until 1833. The twin towers were kept extremely light with open arches, so as to lessen damage from earthquake. However, industrial smog affected the masonry, and, especially, the main façade, restored with much cement, was considerably changed. The free-standing pediment of the side portal with its many finials could be strengthened with less damaging effect [5.1]. Though the statues have disappeared from the niches, the little figures atop the columns are reminiscent of colonial work. Striking are the four eagles below the cornice. The static openwork of the two outside columns is skillfully contrasted with the inner ones, wound with broad fronds. With an effect more fanciful–even grotesque–than religious, a great stylized head tops the decorative central display. The heraldic shield encloses, not the usual coat of arms, but a large flower. Above it is a little crown with a cross on top, and below, a small bearded mask, looking at first glance like a tassel.

Like Monterrey, the bishop's summer palace, standing a few miles west of the city, suffered much from the battles with its neighbor and among political factions of the nineteenth century [5.2]. It was built during a severe famine in 1786 by Bishop Verger, to provide many months of employment. Two squat towers are incorporated into the façade and nestle, as it were, against the huge dome. The portal is separate, thrust slightly forward, and is ornately carved. Once a broad stairway led up to it, for the pilgrims to whom it was a sacred place. In front of the imposing church, the ground falls away steeply, with a view across the city and beyond, to mountain peaks that the folk call the (bishop's) mitre and throne. From the west, the approach is gentler [5.4]. A decorative gateway opens into a walled patio and the bishop's former dwelling, once noted for its fine garden. Today, the caretaker of the place has surrounded the central wellhead with flowering plants

in the most varied containers. He complains that few travelers slow their hurried drive to go up the neglected road.

First a palace, several times a fortress, then a hospital, and now a museum, the edifice has monumental strength. The whole building looks knit together, sturdy and impressive, bearing the graffiti of the brutality which it has experienced.

From Monterrey the road rises steadily for 60 miles to Saltillo, another early outpost, founded in 1575 on a tableland with an altitude of 5,000 feet. Records from the end of the sixteenth century show that the Indians who accompanied the missionaries had already built a church in their barrio, "New Tlaxcala." Around that time, the settlement of Saltillo, separated from the Indian village by a rivulet, counted less than 100 Spanish settlers. However, the land was fertile, the climate healthy, and with the discovery of silver, the population grew rapidly. Indian raiders had to be fought off constantly. All the bells were rung at the threat of danger, calling out the entire male population to the defense, and by the end of the seventeenth century some balance had been reached.

With rising prosperity, Saltillo became famous for its September fair. To this bridgehead of northern expansion came well-made copper vessels, sheep and wool, and buffalo robes from New Mexico. There were luxury goods of Mexican manufacture to be had, wines and oil from Europe, silk, spices and porcelains from Asia. Foodstuffs and implements for the miners and ranches were traded for grain, livestock and hides, and for the famous locally woven Saltillo sarapes.

The present cathedral of Saltillo was begun in 1746 to replace a series of earlier parochial churches on the same site. Its façade shows much originality both in composition and decoration [5.5]. Squat, rounded pilasters, heavily ornate, hold the ebullient carving together. On the second rank, the Churrigueresque columns carry medallions in oval frames topped by plaques with angelitos. Simpler, garland-wound columns in the first and third stories allow a certain breathing space in the tight mass of decoration. The shell, which had become increasingly popular, especially in the north, is developed here to great effect.

At the left, the entrance to the adjacent consistory is kept in modest proportions, with lambrequins on the pilasters and eagles reminiscent of those at Monterrey on the entablature above them. In its solid stonework, the side portal, less ornate than the front, has sturdiness and dignity [5.3].

A high, ornate dome lights the interior. Figures of the four Evangelists occupy the pendentives, molded in *argamassa*, a type of stucco work.

Unique in our experience is the series of eight panels decorating the base of the dome, where a number of little figures kneel as if at a communion rail [5.6]. They are plainly labeled: choir of patriarchs, of angels, confessors, virgins and martyrs–recalling the phrases of the Te Deum: ". . . the glorious company of the Apostles, the goodly fellowship of the Prophets, the noble army of Martyrs praise Thee. . . ." The other three panels show scenes from Holy Week, culminating in the Last Supper, placed over the sanctuary.

The trade regulations set up by Madrid were gauged to provide an uninterrupted flow of precious metal to the Spanish Crown. From the beginning, the mine owner was granted many privileges, and for the support of the industry, which developed spectacularly in the seventeenth and eighteenth centuries, large-scale agriculture was essential. There was an ever-increasing demand for meat and grain to feed the mine workers and the growing population. Hides were needed in the mines, as the ore was usually hauled up in leather sacks that lasted no more than eight days because of rough handling. Leather was in demand also to make harness and pack saddles for the numberless mules that toiled underground and in the crushing mills or in the pack trains that trod thousands of miles of commerce.

By the mid-eighteenth century, a new layer of society had grown rich. It became profitable for the hacendado–the rancher–and the mine owner to form business associations that included also merchants and manufacturers. With the swift rise of affluence came the desire for luxury and social status. The early families who traced their descent from the Conquistadores and whose wealth was derived from the export of indigo, cotton, tobacco, sugar and cochineal from their feudal estates, had to make way for lively newcomers who, in the relentless drive to raise their social status, competed in luxury with those who counted themselves aristocrats. In exchange for a better-assured income to the throne, titles of nobility were granted for a fee. What were far from elegant professions in Spain received the mantle of dignity in the New World. We know of some fifty such grants in Mexico. As usual, the Spaniard, although in the minority, had the advantage of his origin. In Zacatecas, nine of the new condes and marquéses came from Spain, six were Creoles. As we have seen, titles went also to landowners, merchants and traders. Naturally, a handful of high officials, important in keeping the industry within a certain framework, also attained nobility.

This new group had by that time the means to build mansions and palaces, great gardens, donate waterworks and subsidize the building of churches. An eighteenth-century contemporary expressed amazement at the opulence and up-to-date comfort of living in comparatively isolated com-

munities, far from the capital, even in recently opened California. Many styles and decorative schemes are visible throughout Mexico. Some designers benefited from the availability of a wide choice of material, others show a certain tardiness and rusticality of taste.

Juan Landín was one of the many citizens of Saltillo who grew wealthy from the ownership of lands and mines. He gained fame for his generous assistance to the Franciscans in their expansion, donating a large block of real estate within the city for the erection of a church and monastery. A country retreat some miles southwest of the city is connected with his name – a ''fruit garden'' where he and his family could retire on occasion. It was de rigueur that a worthy chapel should lend dignity to such a country seat, where on Sundays and holy days the entire staff could take part in the ceremonies. As fanciful and rustic as is the façade of the chapel at Landín's country seat, now crumbling and deserted [5.7], it also reflects the expert handling of argamassa in its fluent scrolls and graceful garlands of fruit and flowers in high relief, executed with Rococo lightness.

Another ruined hacienda complex, known as that of Don Francisco Urza, stands at an isolated bus stop some eight miles south of the mining town of Nombre de Dios, near Durango [5.8]. It was destroyed in the revolution of 1912 – war has no regard for beauty – and today it is in the last stages of decay. A ragged adobe wall outlines the once-spacious patio. The chapel front is best preserved, as it is faced with stone, while the adjoining living quarters and the crumbling parapet show a construction of rubble and adobe beneath plaster. Holes in the stone window frames mark where grilles and an upper balcony of happier times have been torn away. There is a plaited pattern in stone on the door posts and a graceful fan-shaped shell above the lintel, obscured here by a tree. By a small miracle the paneled wooden door remains. Bulbous finials balance effectively the bold cornice and window frame in the pediment. When the rough stone buttress at the left was built is uncertain – perhaps it was in the last period of occupation, when considerably less taste and money were on hand. The design of the tower is fitted to the building – columnettes and finials repeat the vocabulary in miniature. A broken bell hangs on an improvised beam.

The tower with its scalloped parapets served as an observation point against Indian raids, and later, as a strong point in the successive waves of warfare that washed over that lonely place. What guerrilla fighting went through here, for how many decades! Wandering bandits drove the owners away, established themselves in the unaccustomed milieu and, after plundering the place, moved on to behave the same way at the next hacienda.

After presenting two ruined mementos of an elegant past, it is pleasant to show a hacienda complex that is still in use, though not by the family of the original owner. This is the Hacienda Jaral del Berrio, southwest of San Luis Potosí. Although no longer wearing the glamorous mantle of viceregal times, it at least gives an idea of how these great estates functioned. Behind the three-arched administration building [5.9] is a domed chapel, combining the religious with the secular. The bells did not sound for services alone; a widespread network of communication functioned among neighbors, who, though miles apart, gathered on call and acted as militia. Small architectural details were not economized on. The railing, which like a screen encloses an inner court, has kept its little vases, matching those on the *companario*. The fenced-in areas in the foreground suggest a threshing floor and a space where animals might have been paraded. What strikes our eyes are the masonry cones which served as silos for the fodder of countless animals. A narrow stairway leads up the side of each cone which was filled from above, like our modern metal structures.

The system of stables [5.10] shows the vicissitudes of more than 200 years but still stands with the sturdiness of a fortress. The ribbed barrel vaulting and the solid walls are proof of the Mexican mason's mastery of his craft. The family mansion stood apart on its own plaza, rather neo-classic in decor, with high crennelated towers at the corners, reminders of danger from many sides. Doubtless the chatelaine had her flower garden–though life on such an estate, where few social and educational advances could be made, was seldom ideal for the wife or child of a wealthy owner. Beyond, lie acre upon acre of grazing land, fields of grain, orchards that furnished fruit for preserves, grapes for wine and brandy. It is clear that for the upkeep of such an enterprise not only stablemen and cowboys were needed, but also blacksmiths, weavers–of saddleblankets, rugs and sarapes, even clothing material–harness makers, veterinarians, masons, carpenters, butchers, cooks and household servants. Such a large hacienda constituted a little kingdom within the empire, closely dovetailed, however, with the demands of the mines, the advance of commerce and eventually with political activity.

About the original owner of Jaral del Berrio, the tremendously rich, recently ennobled hacendado, Conde de San Mateo de Valparaiso, a piquant story awaits its novelist. The daughter of the house fell in love with the probably dashing but doubtless impoverished Sicilian Marqués de Moncada, captain of Cavalry, of Old World aristocracy. (At that time, Sicily was a viceroyalty of Spain.) The presumptive father-in-law had promised a

large dowry, but apparently to prevent the fortune from falling under the control of the newcomer–the "foreigner"–the hacendado hired two Creole architects to build the vast sum into a palace for the young couple in Mexico City. Situated in the fashionable Calle San Francisco, street of the silversmiths, today Avenida Madero, the palace became indeed the talk of the town, with its high, second-story *piano nobile* and its unusually spacious courtyard decorated in filigree stonework.

The plan of the building is attributed to the famous Francisco Guerrero y Torres, architect of the exquisite Chapel of the Pocito at the shrine of Guadalupe, near the capital. It served as palace during the short-lived empire of General Agustín Iturbide (1822-23), then was turned into a hotel. In the twentieth century, offices and shops have rented the spacious apartments, and the tourist admires what the guide book calls the Palacio Iturbide, without realizing the romance involved in this pride of colonial architecture.

The Sanchez-Navarro family owned seventeen haciendas in northern Mexico–some sixteen million acres–constituting what was called a *latifundio*. In 1803, Alexander von Humboldt, naturalist and explorer, who was engaged to investigate the colonial economy, reported that 70,000 mules were required alone for the commerce to and from Vera Cruz, and around 50,000 more for the carriages of the capital, not to mention the animals used up in great numbers from overwork in the mines and pack trains.

In the matter of the mines, Humboldt found wasteful and primitive conditions prevailing in numberless cases–overworked laborers miserably housed, with consequent unrest; the absence of any sort of machinery, even pumps. Often the various grades of ore were all being treated by the same method, with a resulting waste of more than forty percent of the silver.

Although the method of extracting silver by the use of mercury had been perfected in the sixteenth century, Mexico, unlike Peru, had no quicksilver mines and was forced to pay an exorbitant price for the metal. By the end of the eighteenth century, most of the mine owners were impoverished. Few profits had been plowed back into the industry. Mortgage and loan banks were instituted by the government in an attempt to stimulate production, but they were seldom repaid and themselves collapsed. In 1792, a College of Mines was founded and the students were honored with uniforms that boasted fringes and embroidery of gold. However, revolution was pending and little could be accomplished to restore the industry.

The hacienda reached its heyday around the mid-eighteenth century, and for more than a century longer it represented immense wealth, both in land

and personal property. But when the regime of President Porfirio Diaz (who was in power from 1876 to 1911) attacked the financial monopolies of the great families, prosperity waned. In vain was foreign and Mexican capital attracted by the granting of various privileges; the enormous colonial system fell apart and now awaits its historian.

Zacatecas is the highest of the great Silver Cities, situated among a group of hills at an altitude averaging 8,000 feet, and 350 miles as the crow flies from the viceregal seat. It is said that as early as 1546, Indians of the neighborhood showed the explorers "stones" rich in silver. Spanish and Creole population moved in. Fortunes were made and lost and made again. Mestizos, Negroes and Indians joined the population, drawn by the fame of the place. The highest authority in residence was the governor. Later a corregidor, or judge, was appointed by the Crown, for it became necessary to regulate the quality of the silver and to try to systematize the delivery and refining of the ore.

Since the days of the Conquest, Spain had sent experts from Europe to advise on the mines. But their knowledge had been of little avail because of the very different conditions in the New World and the fact that the Mexican mines were in the hands of individual owners over whom, in contrast to circumstances in Europe, the Court had little power.

The production of silver in Zacatecas grew to such immense proportions that Humboldt ranked it as the third highest of all the mining centers. Lucrative veins of ore were discovered there as late as 1778, beneath a layer of clay slate. Mining the ore was difficult work, requiring an unusual amount of gunpowder, of which the king's monopoly furnished only a small percentage. But one advantage of the region was that it was very dry, without the danger of flooding from underground water that plagued so many mines elsewhere.

The lack of water, however, caused hardship among the inhabitants. As early as 1700 an aqueduct was constructed to bring pure water down from the mountains for the whole population–revealing a civic-mindedness unusual in those times, as well as competent engineering knowledge [5.11]. One can see the cathedral in the distance and grasp the picturesque situation of this town in its high barren setting.

The wealth of this region inspired the creation of perhaps the most characteristic and original, the most Mexican of Baroque carving among the larger cities, culminating in the Zacatecas cathedral [5.13]. The whole city is a marvel of colonial architecture, but the auto road winds two blocks south

of the cathedral and, at least at the time of our stay, there was no road sign to indicate that one of the grand monuments of the land lay only a short distance away. The edifice was begun in the first years of the eighteenth century to replace an earlier parish church and was finished in 1752, with funds provided largely by increased taxation on the various mine owners. In its façade are displayed an elaboration of sculptured detail and an inventiveness of motif that make one wonder who the carvers were, how they acquired their skill and what other buildings they executed. The theme is comprehensive: Christ stands in the middle of the upper story with his Apostles about him, four on each tier. Above them all, God the Father is enthroned, surrounded by an angelic orchestra. The four Church Fathers are depicted in relief beside the huge choir window encircled by a heavy garland of little musician angels amid a riot of flowers. A tapestry of floral motifs covers the surfaces between, and on the second and third stories each pair of columns has a different decoration. Although Zacatecas was not given a bishop until the mid-nineteenth century, the aspirations of this church to be a cathedral can be seen in the papal tiara carved at the left in the pediment, while the blank space opposite must have held the royal arms, obliterated after Independence.

A detail of one of the corbels [5.12] shows the virtuosity of the sculpture. The deep undercutting, the sharpness of the edges, enhanced by the darkened patina of the stone, achieve a finish that is almost metallic in brilliance. To the Spaniards who insist that colonial architecture is but a weak attempt to copy that of the motherland, the Zacatecas cathedral presents a vehement and weighty contradiction.

Of the religious orders, the Franciscans were the first to arrive in Zacatecas, followed by the Dominicans, Augustinians and Jesuits. Within 60 years, all these orders had acquired large lands, and by the early seventeenth century a Franciscan Province had been created, with authority also over outside mining settlements. Few homes in the town were of particular elegance in the early decades. Adobe and brick were easier to handle than stone, and the mines offered more lucrative employment than masonry. However, by 1595, the first *cabildo* or town hall was constructed of the soft, rose-toned local stone so characteristic of later buildings.

When this writer visited Zacatecas, the Franciscan church and monastery there were being demolished. The severe, elegant lines of the façade show an early style that is rather academic–one might say it has Renaissance echoes [5.14]. Its ruined state reveals many "secrets" of the once-impressive building. The stone façade with its smooth surfaces and compact, precise carving is set up against walls of rubble, strengthened with

stone. The tower is of the thin brick typical of colonial construction, and molded brick shapes the rounded pilasters with their stone bases and capitals. A smooth coating of plaster covered the surface.

The technique of the Mexican builder can best be seen in the courtyard [5.15]. The weight of the great cupola with its stone facing was supported by flying buttresses in stone, while the cloister colonnades were constructed of lighter material. Various changes are apparent–openings sealed up, extensions made, windows or doorways widened or narrowed.

When discussing the colony, some Spanish writers are apt to display an understandable chauvinism. But it should be realized that literary, humanistic and scientific life of a high order existed in the Spanish-American colonies. This was a living, thinking continent, cognizant of European thought but by no means always provincially dependent on it. The more we go back into colonial history, the more we find that those 300 years produced original thinkers, scholars, poets and musicians as well as artists and sculptors. More books were read than most would imagine. Indeed, books were named in the carriers' lists for the long haul to northern mining centers, along with the vital ammunition, much-needed dry goods and furniture. Wealthy "amateurs" set down details of local history that are invaluable to later research; clerics meditated on philosophy, poetic works appeared in neat editions. The flourishing of culture is apparent in the cogent works which, since Republican times, have come from the libraries of ecclesiastics and great families into the hands of book dealers and today are scattered, losing the relevance which they once had in a collection, blurring the profile of the original early bibliophiles. A recent study appeared in the United States citing more than forty-six books published in Spanish America within the last decade that publicize the great activity in the humanities and the sciences during colonial times. Only five such books exist in this country, written by distinguished American scholars before academic atrophy set in and the larger view gave way to specialization.

On the other hand, many a Spaniard kept his eyes on a triumphal return to the motherland and took back with him to Europe only material treasure–gold and silver, pearls, opals, emeralds, jewelry–which could be turned into show or pesetas. Malicious tongues record that an archbishop on his homeward voyage loaded a considerable part of the ship's hold with silver bars and material for jewelry to the value of 800,000 pesos–several million dollars today. Many colonial silver objects, mainly household articles, are preserved in private and public collections in Europe. Probably unique is an entire silver altar from the colonies. The distinguished Mexican art histo-

rian, Francisco de la Maza, came upon it in the former Jesuit priory at Santa María, at the far end of the Bay of Cadiz. Frontal, ciborium and retable formed a veritable cascade of silver. According to the inscription, the piece was the gift, in 1685, of Juan Comacho Gaina, captain general of San Luis Potosí and, later, viceroy of New Spain.

The manifests of the silver fleet give some indication of what enormous wealth was coming out of the colonies. A great number of Spanish vessels fell victim to the violent storms that ravaged the sea lanes off Cuba and the coast of Florida. Recent salvage expeditions have brought to light not only silver and gold in coin and bullion (one ship alone carried some 900 silver bars weighing more than 60 pounds apiece), but also such rarities as a golden chain nearly twelve feet long, a large pearl-incrusted crucifix, gold brooches of elaborate design, gold and silver buttons and religious medals, rings set with diamonds and emeralds, and even a delicate whistle in gold.

In the United States there are ghost-towns where mining stopped and the makeshift wooden buildings which had gone up overnight were abandoned overnight. A blackish grey color covers such a village, a color which the wind brings in the form of a fine dust from around the dead mines. The windows of the only inn are broken, a shutter creaks half off its hinges, and the barber's sign, held by one nail but not wanting to surrender completely, flaps like a flag of desperation. Balls of tumbleweed travel now one way, now another. Even the ghosts are gone by now.

But the Mexican ghost towns have life in them still, and they are haunted by the past, because they have been allowed to turn into glorious derelicts.

Sombrerete, lying an even distance between Zacatecas and Durango, is to many not even a name in a book. In 1565, the place was well populated, and both Franciscans and Dominicans had put down their foundations. While Zacatecas was poor in water, necessitating the building of an aqueduct, Sombrerete had plenty. Besides, it lay in a richly wooded area from which the timber, vital raw material for the mining tunnels and smelting operations, could be had. For a time, its Veta Negra mine proved to be the richest vein of silver in all Mexico, providing some four million pesos worth of the metal in less than a year.

From the first, the proprietors of the Sombrerete mines, the Spanish-born Marqués de Fagoaga and his family, maintained a united management, the sons following the parents in keeping their many enterprises together. They were among the few who plowed profit back into the mines, and throughout the eighteenth century they were great benefactors of the Church. It is

interesting to note that during the years when the struggle for independence was being fought, Zacatecas, Sombrerete and Durango minted their own silver coins, bearing the coats of arms of the localities.

All of Sombrerete's churches are of the native brownish-red stone which can be quarried in the vicinity. At that height, the effect of even the ruins in sunshine is dramatic. Santo Domingo is perhaps the latest of the churches there and its façade is the best preserved [5.16]. Its design presents a splendid example of late Baroque. In contrast to the standard retable façade with its rather conservative build-up, here every story shows a difference. The four Church Fathers guard the foundation. We see twisted columns spiraling away from the first-story niches. The second tier has small pilasters with shallow carving, while in the third are herms–a novelty in this period. Amazingly, the Dominican saints (two of them women) are all in their niches, though the cornices and ornamentation are sorely weather beaten. What gives the composition especial distinction is the rose window in the center. Large, dominating, its convolutions exaggerated by a thick floral garland as frame, it lends effective movement to the whole composition, as if a burst of superhuman effort had opened the academically closed design to gain space for a unique display of virtuoso stone carving.

The Dominican complex involved a seminary where the religious personnel taught theology, philosophy and grammar. At the time of our visit, there were only a few livable rooms, occupied by squatters–an aspect that made the place sadder than an American ghost town.

Durango at an altitude of 5,313 feet above the sea is considerably lower than Zacatecas and has a more temperate climate, related to that of the Pacific coast. Founded as an outpost against the Chichimecas, the place is described at the end of the sixteenth century as having altogether four streets and a small population. But as more and more mines in the area were exploited, the city grew in size and power. Merchants, craftsmen and professionals were attracted to the town, and the religious orders moved to establish themselves. The diocese created there in 1621 was not only the northernmost of all Mexican bishoprics but also the most extensive, its authority stretching northward as far as Sante Fe, New Mexico, and including what was then known of Arizona; in the west, it had no limits but the sea. As has been seen, as late as the mid-nineteenth century, Bishop Lamy traveled to Durango shortly after his arrival in Santa Fe, to reconcile his ecclesiastical colleague to his authority in the newly formed territory of the United States.

The exterior of Durango's cathedral is rather restrained in style and

reveals the slow progress in building [5.17]. Note the difference between the dome over the crossing and the cupola of a side chapel. The airy figures that top the drawn-out lanterns and appear as finials lend a certain lightness to the rather stolid mass. The main façade was much renovated in early Republican times–and was not made more individual. In general, those nineteenth-century "modernizations" produced a depressing hybrid of tradition and fashion.

A closer view of a side portal, which was seemingly less changed, shows again the tall twin towers, their mass lightened by many openings [5.19]. Churrigueresque elements survive in the multilinear cornices and in the lambrequins where the lines of drapery shape the letter M. There is differentiation in the garlanding of the columns in the first and second tiers. In the pediment, two angels hold a crown above a heraldic shield with cryptic symbols. The design has richness and a certain pomp but no exuberance.

As the border of wilderness was pushed back and security advanced, much money was spent on the interior of the cathedral. Remarkably, all the retables in the church still stand in their pristine gilding, token of the wealth that poured from the mines. A statue of the Immaculate Conception is notable [5.18]. On the globe at Mary's feet, Adam and Eve are depicted in low polychrome relief beside the Tree of Knowledge. It is an unusual combination of the Fall of Man and the Virgin as the New Eve.

Durango's secular buildings and private palaces in no way took second place to the churches in splendor. The palace of Count Juan José Zambrano became not only a showplace but also the subject of a piquant episode. Zambrano was a hacendado as well as a mine owner, a multimillionaire who, during the second half of the eighteenth century, successively filled the posts of mayor, chief magistrate and governor. Around that time (1772), 151 mines are reported to have been in operation in the area; sixty-five others were already exhausted, under water or abandoned.

In a town where even the finest houses were, almost without exception, one story high, Zambrano's palace, which occupied the space of four city blocks, had a lofty second story, imitating the Italian *piano nobile* [5.20]. An arcade with solid round columns seems to lift the elegant upper rooms above the ordinary life in the street. A gallery with a once-fine ironwork railing encircles the second story. Richly developed moldings over the tall windows–rather, doors–give the effect of valances and emphasize the imposing height of this section. In one part of the complex, Zambrano built a private theater. This was not in itself a particularly remarkable gesture, for other grandees also had their ballrooms and little theaters; but he apparently wished to surpass everything that had gone before. Everyone who counted

in the town and vicinity was invited to the theater's inauguration in 1800—and there was accommodation for them all in the theater's 26 loges. According to the *Gaceta de Mexico*, the carving and decorative stucco work, the gold, the velvet hangings and upholstery represented an outlay of 22,000 silver pesos. Over the stage was painted the family coat of arms—one wonders how far back the past of this family went to warrant that display.

History has it that Zambrano planned also a gold balustrade for the gracefully winding staircase to his theater. But the colonial parvenu who had appropriated all the trappings of greatness in such a short time finally paid for his boldness. The king had him recalled to Spain—"deported" as they say—for his audacity; for not even the king's own exquisite *Teatro Real* opposite the royal palace in Madrid could boast a golden railing. The writer had the good fortune to see the royal theater in full splendor in 1925, but in the Spanish Civil War it was looted and burned—a sore point for any Madrileño to hear mentioned. The Durango theater, when we saw it, was the warehouse of a lumber dealer, and sacks of cement, 2 x 4's and broad planks were piled where once the jeweled and perfumed ladies sat. A shabby movie house now occupied another part of the complex. The section of the palace shown in the illustration had become the office of the state government. There, simple folk could come with their complaints; and poorly paid employees, touched by the importance of their positions, might listen, even take notes but seldom take action. One might say that the spirit of the past lingered still, as if corruption and indifference were built into the stones of this place.

Westward from Durango, the terrain drops rapidly and within a little over 100 miles, the Villa de San Sebastian, (renamed Concordia in the nineteenth century) lies at an altitude of only about 1,000 feet. Twenty Spanish families were registered there in 1604. Soon they had a captain of the garrison with a salary of 600 pesos a year, augmented by the growing profits from nearby mines. The town appears on a mid-seventeenth century map on which only a few places in the region are noted. Uncertainty about Indian attacks, neglected roads and the distance from more stable market centers posed almost insurmountable difficulties to miner and missionary.

Like the more famous colonial church at Taxco, Concordia's has two patron saints—San Sebastián and Santa Bárbara. No single photograph can give an idea of the organized richness of the church's facade [5.21]. The effect is sunny—rich without ostentation. The stones glow in the golden beige of old ivory. The flowery frames of the niches, the corrugation around the central window, the basket-weave patterns of the panels and in the pilasters, all are carved with precision and delicacy. Medallions, shells and

small figures make up a varied ornamentation, but are so spaced as not to disturb the general balance. Two long, engaged columns at the sides seem to enclose the design. In the pediment, we see Sebastian standing between two stocky scrolls with a shell as a baldachin. The Virgin of Guadalupe appears above him, and Barbara stands on a column at the right, against the sky. She is invoked during thunderstorms and is the patroness of artillery and of those who work with gunpowder–relevant for mining regions. Inside, the groins of the vaulted ceiling are carved with flowers and leaves, and the embrasures of the sacristy windows are flared and fluted to resemble shells.

The complex is a monument to the wealth which the three great mines of the region produced. Over the sacristy portal, a carved text announces that the building was erected "a Devoción" of the Marqués de Panuco in 1785. The church itself probably dates somewhat earlier. The mine owner was a Creole named Francisco Javier Vizcarra, who was granted his title in 1772. Perhaps a headless stone figure in eighteenth-century garb, which stands on the terrace before the sacristy, is a statue of him.

The community of Nuestra Señora del Rosario lies some 25 miles farther west, near the Pacific Coast, at the site of the famous Tajo gold mine. Its original church was erected also in the eighteenth century, near the mine's entrance [5.23]. The retable façade shows fine workmanship in the consoles, the apportionment of the garlanded columns and the variety of paneling. Typical of colonial work are the little figures in the round medallion of the upper story and supporting the topmost niche, as well as the angel heads that stud the otherwise severe molding around the central window. Long, slender stone ropes at the sides seem like curtain pulls, that close a view. This church is less elaborate and probably earlier than Concordia's. However, a comparison of the fine carved window frames in the tower with those at the other church suggests that some of the same craftsmen were employed at both constructions–or, at least, that one group had learned much from the other.

Flooding caused the Tajo mine to be abandoned, and by the 1930's the building was near collapse. But with the cooperation of outside interests and the enthusiastic help of the local population, it was transported, piece by marked piece, some six miles from the mine head and reerected on solid ground. At the time of our visit (1963), the over-size statues of the impressive retable were being regilded in the new building by the colonial method [5.22]–glue, heated on a small brazier, was used for priming the carved wooden surface, after which gold leaf was stroked on with a rabbit's foot and burnished with a piece of bone.

106

The difficulties of advance from the last secure posts into the vaguely charted regions of Sonora and beyond, and the accomplishment of the intrepid men who maintained themselves there, are evident even today. In colonial times, the course of rivers and Indian trails were the routes of forward movement. Even though the valleys were rich, the settlements were isolated and far apart. The solidity of the buildings erected only a few decades after a mission's establishment must be seen to be believed.

Batuc, a one-street Indian village in Sonora, is situated in a broad fertile valley with the Moctezuma River to the east. A principal settlement of the Yaqui Indians, its name means "above the river." Jesuit missionaries built a church here as early as 1629. In 1741, the Jesuit missionary, Alejandro Rapicani, brought new life to the place and, within three years, had started the construction of a large, impressive building. According to the memoirs of a fellow Jesuit, a skilled mason was engaged to instruct the Indians in how to hew and set the stone. The material, drawn from a nearby quarry, had a shining rosy tone and was easily cut and polished. In 1764, the church is recorded as serving 60 families of Yaqui Indians and related tribes.

The façade, one of the finest in Sonora, has three stories and an octagonal window flanked by niches [5.24]. Four squat obelisks crowned with balls finish the rather austere design. Multiple cornices and coffered pilasters suggest acquaintance with more sophisticated building. An outside staircase leads to the roof. The exquisite keystone was carved in three pieces so well integrated that only close inspection reveals the separations [5.25]. The subject is unusual. It is St. Joseph–identified by his flowering staff–who holds the sleeping Child Jesus, while the Dove of the Holy Spirit hovers over them. Cherubs surround the group; their stylized wings look like leaves. An inscription above the heavy cornice dedicates the building to "San Francisco Xavier. . . India . . . Apostolo."

Nothing could better document the scarcity of wood in the region than the fact that the interior was entirely of stone and plaster. Timber was scarce in these regions and the mine owners had priority–wood was vital to their operations, furnishing everything from lintels and beams to support the tunnels to charcoal for smelting. Indeed, around the mid-eighteenth century, King Charles III, ruling in favor of the mining industry, forbade the use of wood in church retables. When we saw the church, statues and paintings and all other such accoutrements were gone. There remained a built-in, simple retable, a confessional and a graceful pulpit swinging out from the opposite wall–all of masonry (1963).

At the time of our visit, a dam was being built at the confluence of the Moctezuma and the Bavispe, where they form the Yaqui. A huge artificial lake, many miles long, would soon cover the valley to serve a hydroelectric plant. Several villages along the shores were being evacuated. The dignified façade of Rapicani's church was rescued from the flood and now stands like a large architectural screen at the southern entrance of Hermosillo, the state capital.

Another structure at the north end of the town apparently was the first ambitious stone church there [5.26]. To our knowledge, this delightful little building has never been published. Although a sad ruin, without roof or door, it captivated our attention by its noble yet unassuming lines. It was built of native stone, roughly shaped and laid in random courses. Its proportions are graceful, the corners sharp, the roof level is still true. A crown topping the tower affirms its dedication to the Queen of Heaven. In this photograph it is preserved for posterity, for by now the structure has collapsed into a watery grave [5.27].

Northwest of Batuc, in the valley of Rio Altar and rather difficult of approach, lies another Indian village—Oquitoa, a quiet agricultural community, now benefiting from improved irrigation. The church there is one of a unique group of individually interesting mission buildings in northwest Sonora. It was a hard life, plagued by illness, bad and uncertain communications and Indian forays; there was little possibility of raising great and showy churches. After the more elaborate buildings, decorated in Baroque design that we visited, we see here a simple structure, parallel in time with those which were better financed and served a greater and more mixed population. According to historical data, the present church was being built by the Jesuits in the first decade of the eighteenth century. It is barnlike with thick walls—probably not very different in structure from those which went up as soon as there was enough population to erect a place of worship that could withstand the climate better than the *remadas* and lean-tos of the first missionaries. Dedicated to San Antonio Paduano, the church stands on an elevation overlooking the open valley. It has a cruciform plan and the exterior is undecorated. But the façade, as it was before 1950, shows considerable individuality [5.28]. A protruding frame of molded brick encompasses the entire front in two sweeping curves that meet in a point on the bell wall. Well-designed consoles below the niches add plastic interest, as do the pilasters with their protruding capitals and bases, perhaps calculated to support columns some day. Whether the niches contained statues or the painted figures of saints that some of the more prosperous communities gave their churches cannot be established.

A recent "restoration" has changed the effect, perhaps to simplify the work of the mason [5.29]. Heavy, tapered pilasters emphasize the solid block of the second tier. The curves are minimized, pushed into the background, the supports of the bell tower drawn across them. Only the original corrugated shell lining the portal is left. But even here the hatched pattern is gone from the arch, which in the earlier version gave an eyebrow-like emphasis to the entrance.

The chain of missions that stretched from the Mexican states of Sinaloa and Sonora into Arizona was nearly broken by the expulsion of the Jesuits (1767). There were not enough Franciscans to take over this vast territory in addition to their own, and it was left without ecclesiastical leadership. During the Jesuit regime there was no resident priest at Oquitoa–which is indicative of how the Order judged the importance of the village. When the Franciscans came, they no doubt carried out changes in administration as well as in architecture, as they nearly always did. A resident priest was recorded around the end of the century and by 1830 the place was a *cabacera*, mission headquarters. However, before the nineteenth century closed, it was again a *visita*, as the present state of the village would fully justify. Thus the church at Oquitoa comes again to the status in which it began, with only a visiting cleric every three or four weeks.

With the end of the Spanish hegemony and the revolutions of the nineteenth century, the widespread, remote regions of Sinaloa and Sonora fell into a state of apathy. Without stimulus, these villages and even pros-perous mining towns–some of which once boasted families who ate from solid gold tableware–fell into decline and today, without good roads, they have become real backwoods. Some churches disintegrated after seculari-zation. Some lingered on, usually without a priest. Some were strengthened and are now used as parochial churches. Others are literally falling apart, prey to picnicking vandals.

The state of Sonora is now judged the richest mineral region of Mexico, producing gold, silver, copper, lead, even coal. But after the turmoil which more or less characterized Mexican politics for a century after 1820, the region became notorious for its desperados and its savage Yaqui Indians. Even at the beginning of the twentieth century, wives and children of American miners were confined to the precincts of the mining camp and sometimes had to be sent back to the United States overnight by whatever facilities were available.

This region should not be left without a mention that when the French king, Napoleon III, with his conspirators, manipulated the affairs of Mexico, the potential wealth of Sonora was so tempting that a special status

was given the state in the projected "empire"–and as a prize for coopera-
tion, the group planned a Dukedom of Sonora for one of their associates, in
1864. But it was no more than a plan and as futile as the role of emperor was
for that unfortunate Habsburg, Maximilian.

Bacadehuachi stands on the opposite border of Sonora from Oquitoa, in
the morning shadow of the Sierra Madre Occidental, amid prosperous
ranches and with a number of still active mines nearby. The rough uncertain
road to the town fords the Bavispe River and winds its way up to a higher
plateau. At the sharp turns, our four-wheel-drive Jeep Wagoneer scraped
the rocky walls, colored with the red and yellow of their mineral content.
The forbidding mountain range rose before us from the broad tableland like
a barrier, and at its foot we could see the twin-towered church glimmering in
the distance.

This impressive building, dedicated to San Luis de Gonzaga, stands in
contrast to the modest church at Oquitoa–it is a missionary padre's vision
made three dimensional [5.30]. The two sides of the façade hinge forward
like the enfolding wings of a triptych. Striking and unusual are the garland
imitation and the plastic niches, as well as the miniature, shrinelike bal-
conies to right and left of the entrance. Wind and weather have outlined the
cornices with mineral dust and lichen. The two massive towers that buttress
the great bulk of the structure suffered in an earthquake in 1887 and are now
only a third of their original height.

The interior has great dignity [5.31]. The nave is high, narrow and very
long. Fluted pilasters, topped by heavy overhanging cornices of molded
brickwork that make one think of basketry, break the monotony of the wall
surfaces. A console of brick laid in a receding stepped pattern supports the
masonry pulpit, and brackets of the same type are set in the pilasters,
evidently for statuary. The soaring barrel vaulting, emphasized by its series
of arching ribs, is intact after 200 years. Apparently to support the thrust, a
low, vaulted ambulatory, like a series of connecting chapels with very thick
walls, runs along the sides of the building and across the back of the apse. A
dome at the crossing lights the interior, and another, over the ambulatory,
casts an aureole around the statue of Virgin and Child standing in an open
archway on the gilded retable. The serene figure amid the golden glitter
contrasts sharply with the whitewashed surfaces and remains visible even in
the twilight.

It is believed that Nicolás de Oro, resident Jesuit priest for more than
thirty years in the first half of the eighteenth century, is responsible for the
work. The narrow nave, the thick walls, the absence of windows might be

said to indicate hesitant architectural knowledge. On the other hand, the ground plan complies with sophisticated traditon. One must remember that the church stands in an earthquake region—an imposing "sister" building in a neighboring valley was leveled by such a catastrophe.

The monumentality of this lonely church can best be seen from the rough meadow behind it [5.32]. There was no effort to elaborate the outer construction. The half-cylinders of the barrel vaulting, the rounded domes and the great cubes of the lanterns echo the inner structure and give the building its unique character.

We spent the day studying the church. Photographs were all done while the full sun illuminated even the dusky interior. The old woman who had come over to watch us when we started work said that in reality they had no priest—the visiting priest came all too seldom and her soldality had to guard the place. She pointed out that the house opposite the church on a corner of the plaza, taller and better built than the others around it, was once the *casa real*, the official guesthouse for important visitors. Now, in its pitiful state, it is used as a jail. She told us that near the town are two famous eternal springs, one cold, the other flowing with hot water. People used to come from other places—across the mountain pass from Chihuahua which is just as near the village as is Hermosillo, the new capital of Sonora—to visit the springs. And the padres in colonial times made much use of them. They have never gone dry.

Later, an old man appeared, saying he was the sacristan and wondered whether we planned to spend another night there—because the road is too bad to drive in the dark. We assured him that we had a place to put down our sleeping bags. Then he produced a key and led us through the darkening nave into the sacristy. Closing the door with gestures of caution, he brought out two processional crosses of silver, beautifully chased, and told us that one had been made locally in colonial times, the other brought in somewhat later from the south. It was shortly before sunset, but he stood hesitantly, as if he needed to be assured that we would not ask to photograph his treasures. He put them back and then brought out a neat silver box, some ten inches long, with a scattering of flower petals finely chased on the body. A pattern of double eights in scroll work at the corners formed little feet. It could have been a reliquary—for it was the rule that every church in the colonial empire should be founded on the relic of some saint. The old man said that both the silver and the workmanship, which was delicate though not sophisticated, were local. We made our notes, and my wife sketched the little box. The sacristan received his tip and went away so fast that we did

not even see where he disappeared. The sketch of the box records, on two rings at the sides and on the tongue of the clasp, altogether three silver pendants in the shape of miniature frogs.

It was dark by now. The church stood a mute mass. The silver objects were back in safekeeping–as safe as the place could offer–sad fragments of colonial wealth. The town was quiet–everyone was at the evening meal, and the curtain that had gone up before our eyes was rolled down.

Neither the silversmith nor the person who ordered the box could know that in European Roman Catholic iconography the frog, one of the plagues of Egypt, had an evil significance, likened sometimes to heresy, or to the sins of worldly life. Here it would seem it had another meaning: frogs were symbols of water in pre-Columbian times, and Bac implies water in the language of the Pima Indians. In Sonora there were Jesuit missions at Bacerac, Bacoachi, Bacoancos. In Arizona, just across the border, is the lovely mission church San Xavier del Bac. Now we were standing on the plaza of Baca-de-huachi.

In this subtropical region, the sun had fallen into the ocean and in the ink blue sky the first stars lit up. Before our primitive night quarters stood the Jeep Wagoneer, equipped with cooking and sleeping facilities and tools to make the little-traveled roads passable. We were at the end of the trek which had taken us into the land of mines and missions.

One province with considerable metallic wealth joined viceregal Mexico much later than the rest of that empire. California was the goal of the Franciscan Fray Junipero Serra, who made his way there on foot and founded his first mission, in 1769, at San Diego, and his last, San Francisco, in 1777. Spaniards, mainly colonials, prospered under the system of land grants in this land of blessed climate. Not in vain was California named after a paradisiacal island described in a sixteenth-century Spanish romance of chivalry. This book, *Las Sergas de Esplandián*, by Garci Rodríguez de Montalva (1510), fired the imaginations of explorers who sought the near-Eden it described. New World California became a region to which people, tired of political upheaval, came, hoping for freer, more idyllic living than was possible in Old Mexico.

Even before the gold rush, placer mining was paralleled by underground shaft mining. However, at that time little of the region's potentialities was realized. Humboldt makes mention of a "Santa Ana" mine, but does not give any data. It was usual to name a mine for some saint, generally a woman, and sometimes for the wife or favorite daughter of the owner.

We have many evidences of the complex society that grew out of the

wealth of the mines, but few pictures of the mines themselves. The painting illustrated here shows the blessing of the Enriqueta mine in California [5.33]. We see an open-air altar with a statue of Mary and the Child wreathed with flowers. The priest is officiating and the folk kneel before him– including the men who evidently hope to get a living by working in the mine. A ray of sun falls on a small picture that hangs at the mouth of the tunnel, invoking divine protection. There is music–a guitar, a banjo and a violin. And in the foreground, a group led by a man in the garb of a Mexican *charro* is breaking out boxes of firecrackers with which to top off the celebration.

The gentry look on, elegant and aloof. Their dress bespeaks the period of around 1840. Some are arriving late–a most common custom of Latins in general. From the puff of smoke in the lower right corner, it would seem that they came by the narrow-gauge railroad that would later carry the ore. One of the women makes the short climb on horseback, one on a little white mule, while others walk with the men, holding parasols. Fine-bred horses in the foreground, left, carry elegant side saddles.

The painting, in oil on canvas and signed by H. Edouardt, is in the Bancroft Library at Berkeley, California. Hubert Howe Bancroft (1832-1918) was born in Ohio and went West, not after gold but more lasting values. By the age of 20 he was established in San Francisco as a bookseller, but he soon gave up his business to devote himself to the collection of material on the early West and Southwest. It was an especially propitious time for this work, because when the United States took over California in 1849, not only the flag but also much of the population changed, and the documents and records of the regime when Spanish was spoken exclusively started to be dispersed. Books, pamphlets, old newspapers, personal narratives, transcripts, old maps–all were of interest to Bancroft. At the end of his life, some 60,000 volumes of material were on hand and 39 books had come from his pen. Bancroft had devoted his life to preserving what the mills–not only of the gods, but also of human carelessness and indifference–were so swiftly grinding away. In 1905, the University of California acquired the collection and placed it in a library named for him.

Race horses, their upkeep costing a fortune; eighteenth-century English art, housed in a new building that it already overflows, to the outlay of nearly a quarter billion dollars, are pastimes indulged in by scions of wealthy parents. We see their names in the newspapers. It would be inspiring if they were connected also with the preservation of the cultural heritage of this continent, from which their tremendous riches derive. Bancroft, with only a fraction of such sums, made an inestimable contribution to the scholarly world.

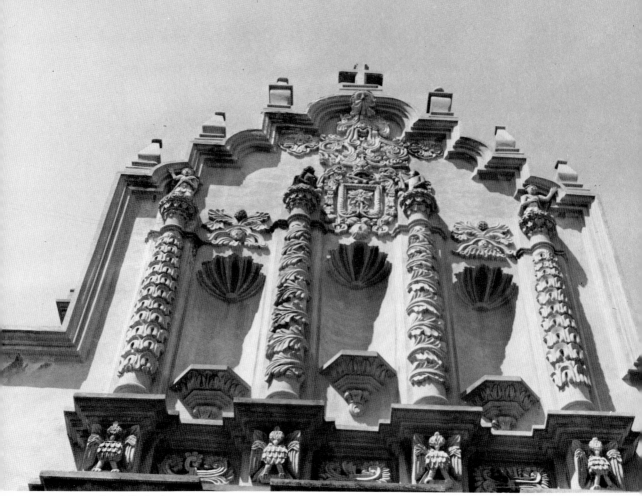

[5.1] Cathedral side portal. Monterrey, Mexico.

[5.2] Bishop's summer palace from the front. Monterrey, Mexico.

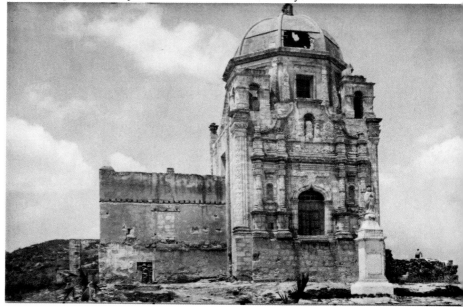

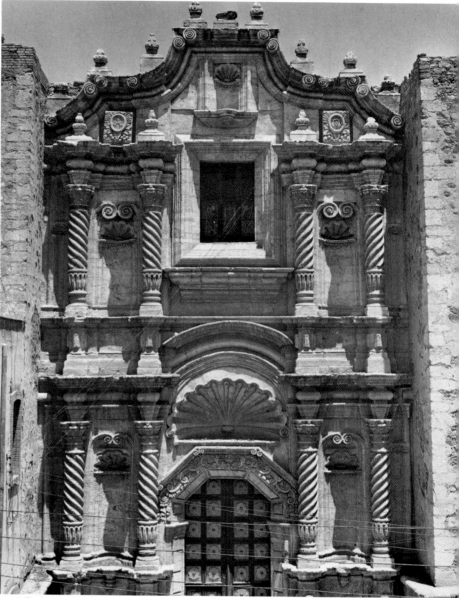

[5.3] Cathedral side portal. Saltillo, Mexico.

[5.4] Entrance to bishop's palace. Monterrey, Mexico.

[5.5] Cathedral façade. Saltillo, Mexico.

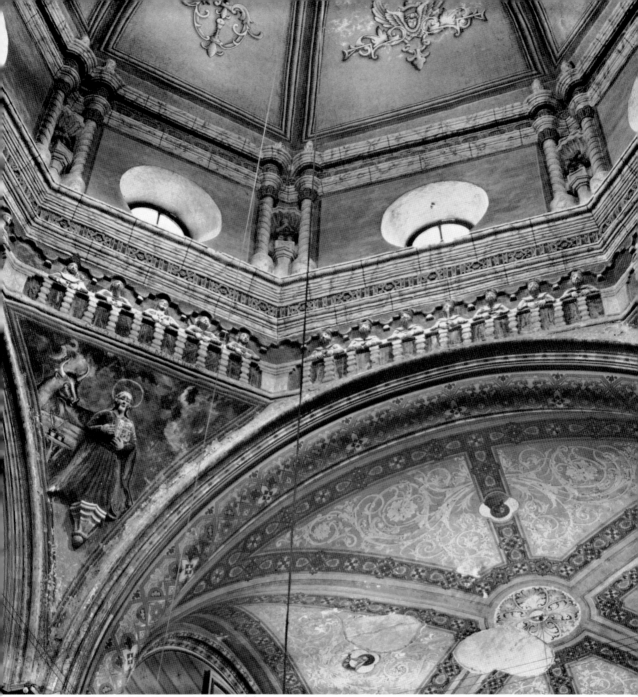

[5.6] Choirs of the Blessed. Detail of dome.

[5.7] Hacienda ruins near Saltillo, Mexico.

[5.8] Ruined hacienda near Nombre de Dios, Mexico.

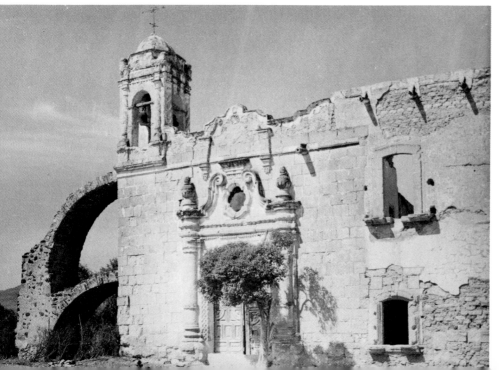

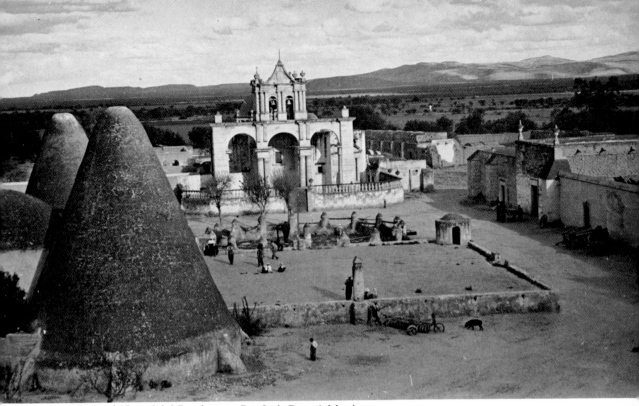

[5.9] Hacienda Jarral del Berrio near San Luis Potosí, Mexico.

[5.10] Stables. Hacienda Jarral del Berrio.

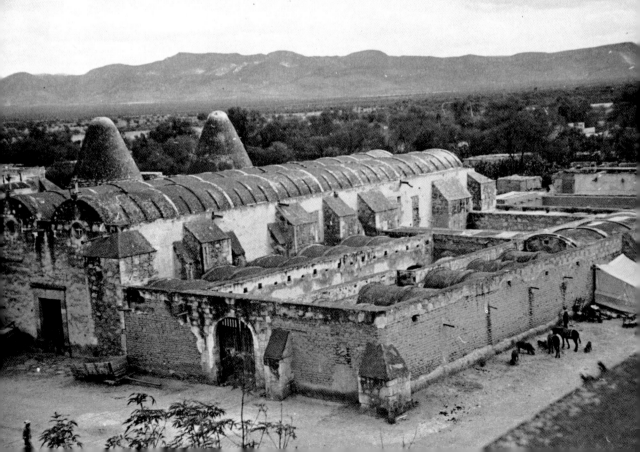

[5.11] City view with aqueduct.

[5.12] Detail of carving. Cathedral.

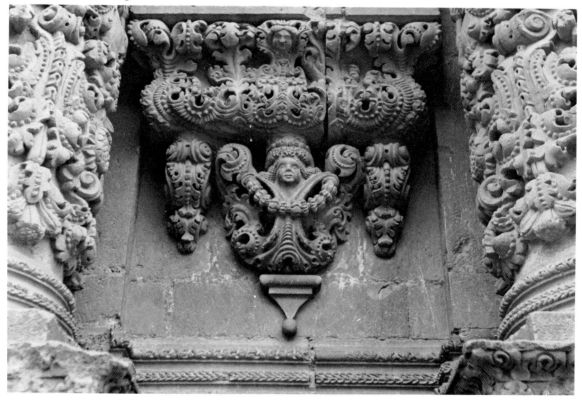

ZACATECAS, MEXICO.

[5.13] Cathedral façade.

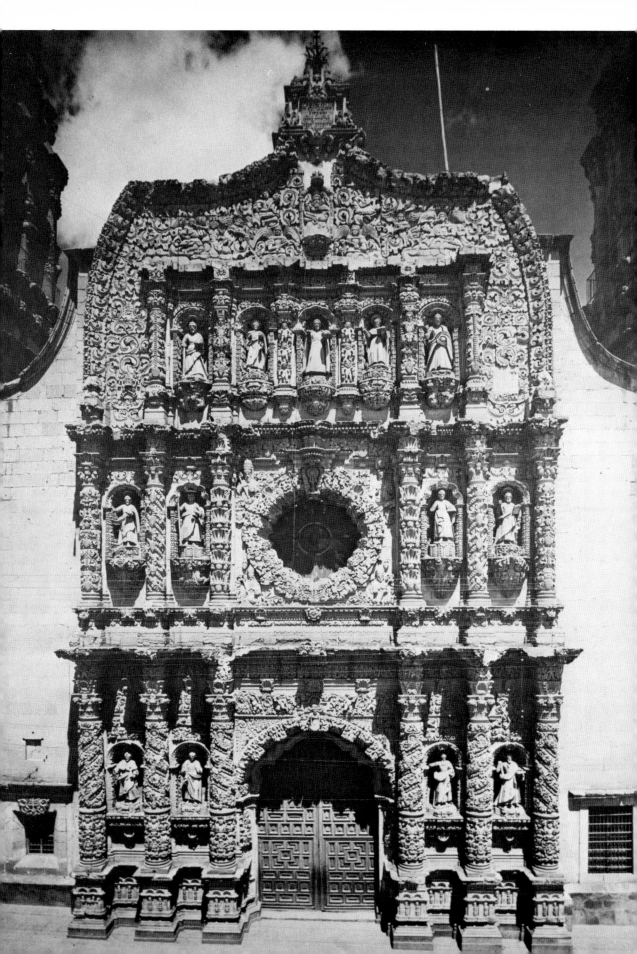

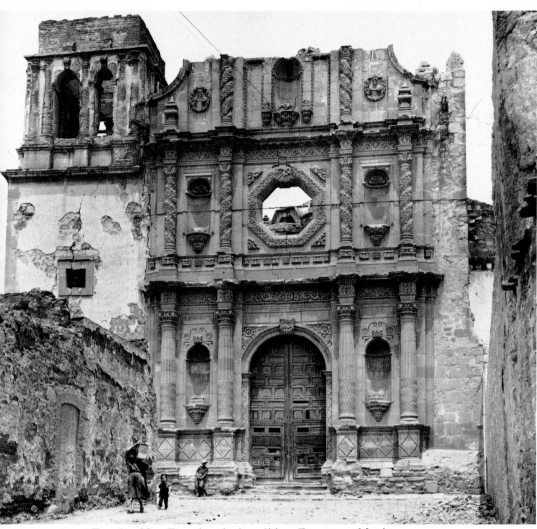

[5.14] Façade of San Francisco in demolition. Zacatecas, Mexico. 1953.

[5.15] San Francisco cloister. 1953.

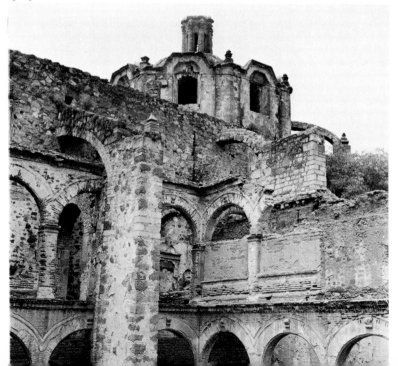

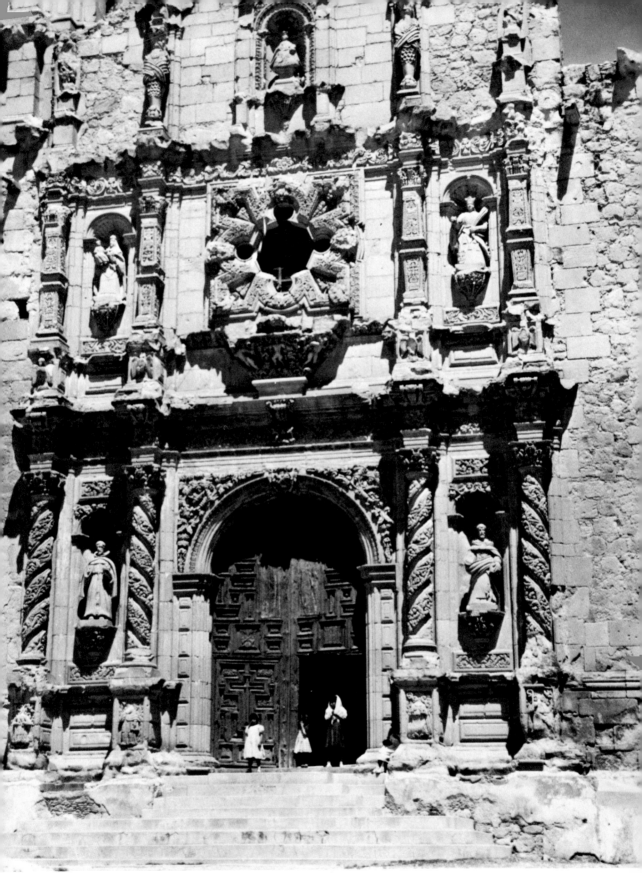

[5.16] Façade of Santo Domingo. Sombrerete, Mexico.

[5.17] Cathedral. Durango. Mexico.

[5.18] The Immaculate Conception. Durango cathedral.

[5.19] Side portal.

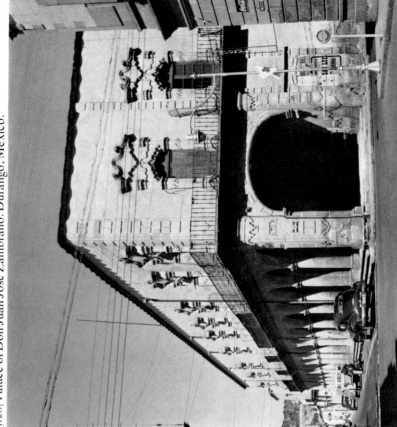

[5.20] Palace of Don Juan José Zambrano. Durango. Mexico.

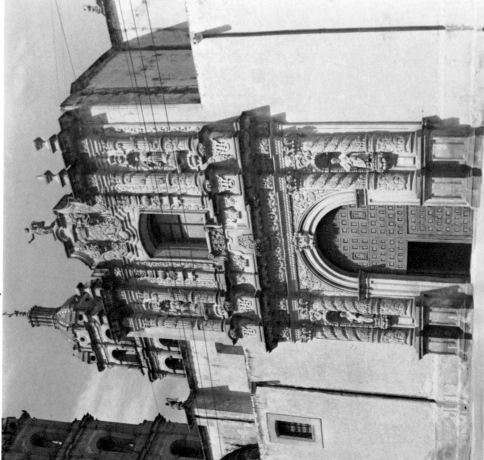

[5.21] San Sebastián y Santa Bárbara. Concordia, Mexico.

[5.22] Re-gilding colonial statues. Rosario, Mexico.

[5.23] Rosario church on original site.

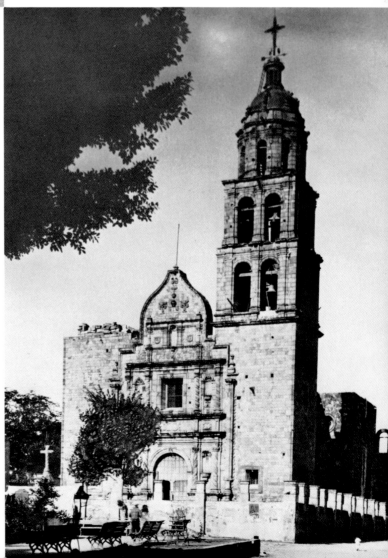

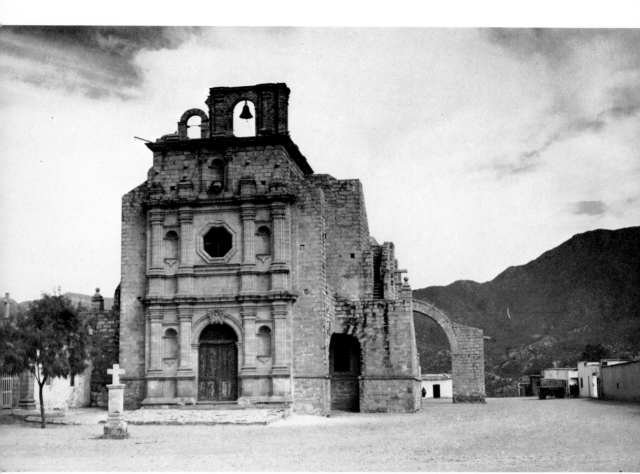

[5.24] San Francisco Xavier. Batuc, Mexico. 1963.

[5.25] Keystone to main portal.

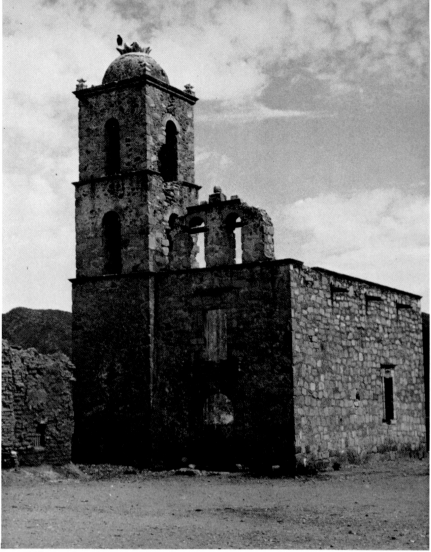

[5.26] Early church. Batuc, Mexico. 1963.

[5.27] Inundated. 1968.

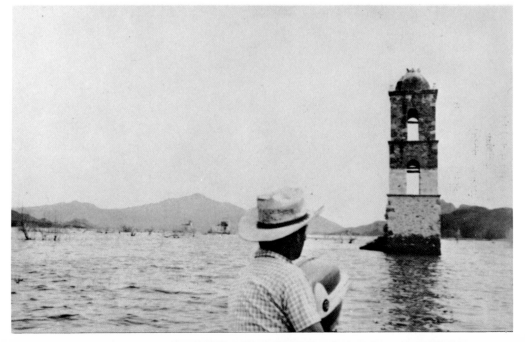

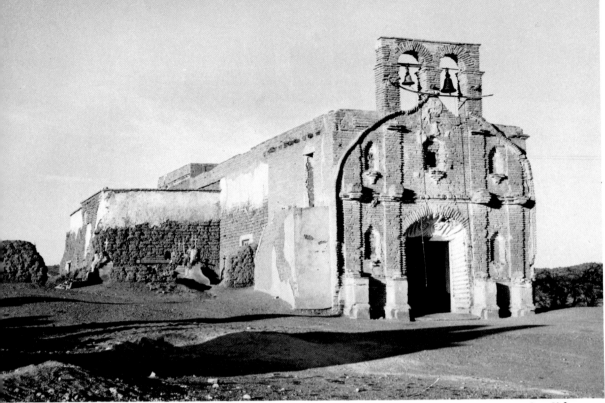

[5.28] In 1955.

SAN ANTONIO DE OQUITOA. OQUITOA, MEXICO.

[5.29] In 1963.

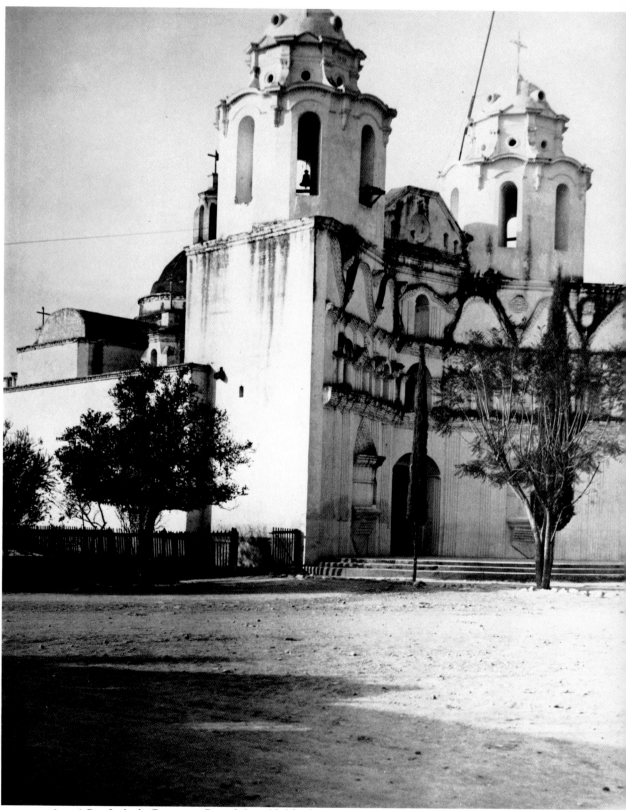

[5.30] San Luis de Gonzaga. Bacadehauchi, Mexico.

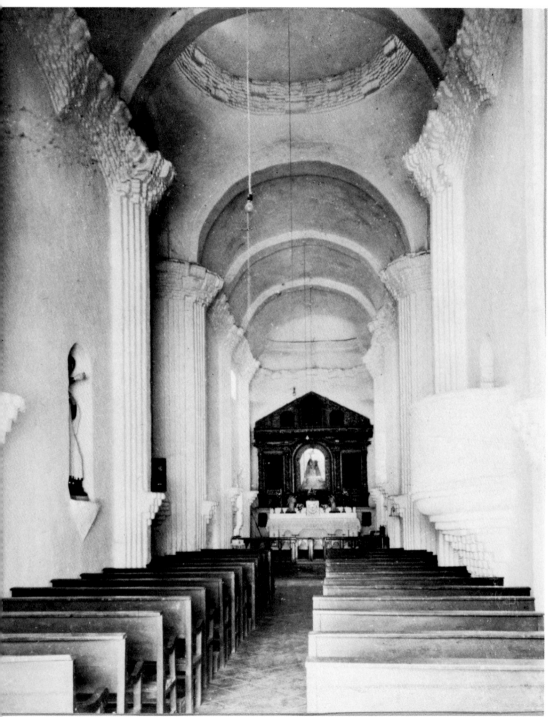

[5.31] Interior. 1957.

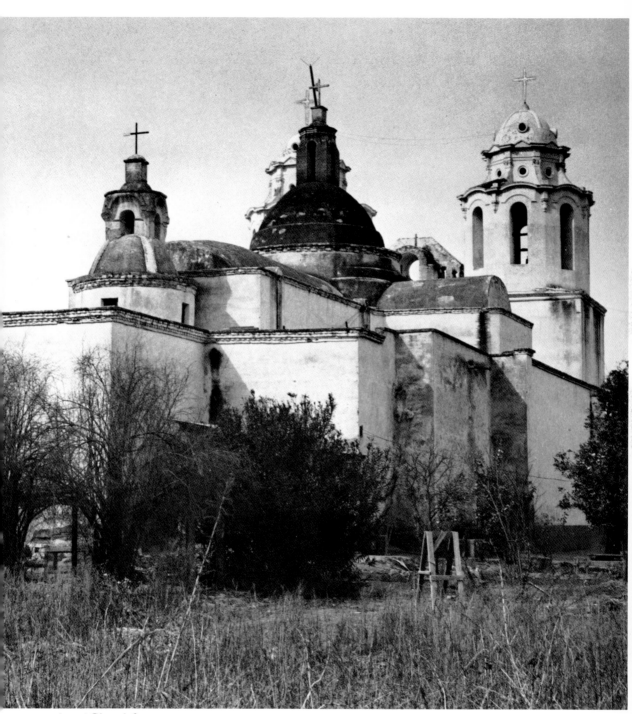

[5.32] Church from rear.

[5.33] Blessing of the Enriqueta Mine, California, by A. Edouardt.

Archangel Musketeers

The colonial painter in Spanish America, unlike his European contemporaries, had no tradition of the Romanesque, Gothic and early Renaissance upon which to base his work. He was not even a painter in the European sense of the word. When he was called upon to produce pictures, the Baroque style was prevalent in Europe, and this was the "language" in which he was taught. As painting served the church almost entirely, his models were generally religious prints or illustrations from the Bible and other sacred works. These, however, were never colored and seldom larger than the page of a prayer book. For the needs of the New World they had to be enlarged, sometimes nearly to life size, and embellished with color. Here the painter could exercise his talent with more freedom. It is interesting to study the variations on a prescribed religious theme. Most have regional touches. In the High Andes, colorful birds fly through the sky or perch on trees, native flowers dot the ground, small animals fill in corners of the landscape as in colonial Peruvian tapestry.

Purely technical matters also contributed to the distinctive character of Hispanic-American painting. In Europe, oil paintings were executed on tightly woven linen which was evenly spanned on a stretcher, primed to seal the porous material, and coated with a grounding. The main colors were then laid on, followed with shading and highlights, glazes and varnishes.

In the Spanish colonies, European techniques could be followed only to a certain degree. Imported ingredients remained scarce and very costly. The supply of linen was never adequate. On the other hand, cotton was native to many parts of the New World. An excellent cotton cloth was produced in the Peruvian highlands. Indeed, one conservator has noted that sometimes the material is so firmly woven that only very high magnification brings out the difference from linen. It is safe to say that the majority of colonial Peruvian paintings were executed on cotton fabric. As the demand for paintings increased, and the scarcity of material became evident, fabrics were re-used, remnants patched together and other makeshift solutions were devised. Cloth woven from sisal and other tropical fibers is found occasionally, even as the base for excellent work.

Linseed oil, a vital material for the European painter in the blending of pigments, was another highly expensive item in the colony. The colonial painter used mixed media in his work to obtain the desired shades, sometimes combining oil, tempera and water color on the same picture. His pigments also were based partly on ancient practice; even dyes were used as in pre-Columbian times.

Colonial painting of Spanish America has several peculiarities that this writer has never found noted. Nails were a rarity, but an excellent glue was at hand, the production of which went back to pre-Columbian times, and it was the custom to glue the fabric onto the stretcher. Further, the picture was often painted to the very edges of the material, and no strip was left for folding over the sides. Therefore, in many cases it can be noticed that the painting has been crudely cut off the old stretcher, and the edges of the picture are damaged or lost.

A new Christianity was evolving in the Americas, and the painting reveals something of its development. We have seen how in Christian concepts subtle changes were tolerated by the missionaries and priests to bring them within the grasp of the neophytes–changes that were hardened and confirmed with the passing years. As a case in point, it is rare to find a figure of one archangel alone in European painting of the seventeenth and eighteenth

centuries, even the dramatic figure of Michael with his sword of flame. In the Spanish colonies, he appears frequently, also sometimes as guardian of the Virgin Mary, sometimes accompanied by Gabriel and Rafael.

Although the portrayal of angels and archangels and of warrior saints has a long tradition in Byzantine art, the band of the Seven Archangels was neglected for a long time in Europe. Their cult was rejuvenated in the sixteenth century, when a fresco representing them was revealed under a cover of whitewash in the church of Sant'Ana, Palermo, Sicily. Charles V donated the means to erect a new church at Palermo in their honor. Pope Pius IV (reigned 1559-1565) consecrated a church to them in Rome. A statue of the Archangel Michael, taken from a design by Raphael, was placed on the top of the tomb of Hadrian, now known as the Castel Sant' Angelo. Later, a series of angels carrying the symbols of the Passion were carved after drawings by Bernini to stand on the ancient bridge which leads to that fortress across the Tiber. A book was devoted to the Seven Archangels, and the Plantin Press in Antwerp, as *prototypographus regius* to Philip II of Spain, printed a picture of them from an engraving by Jerome Wierix. By the mid-seventeenth century the cult was disseminated throughout Europe and reached the New World.

The Council of Trent had defined the proper representation of archangels and other heavenly messengers. They should be floating on clouds or surrounded by them; they might be depicted presenting symbols of martyrdom, a cup or ciborium, blowing a trumpet, carrying a crown or the instruments of the Passion. Such heavenly apparitions were effective in strengthening the faith of Indian converts, for whom the supernatural appeared in vast manifestations, phenomena beyond their powers to control. Having made the voyage across the ocean, the Seven Archangels as a group decorate a retable at the Jesuit center of Tepotzotlán, Mexico. They are carved in stone on the façade of the exquisite eighteenth-century church of Aljojuca, Puebla. And in the cathedral of Tegucigalpa, Honduras, they stand not only on the façade but, carved in wood, polychromed and gilded, on the magnificent Rococo main altar. In the church of San Martín at Potosí, Bolivia, a frieze of archangels surmounts a series of splendid paintings [6.1]. In all of these representations, the archangels are shown with symbols of the Passion or their own individual attributes.

The New Mexican *santero* of our Southwest had a limited repertory of favorite saints and rarely depicted archangels. Here is his delineation of the

three highest in the Hierarchy of Heaven, painted on a thin wooden slab [6.2]. Rafael at the left is identified by the fish in his hand and his wanderstaff shaped like a cross, with the phial of healing potion dangling from it. Michael stands in the middle. In one hand he wields, in a striking pose, the sabre of an infantry officer; in the other, he holds the scales with which souls will be weighed at the Last Judgment. The monster of evil cowers beneath his feet–here suggestive of a mountain lion with a human head. Gabriel is shown at the right, in one hand a goblet–the Cup of Gethsemane–in the other, a palm. Rafael wears a headband with a star, Michael, a plumed helmet from medieval times, and Gabriel, an imperial crown with the cross. The two flanking the central figure, as if copied from statuettes–the *bultos* of the region–stand on pedestals to appear on the same level as Michael.

Breathing a very different atmosphere is the painting of an archangel by José or Juan Correa from early eighteenth-century Mexico [6.3]. Here the angel is presented in a magnificent costume. The translucent shirt and the folds of the rich tunic draped over it are executed in finely drawn detail. The facial expression, the delicate gesture of the fingers, and the jewels decorating footwear, sleeves and chest, show the painter in full command of his craft, although the work transmits little emotion. This is Rafael, who is said to present to God the prayers of saints, symbolized by incense.

To our amazement, we came upon a painting of an archangel with a musket in his hand while on an extended survey in Alto Peru, in the village church of Zepita which lies a stone's throw from the Bolivian border. The winged warrior is shown ramming in powder and bullet [6.6]. Here Michael's flaming sword with its supernatural power has been exchanged for the terrifying weapon of the conqueror. We photographed the picture, hanging high on the discolored walls of the abandoned church, and were the first to bring the subject to wider attention, publishing it in *Baroque and Rococo in Latin America* (1951).

The painting was in good condition considering its age and showed no sign of having been tampered with. As it was without a frame, the custom of gluing the fabric to the stretcher, even to the support across the middle, is revealed here clearly.

The work is modest in color. The angel stands against a neutral background. His large, feathered felt hat, knee breeches, shoes with bow ties, the laces and the long wavy hair are all in the mode of the gentleman of the late seventeenth century. His garments are elaborately patterned and tooled. Behind him, the folds and deep lace border of a heavy cloak can be

descried. (An eighteenth-century traveler mentions the extravagant use of broad lace in the costume of affluent Indians.) There is a joyous expression in the face; indeed, the whole unretouched picture radiates friendliness.

Archangels as musketeers have been found most frequently in what is today Bolivia. At Uquia and Casabindo in the Argentine province of Jujuy, just off the road north of Salta, the nave walls of the churches were hung with paintings of winged beings equipped with muskets–the so-called *angeles caballeros*, gentleman angels. In the church of the rich and ancient village of Calamarca, 30 miles south of La Paz, Bolivia, a remarkable galaxy of some 36 such figures included a flag bearer, a trumpeter, drummers and halberdiers, as well as musketeers.

The illustration [6.4] shows a courtly figure holding a trumpet from which hangs a heraldic flag; in his left hand he carries a crown. This is Gabriel, Man of God, the divine herald. He is the angel of the Annunciation and the harbinger of the Last Judgment. The name "Salamidei," crowded in at his feet, is such a distortion that one wonders if it was not added later or put in by an artist who was illiterate. The bright-colored wings, the sumptuous clothing, with broad plumed hat, silk stockings, shoes tied with bows, lend the figure a flamboyance that carries through the cycle of our examples.

An archangel picture still hanging in the church at Calamarca [6.5] is so much like the trumpeter in stance and bearing, even to the pattern on his costume, that the two are doubtless part of the same group. The inscription *Habreldei* suggests that he also is supposed to represent Gabriel. The old church is said to have been destroyed by fire, but the present building retains much colonial flavor. Paintings of Archangel Musketeers are grouped on both side walls. It is clear that they are not all by one hand, perhaps not even from the same epoch.

The herald's picture was taken from a negative lent us by the late Cecil Guzmán de Rojas, at that time director of the Fine Arts Institute in La Paz. We commiserated with him about the neglect of such telling and unusual relics of Spanish colonial art. It is an open question where in Alto Peru the first versions of such angels were painted. The wholesale destruction and dispersion of colonial works discourage conclusions. Some of these figures, so elegant of dress and dignified in bearing, found their obscure way to Europe. In the process of "restoration," their wings were painted out, and they were identified as portraits of distinguished royal personages.

The Conquistadores had arrived in the New World with guns, which with

the horse were beyond the realities of Indian life. Warring nations in Europe, however, were already working on the technical problems of firearms. The arquebus, or caliver, had been in use since the beginning of the sixteenth century. It was a hand gun with a rather short barrel, fired by a rope "match," or fuse, held in the hand. Around 1540, the Spanish army, at that time one of the best disciplined and well equipped of fighting forces, came up with a much heavier piece, of the type we know as a musket. It was a matchlock with a barrel more than a yard long. Because of its length and fire power, a two-pronged rest was needed to steady the barrel. This weapon was so efficient that one observer equated a musketeer with two cavalrymen in effect. It was widely imitated throughout Europe by–surprisingly–an arms agreement among major European powers. The flintlock–the "long gun"–was a still more efficient development. Both English and Americans used it in the French and Indian war and in the American Revolution.

A military manual, *Wapenhandelinghe van Roers Musquetten*, "An Exercise of Arms," by Jacob de Gheyn, published in 1607 in Gravenhagen, The Netherlands, shows how to use the somewhat cumbersome matchlock. The procedure is illustrated step by step, from the taking of the gun in hand to the loading, carrying, aiming, firing and cleaning it, listing 42 commands in all. Text and captions are in Dutch. Other countries later printed the same type of manual; these reveal incidentally the transformations in dress as well as in the form and handling of the musket itself. Both album figures illustrated here use the early matchlock with pronged support. The first is taken from Gheyn's book and wears the garb of a fighting man [6.7]. The French Palace Guard of 1660 is more decorative than martial [6.8].

Our Archangel Musketeers are certainly not garbed for war. Their costume seems derived partly from the flamboyant style of The Netherlands in the mid-seventeenth century, partly from Spanish colonial uniforms. Even before the accession of a Bourbon to the throne of Spain, French influence also played a part. A visitor to Lima in the eighteenth century described the viceroy's bodyguard as composed of 160 horsemen, with captain and lieutenant–who had to be of pure Spanish blood–wearing blue uniforms turned up with red and laced with silver; and infantry consisting of 50 halberdiers in blue, with crimson velvet waistcoats laced with gold. The officers' shoes were often fastened with diamond buckles, even with pearls, and some had heels of wrought silver.

Small wonder the extravagances in the portrayal of archangels! In the paintings shown here they wear richly embroidered coats edged with gold braid and lined with cloth of some bright color. The ballooning sleeves are

slit to reveal silken shirts with lace cuffs. Lace also edges the biblike collar of translucent stuff. The tunic is again of another patterned material. White silk stockings are gartered with flowing ribbons to match the bows on shoes. Sword and dagger hang from the sash, and curling ostrich plumes adorn the broad flat-brimmed hats. Such costumes remind one of prints of early Venetian operas and the Comédie Française or the costumes for gala performances, like those of Handel, for the entertainment of royal and aristocratic courts. In the paintings of Alto Peru, they reach an ebullience and sumptuousness found nowhere else in the world. Here we see the metamorphosis of the stiff military figure into Baroque exuberance—a style peculiar to the region. Even in Mexico such flamboyance is not encountered.

With the end of the seventeenth century, the Habsburg rule in Spain and her dominions came to an end. Louis XIV of France manoeuvred his Bourbon grandson, as Philip V, onto the Spanish throne. The French monarch apparently intended to control Spain through family connections. He may even have hoped that treasure from the New World would help balance his budget, bankrupt from many extravagances, including that monotonous monstrosity, his palace at Versailles. The Spanish aristocracy soon made it clear that France had not gained a province there. Nevertheless, the presence of a Bourbon ruler brought a new color even into the life of the Spanish colonies. The viceroy of Mexico, who had been an ambassador to France, arrived in a French ship, avoiding English and Dutch privateers, and French touches of luxury were added to colonial life. The uniforms of the Palace Guard, already full of pomp, took on new details from the French army. The francophile ruler in Lima issued a proclamation in the first year of his reign (1701) that no mestizo, mulatto, zambo or quadroon could attend the university in Lima.

The sequence of archangels presented here, though approximating the various poses of the arms drill as published by Gheyn, shows considerable difference from one to another in uniform and in painterly style. In some, the weapons are carefully delineated, in others, the ostentatious costume dominates.

First of all is shewed to every Muskettier, how he shall handsomely carye his Musket . . . and the matche kindled at both ends between the twoo smalest fingers of the left hand . . . [6.9]*

*The words of command in this section are drawn from: Jacob de Gheyn, *The Exercise of Armes* (sic), facsimile of 1607 Dutch edition, with translation and commentary by J. B. Kist. (McGraw Hill) New York, 1971.

In this painting (42½ x 31 inches), the richly brocaded blue-grey coat is bordered with gold. Contrasting shades of red in costume and wings make for extraordinary elegance. Relaxed and assured, the youthful musketeer looks out of the picture directly at the viewer, bearing the long-barreled gun with nonchalance. The portrayal is the epitome of a romanticizing style. Our figure is indeed "out of this world." If the name Salamiel *Pax Dei*, "Peace of God," is correct, it refers to the ruling prince in Jewish lore of the "Watchers" in Heaven, a figure that later fell into disrepute. On the other hand, Salathiel–"Prince of Wisdom, Prince of the World, Prince of Peace"–is the only angel in whose motto the word *Pax* appears.

The popularity of the musketeer in Europe can be seen in the Delft tile decorated with his figure [6.11]. It is a commercial product of The Netherlands. Such tiles reached the colonies as ballast in Dutch ships and gained in value the farther they traveled from the harbor. The Gheyn engraving [6.10] is the original illustration of the following position:

. . . how he shall with the right hand hold the peece in ballance with the mouthe upwards, without tutching the body . . . [6.12]

In the apparently unrestored painting of this Archangel Musketeer, there is a definite similarity in composition to the figure in Figure 6.9. They have the same stance. Both look out of the picture, with rope match in the left hand. The costumes have a similar cut. In both cases the musket has a silver decoration on the end of the stock. Here the bib has been replaced with a lace collar and flowing tie with small metallic balls on the end. The color scheme, however, makes for an entirely different effect, a contrast to the golden lights that emanate from the previous painting. The red-edged wings are emphasized and enlarged by skillfully drawn, fluent gold lines. The rich red color of the cloak brings out the opulence of the material, knotted at the shoulder. The hose are red, embroidered in gold, and touches of the same tone light up the looped ribbons of the sash. Large medallions in gold blaze against the dark ground of the coat, giving the figure almost the two-dimensionality of an icon.

The names of the Seven Archangels are many, depending on the epoch in which they were listed. Mystic writings as well as the Apocrypha add to the variety of mottos and attributes associated with them. Especially in Alto Peru, the misunderstanding of an illiterate painter in copying a text could

cause discrepancies and distortion. In this case, "Osiel For...od Dei" (Fortitud?) might be equated with Uriel, whose motto is *fortis Dei*, or *fortis socius*, "powerful ally."

...how he shall well and readily take the matche out of the left hand...holding ever the Musket in a due height... [6.13]

Again in contrast, the representation here is more reserved. Though the archangel still faces the onlooker, the different position of his wings makes for a different balance in the composition. Here the tunic is most sharply defined, with its square lace collar and impressive jeweled buttons. The exaggerated bouffant sleeves seem almost an afterthought, as if to give some airiness to the rather aloof figure. The picture was apparently cut from the original stretcher, curtailing some details. He also bears the name Salamiel, and the crown may denote his princely status.

The photograph of this painting was sent to the writer from Brussels, Belgium. Various identifications had been hazarded in that far land, and even an art historical essay was published, equating the figure with a Portuguese prince who was killed in battle and thus, sanctified.

...how he shall...with two forefingers cover the pan lidde (for feare of sparkes falling therin) and also open the same handsomely when he will put pouder in it... [6.14]

In this apparently unretouched work, wear and tear show at the sides. The wings are interesting, enlarged by feathery outlines as in Figure 6.12. Despite the heavy gilding of the dress, there is considerable movement—even a certain realism in the piece. Details of the costume are logically presented, from the jeweled brooch at the neck to the huge bow on the right shoulder that holds the billowing cloak. Dagger and sword hanging from the belt are clearly indicated. Between the fingers of his left hand, the glowing ends of the lighted rope match can be seen, held in the prescribed manner. Even the mechanics of the gun are clearer than in most cases. Flowers adorn his hat, and white roses overflow a cornucopia at his feet—attributes, according to one sixteenth-century listing of the archangels, of Barachiel whose name connotes the Blessing of God.

...how he shall put the pouder out of the...flaske, holding always the peece from the ground, if he be able to doo it... [6.15]

This elegant figure is distinctly part of a series which includes Figure 6.19.

It is the first instance in which, except for their pelicanlike wings, the young guardsmen seem quite of this world–human, relaxed and natural. Their uniforms, painted with care, differ only in coloring, one coat being slate blue, the other a dull red. The great lace bibs have a similar fernlike pattern; both coats are close fitted, fastened with jeweled buttons, and braided with gold; huge turned-back cuffs replace the ballooning sleeves of the earlier figures. The shoes are sturdier, extending above the ankles, with jeweled clasps. The drapery of a voluminous cloak is barely suggested. Ribbons have been added to the shallow beplumed hats. Neither figure holds his rope match in the prescribed manner–and indeed by their time (early eighteenth century) the flintlock had surely replaced the more cumbersome weapons of previous years.

Here there is a lighter mood–a Rococo touch, as the first musketeer looks down with assurance at his task, and the second, smiling and cocky, turns his head toward the viewer as he marches smartly away.

. . . how he shall with a turned hand draw the skowring-stick out of the stock . . . but no waye suffering the Musket to come to the ground, if he be not too wearie . . . [6.16]

More heavily restored than the others shown here, this portrayal is highly flamboyant. It presents another variation of the figure from the hands of the colonial painter, one of the few this writer has seen that has a landscape in the background. One wonders whether the fruit-and-flower-decorated tunic or the bright multicolored birds, so typical of the Cuzco circle, originally belonged in the composition.

. . . how if he will shoot with a bullet . . . take speedily the bullet out of his mouthe or place where he usually carrieth them, and so let it fall or roule into the Musket . . . and how he shall with the skowring-stick ramme the pouder and bullet together in the Musket . . . [6.17]

Although not in the best condition and possibly partially repainted in the lower section, this figure has a certain monumentality. The wings are scarcely visible. The tunic is plain in color, suggesting velvet with a heavy border. Long wavy hair brushes the shoulders. The large jabot throws emphasis on the face, bringing out the immediacy of expression.

. . . how he shall with one hand lay the peece . . . upon the shoulder, being very readye with the other hand to hold it fast there upon . . . [6.18]

Asiel *Amor Dei*, "Love of God," stands at the ready, the lighted rope match in his left hand, as if waiting for the command to fire. In costume, the figure is somewhat similar to the previous one, though different enough in execution to indicate another hand. The wings are delineated with economy. The forward thrust of the left foot is especially well observed. With eyes fixed on the target, the face expresses concentration and concern.

. . . how he having the peece upon his shoulder, going to be sentinel shall hold and carye it again, like as is sayd at the first figure . . . [6.19]

Our gallery of Archangel Musketeers comes to a close with the sentinel. This figure has been touched upon in connection with his companion in Figure 6.15. Left hand on hip, he looks out of the picture as if curious whether the onlooker notes how elegant and debonair he is. The multicolored plumes of his hat are complemented by the flying ends of a bow tie. The flaring skirts of his coat, the angles of the broad cuffs and swinging cloak end add to the springing movement of his exit.

Another Archangel Musketeer, related to those presented here, is in the International Institute of Iberian Colonial Art in Santa Fe, New Mexico.

In Europe, the evocation of patron saints for the protection of people, places and institutions is widespread. Many towns bear the names of their patron saints. In the United States the names St. Augustine, St. Louis, San Francisco reflect a similar derivation. In landlocked Bolivia, a neophyte Christianity seemingly found security–the assurance of protection for the righteous and just punishment for the transgressor–in the heavenly warriors whom they portrayed in a manner that occurs nowhere else.

Few if any aesthetically or technically competent works on the painting of Alto Peru have been published in Lima. The elegant society, who travel to European luxury resorts, serve dinner on colonial silver and display colonial furniture, have not thought to sponsor a foundation or a scholarship to study this art, which, fragile and neglected, is going to pieces.

What scarce literature exists on the subject was published elsewhere on this continent. Now that in Düsseldorf, West Germany, an exhibition of some 122 South American colonial paintings has achieved international acclaim (1976-77), the interest of Europe also has been aroused. But hundreds of paintings have perished in little-used or abandoned churches. They are lost, and, to our loss, no effort can bring them back from limbo.

145

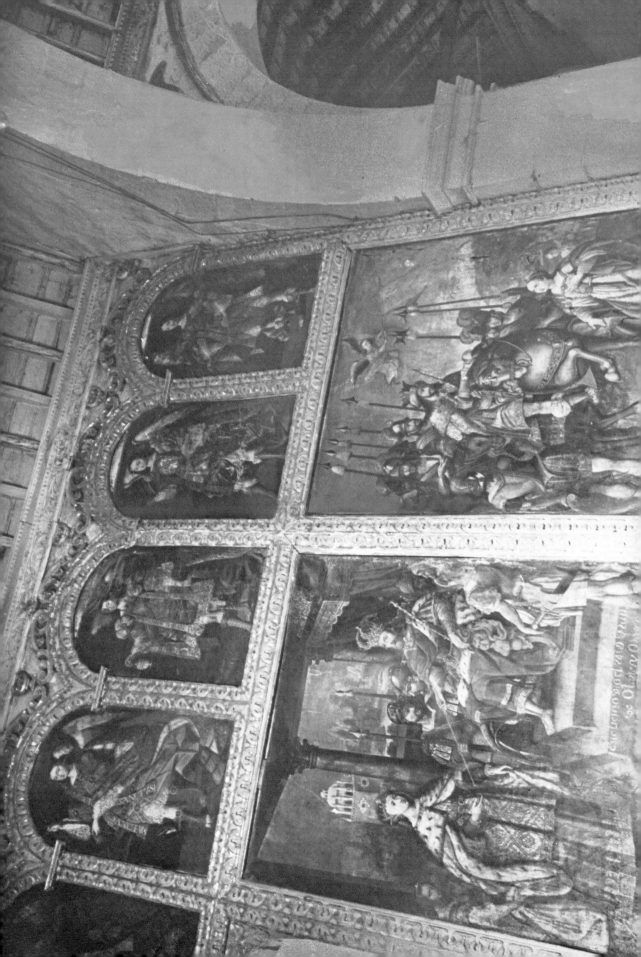

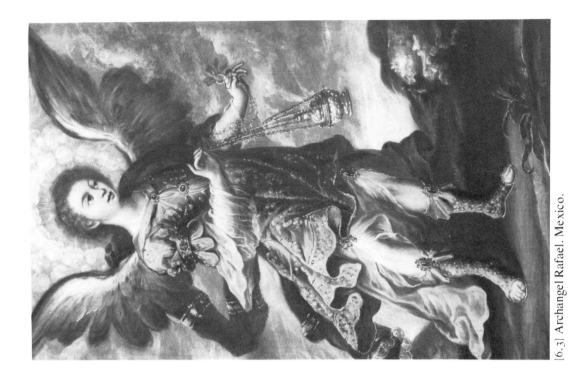

[6.1] Detail of sanctuary. San Martín. Potosí, Bolivia.

[6.3] Archangel Rafael. Mexico.

[6.2] Archangels Rafael, Michael and Gabriel. New Mexico.

[6.5] Archangel Musketeer. Calamarca, Bolivia.

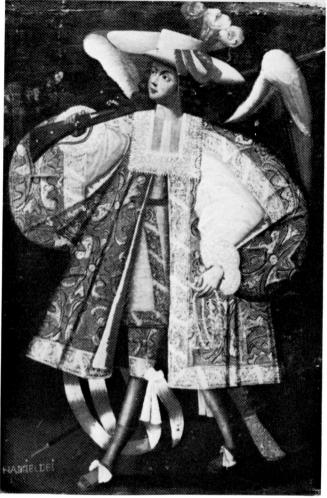

[6.4] Archangel Trumpeter. La Paz, Bolivia.

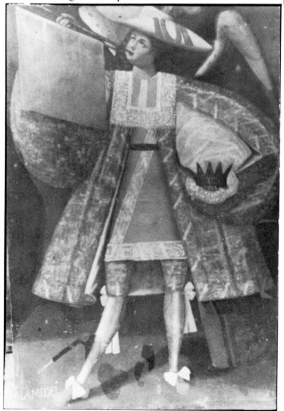

[6.6] Archangel Musketeer. Zepita, Peru.

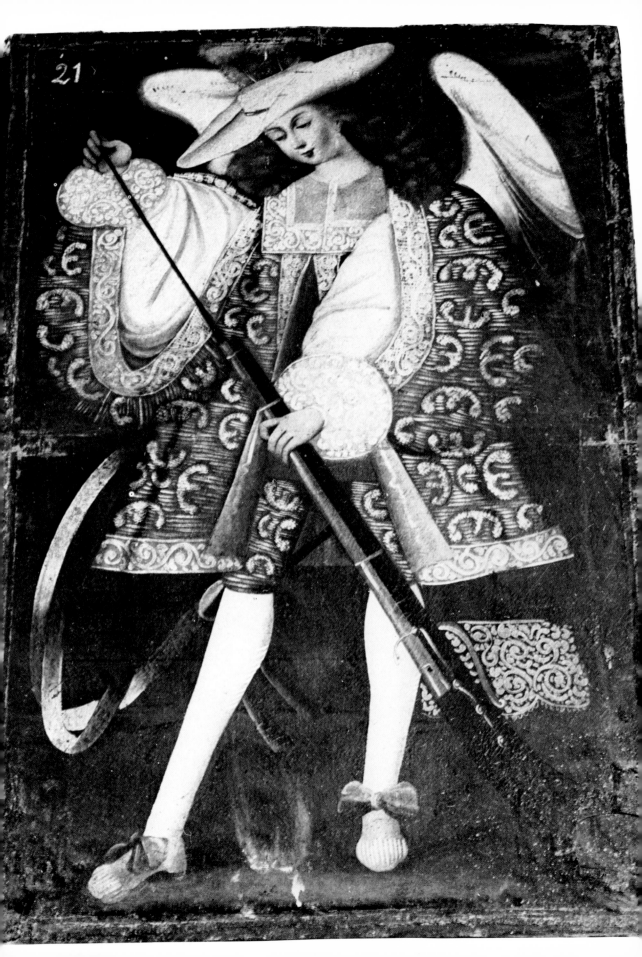

[6.7] Loading the musket. Engraving, after de Gheyn.

[6.8] Seventeenth-century French Palace Guard. Engravin

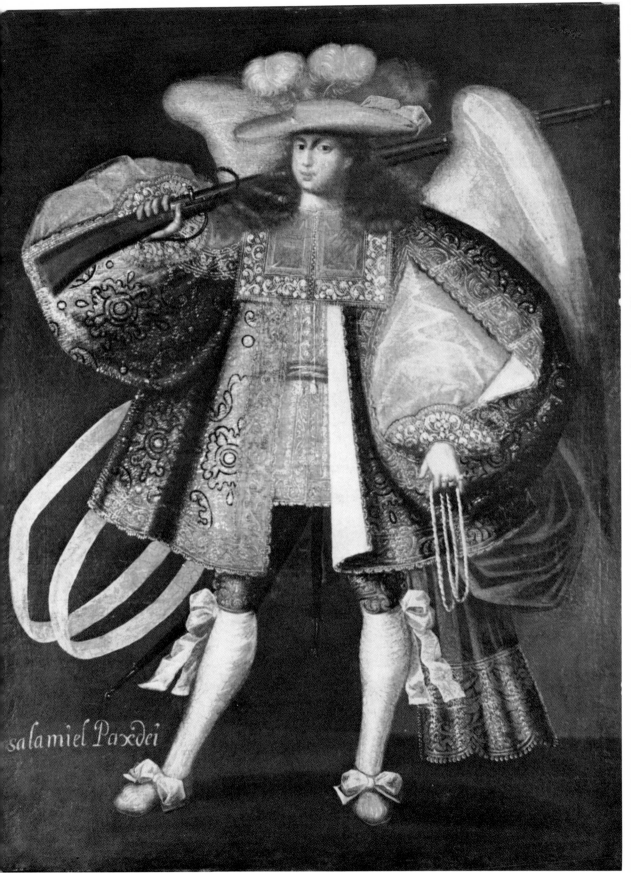

[6.9] *"how he should carry the weapon."*

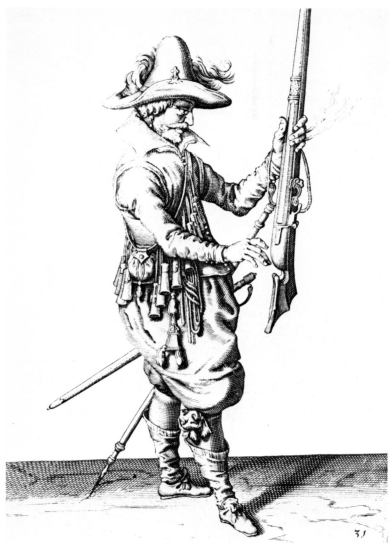

[6.10] Present arms. Engraving, after de Gheyn.

[6.11] Delft tile of musketeer.

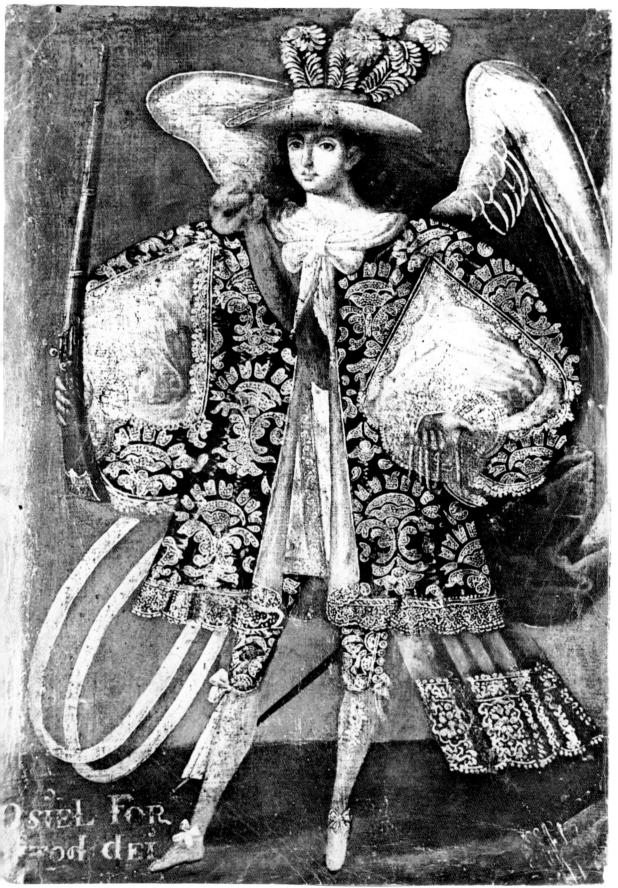

[6.12] *"how he should hold the piece in balance."*

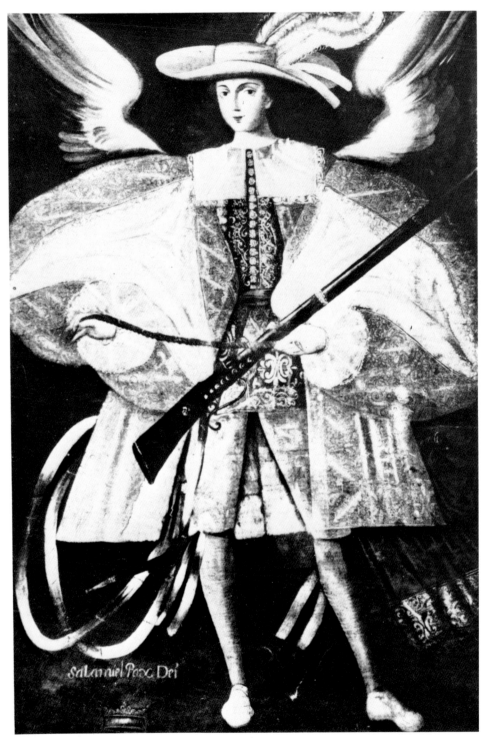

[6.13] *"how to take the match in the left hand."*

[6.14] *"how he shall open the pan lid."*

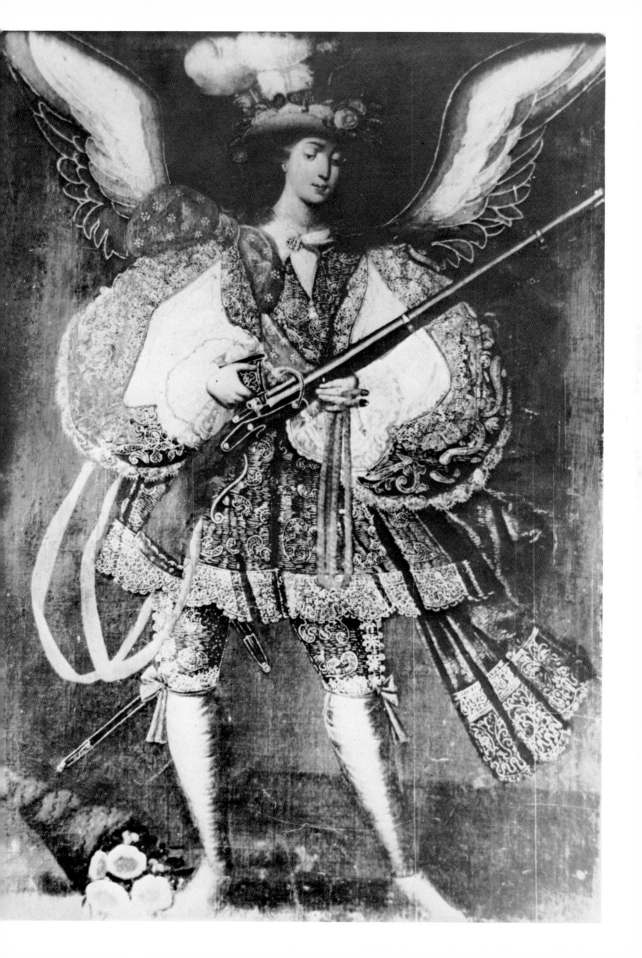

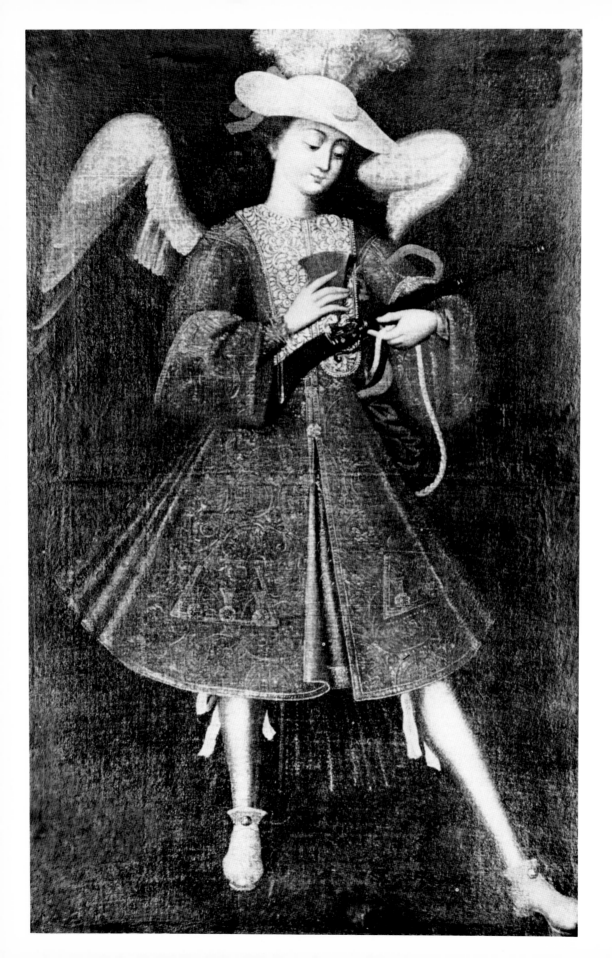

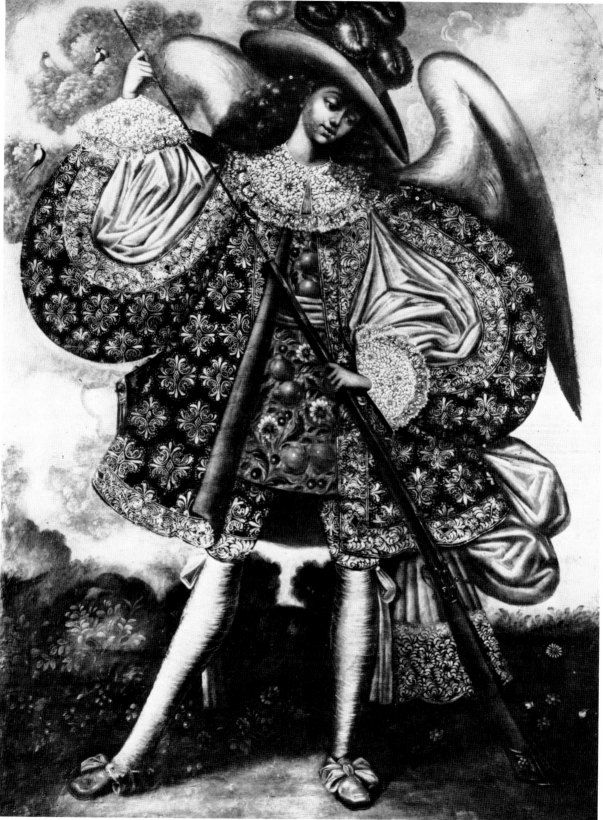

[6.16] *"how he shall draw out the scouring stick."*

[6.15] *"how he shall put in the powder."*

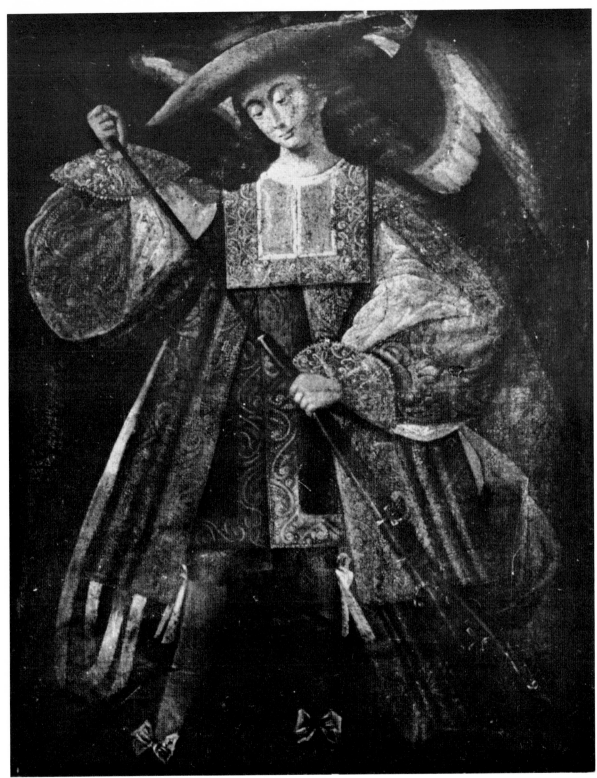

[6.17] ''*how he shall ram in the bullet.*''

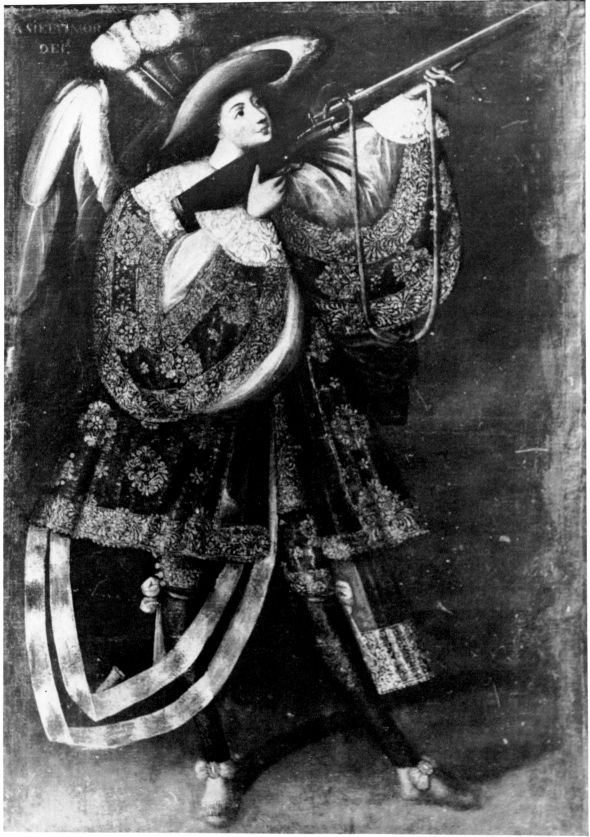

[6.18] "*how he shall aim the piece.*"

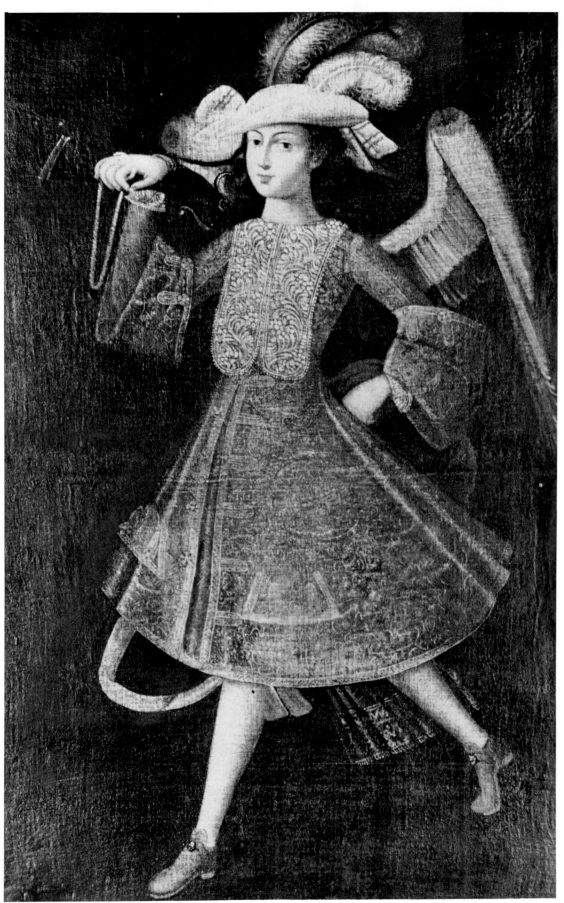

[6.19] *"how he shall march away."*

7

Alien Pennants on the North Pacific

Even if Cortés had not built the capital of New Spain on the ruins of Tenochtitlán, he would deserve a unique place in history for initiating the exploration of the Pacific coast. Not only did he lead expeditions into Honduras and Nicaragua and send supplies and gifts to Pizarro in Peru, but also he had ships constructed at Tehuantepec and Acapulco to sail the coasts of Nayarit, Sinaloa and Sonora in Mexico's northwest. For lack of capable local pilots, he even sent to Spain for some to fill the need. Some of his vessels followed the wilderness shores of Baja California out into the open Pacific. By 1539, it was clear that Lower California was a peninsula, not an island as had been surmised, a fact that several subsequent voyages confirmed. Father Eusebio Kino's map (1701-2) was a ratification of this fact. Cortés himself sailed along this coast–indeed the Gulf of California is still sometimes called the Sea of Cortés.

The administration of Spain's vast holdings in the New World was organized with amazing speed, the purpose being to facilitate the passage to Spain of gold and silver from American mines and the other treasures of the

New World. The fleet sailed from Spain once a year, ladened with goods for the colonial trade. It usually separated in the Antilles, one section proceeding to Veracruz, the other to Cartagena, in the *tierra firme* (now Colombia) and eventually to Portobelo, Panama.

Cartagena, "Pearl of the Indies," gateway to New Granada and South America, was one of the richest and best fortified of the colonial ports. On arrival there, the commander of the *flota* sent a messenger ahead to Por-' tobelo with dispatches for Panama and Lima, which were forwarded across the Isthmus and by boat down the Pacific coast. Other messengers started overland to Bogotá, Lima and intermediate stations. To Cartagena, for shipment to Spain, came the gold, the emeralds and opals of the Colombian highlands, the pearls and tropical products of the lush Venezuelan shores. In Callao, harbor of Lima, the king's revenues had been accumulating from the great silver mines of Potosí and the Peruvian highlands, traveling more than 1,300 miles by muleback and ship. With this hoard, Peru's Silver Fleet moved northward on the Pacific, eventually to be joined by a vessel with treasure from the Kingdom of Quito, Ecuador. Within three weeks, they lay off Panama and began transferring their cargoes to muleback for the hazardous crossing of the Isthmus, through tropical forest and swampland, back to Cartagena, in the deadliest of climates.

Large fairs were held in every port on the occasion of the fleet's call. The one at Portobelo, as described by Thomas Gage in 1637, lasted for fifteen days. Eight armed galleons and ten merchant vessels put in at this port. The little town, stewing in tropical miasma, sprang to sudden life. Prices rose twentyfold, and lodging and food were at a premium as merchants and traders descended upon the place. Besides precious metals, a variety of colonial products from the different regions awaited shipment to Europe. Indigo, cocoa, tobacco, and cinchona bark for quinine could be had from Ecuador, cochineal and tortoise shell from Middle America, vicuña cloth from the Andes, dried meat, cordage and leather from Chile, precious gums and many kinds of rare woods as well as timber. Transactions were made not in coin but in silver bullion weighed out in bars, which lay piled in the marketplace without danger of theft. But many who had come to make their fortunes never returned home, for sickness overtook them and epidemics broke out. For the return voyage, the ships reassembled at Havana to clear for Spain.

Already in the mid-sixteenth century, the treasure-laden flotilla was harassed by privateers, mainly English, Dutch and French, and had to travel in armed convoy. It was a much-coveted prize also of freebooters–

read, "pirates"–whose ruses and daring increased with the value of the shipments. Like the harbor fortifications in the colony, the armed convoys rarely came up to requirement, and precious cargo sometimes landed at a port other than that for which it was destined. Devastating tropical hurricanes also took their toll. Undoubtedly millions in bullion and jewels lie scattered beneath the seaways between the New World and Europe, intriguing the imagination and the ingenuity of modern divers. Nevertheless, despite danger and loss, the Spanish fleet sailed to Cartagena until 1748 and to Veracruz until 1778, at which time privileged trading companies took over the business.

With the occupation of the Philippine Islands, Spain's wealth was redoubled, and for a time she enjoyed a virtual monopoly of the Pacific seaways. But when, at the end of December 1578, Francis Drake, English gentleman privateer and privateering gentleman, dared the Straits of Magellan and appeared on what was called the Great Southern Sea, the Spanish illusion of an inviolate Pacific shattered. One among his many historical exploits gives an idea of how completely unaware Spain was of the need to protect her cargoes in the Pacific. On putting into a friendly bay of northern Chile to take on water, Drake's men found a group of llamas laden with a cargo of silver bars and guarded by a single Indian muleteer who was sleeping in the pleasant shadow of a large tree. The English soon had the silver loaded onto their ship, without even waking the driver.

The name Drake struck panic throughout the coastal cities, as he and his contemporaries wrought havoc on the Spanish treasury. They preyed not only on the silver pouring in from the mines of Peru and Mexico, but also on the Manila galleons which plied the Pacific between the Philippines and the harbor of Acapulco with cargoes of silk, chinaware and spices. In 1587, Thomas Cavendish came upon a great Spanish ship, unwarned and unarmed, off the lower coast of California, with a cargo of some 122 thousand pesos in gold, oriental pearls, silks, satin, damasks, musk and conserves of exotic fruits. He transferred the booty to his own vessel and put crew and passengers ashore, providing them with food and weapons to defend themselves against hostile Indians. Then he ordered the galleon to be set afire. However, through skillful handling, the victims saved the hull and repaired it well enough to be able to limp into Acapulco some two months later.

In the following century, more and more buccaneers infested the Pacific. In 1709, Woodes Rogers captured and exacted considerable ransom from the city of Guayaquil, Ecuador–far from the zone where Spanish warships were cruising. A coastwise ship also fell into his hands, with thirty tons of

religious objects–five hundred bales of papal bulls, images in wood and stone, holy medals, rosaries and crosses; there were fragments of bones labeled with the names of saints, destined for reliquaries, to serve the tradition that every new church should be founded upon such a sacred relic.

In 1740, Admiral George Anson of the British Navy was able to waylay the famous galleon *Covandonga*, carrying around 1,400,000 pesos in coined silver, together with silver bullion to the value of some 36,000 ounces. And during the Seven Years War, a fleet under Admiral Samuel Cornish captured Manila and took over the *Santisima Trinidad* entire, loaded with Asian treasures. She was sailed into Plymouth with a British crew to the jubilation of all. The vessel of around 2,000 tons was perhaps the largest that the population of London had ever seen, with a gun deck nearly 170 feet long and a poop that rose over thirty feet.

By the mid-eighteenth century, the burgeoning mining activities in northwest Mexico sharpened the need for better and safer communications. Not only merchandise, coming and going from the Philippines to Acapulco, but also the rich mining stations north of Guadalajara demanded protection from the raids of audacious pirates. In Sinaloa and Sonora, the mines were becoming profitable, and some, like Rosario, were within reach of a cannon shot from offshore. The missionary work which was expanding inland into Arizona and into both Californias along the coast had to be furnished regularly with escort, comestibles and protecting garrisons. Foreign ships came and went, all too often unmolested. Spain's losses in treasure and carriers had grown to tremendous proportions.

The administration of the Indies, sitting in Madrid some 6,000 miles from the problem that constituted an ever-bleeding wound in its economy, finally had to face the need for another harbor and naval facility, where ships could be built and repaired on the western shore. It was not until 1768 that a site called San Blas was selected for the new royal seaport. It lies about 800 miles from Acapulco, as measured along the winding northern shore of Pacific Mexico. There was an inlet at San Blas which, although surrounded by insect-infested marshes, was advantageous for the construction of a naval base and shipyard. It was guarded by a bluff 150 feet high, ideal for a fortress, as three sides were precipitous and the fourth was steeply sloping. In the rainy season it was surrounded by water and marshy ground. Fortunately, fresh drinking water was abundant. The seasonal fluctuations created great pans of salt from the evaporation of sea water. This proved a lucrative item of trade, as salt was of major importance in the extraction of silver from the ore.

It was some years, however, before solid well-kept buildings went up to

accommodate the naval officers from Spain who took charge of military affairs. The location was indeed a great aid to Spanish warships that by now had to patrol not only the Bay of California but also the Pacific waters of both Baja and Alta California. The arsenal was spacious enough to assure the steady production of new vessels. Plentiful wood was at hand, and in the mountains were forests where the necessary tar and pitch could be obtained. The site was approached by a broad well-kept road strengthened with large stones and supported by powerful *zapote* wood beams in places where, like causeway passages, the tropical rains had produced stagnant water. Here came the best shipbuilders to construct brigantines and galleons. Documents tell that some master builders obliged themselves to work only for a set time, after which they could not be persuaded to stay on in the humid disease-infested climate. The houses of the paymasters and harbor officials, the arsenal and annexes, and the massive stone church were among the most impressive of the region. But those whose position allowed it, moved to Tepic, some thirty miles upland, on a lovely plateau at the healthy altitude of 3,000 feet.

The fortress, erected on the overhanging cliff, had to withstand not only the bombardment of corsairs but also the onslaught of recurring savage tropical storms that inundated the region. The cannons, now set on masonry bases, reflect the bloody reality of life there in the eighteenth century [7.2]. The wild banana plants and the giant trees in the background are the only living things on this hill now, reminders of the amazing variety of virgin timber that was once available, not only for the needs of the port but also for use in the surrounding mining regions.

Even in ruins, the large church shows the same solid workmanship as the fortress [7.1]. The choir window is flanked by carved medallions of saints, resting on columnettes. The belfry also had a framing of pilasters. Craftsmen, gathered here to make cannonballs, cast the bells in situ. Though roofless, an impressive nave can be imagined from the arching ribs of a vaulted ceiling and the carved medallion decorating the choir support that are just visible inside. The portal is a dignified wreck, but the assured lines of arch and pilasters are examples of what skill and taste went into the structure [7.3]. Here once stood a church strong and elegant in its simplicity. The finely chiseled Roman lettering above the door, *Deus fortis inmortalis* . . . , is especially appropriate on this forsaken hill–"God, my immortal strength." This was a transit station for the Jesuits when they were expelled in 1767. From here, a year later, the Franciscan padre pioneer Junipero Serra sailed to found the missions of California.

By 1773, both military and commercial benefits had begun to make

themselves felt. For at least 35 years, the port of San Blas functioned as a royal arsenal with incomparable success, acknowledged not only in Mexico but also in the councils of Madrid. It was shipyard and supply base for new garrisons as far as California, and in its heyday counted 30,000 inhabitants.

With prosperity, the coastal route northward also developed. It was decided that Mazatlán's crescent-shaped bay offered the best facilities for another port. It lay about two hundred miles northwest of San Blas, just opposite San Lucas, the southernmost point of Lower California. The prevailing winds were auspicious for traffic on the Bay and to the peninsula, where missionaries labored at their unrelenting work. Oceangoing ships that were short of supplies or in need of repair and of rest for their crews could put into one or the other of these harbors before moving out again into the unpredictable open Pacific.

Mazatlán in Nahuatl means "place of the deer," indicating that the hunting there was good, a most useful fact from the point of view of fresh food. The town's coat of arms shows not only an anchor and the two islands that are prominent in the harbor, but also a deer's head with a Nahuatl "speech bubble" issuing from its mouth. According to local historians, the harbor has functioned since 1603. There was a small fortress here also with eight cannon conveniently placed on a height above the town, from which the troops could observe the entrance to the harbor. With its crescent-shaped bay, rimmed with the black sand characteristic of Pacific shores, Mazatlán became one of the best ports of the viceroyalty, connected with warehouses for military material. Far from the capital, these towns suffered not only from storms, flooding and disease but also from the uncertainty and irregularity of supplies. In the maintenance of a garrison and a growing population, Mazatlán's greatest problem was fresh water–for it was not until 1886 that potable water was brought down from the mountains in some thirteen miles of pipeline. The inhabitants, like those in San Blas, soon found that life in the nearby highlands was more salubrious, and the more affluent moved when possible to San Sebastián (now Concordia) from Mazatlán.

By this time the struggle over the sovereignty of the Pacific was in the open. England, France and Russia were striving against the Spanish monopoly. Basing herself on the pope's grant of 1492 which divided the newly discovered subcontinent between Spain and Portugal, Spain laid claim to all the vast northern territories along the Pacific coast, and eventually explored as far north as the Alaskan mainland in an effort to gain a firm hold on the new lands. There was hope also of finding a west-east passage by way of Hudson Bay, which the English under Sir Martin Frobisher had

attempted from the other side. Missionaries, settlers and accompanying soldiery had already advanced into Upper California. A *presidio* or garrison was established at Monterey in 1770; San Francisco was founded in 1776. But because of frequent fog and dangerous currents in San Francisco's magnificent bay, Monterey was chosen as the major port in that region.

The Mexican viceroy, Antonio Bucareli, himself planned and directed the first expedition from San Blas to exploit the farther northwest coast. Ensign Juan Pérez, assigned as the leader, set sail in the spring of 1774 (three years before Captain Cook's expedition), with a mandate to stop only at Monterey (California) to deliver supplies and comestibles and to take on provisions for a year's voyage. There was to be adequate stores of water, food and medicine, as well as ammunition and small arms. To make friends with the Indians, he carried 468 bundles of beads and bright cloth. His precise instructions even covered the way to deal with foreign vessels that might be encountered and with skirmishes on land. By mid-July, Pérez made a landfall on what today is known as Queen Charlotte Island (British Columbia). He scouted the passage, now called Dixon's Strait, between the island and an archipelago. The Indians were all friendly and glad to engage in barter. In early August, Pérez and his company came upon an excellent berth which they called the Bay of San Lorenzo de Nootka. It was known that Russian fur traders gathered there in certain seasons, but as Pérez's task called only for reconnoitering, he made no effort to come into contact with them.

The following year another expedition set sail for the Northwest under the command of Bruno de Hezeta and Juan Francisco de Bodega y Quadra. Their reception at Nootka was friendly, but bad weather and much illness forced the commander to return to base. In the fall of 1789, the best-equipped fleet was readied, although owing to a critical shortage of vessels at San Blas, it consisted of only three ships. They carried cannons, transported from Acapulco, a chaplain and missionary friars as well as soldiery and the crew. They anchored at Nootka in April. The natives helped bring the supplies ashore. The eight new cannon were put into position "formidable to behold." Spanish officers, soldiers, chaplains and crew assembled on the beach to take possession of the harbor in the name of the Spanish Crown.

Visualize the solemn ceremony in a savage country, witnessed by Indians who had never seen anything like it. The royal standard was raised to the accompaniment of artillery salutes. A friar sang the Mass, and many Spaniards knelt to receive Holy Communion. Father Palóu gave a sermon,

exhorting the Spaniards to give thanks to God for their safe arrival and to continue the voyage with courage until their final goal was reached. According to the record: "In commemoration of the great Mystery which the Church celebrated on that day," the port was named La Santisima Trinidad.* Trees were felled with the help of the natives. Eight houses for living quarters, a number of storerooms, a small hospital and even a shelter for the Indian laborers were erected.

Soon after Bodega was established at Nootka, the English navigator George Vancouver reached the settlement, having circumnavigated the island that bears his name today. He had sailed with Captain Cook on two earlier voyages and was more or less familiar with these waters. In an engraving from his report which was published posthumously, the place is called "Friendly Cove, Nootka Sound." It shows a number of solidly roofed structures [7.4]. A small building stands at one end of a fenced-in plot, and a tall cross dominates the shore. Cross and chapel leave no doubt that missionary work started immediately after life began at the settlement–recalling to mind the enterprise and dispatch with which the Franciscans who accompanied Cortés had put down their roots.

What could have been a very unpleasant confrontation between Vancouver and Bodega was turned into a cordial meeting through the Spaniard's gentlemanly behavior and the patient negotiations of the experienced Englishman. The conversation must have required the help of an interpreter: it was not deemed necessary for an Englishman to speak passable Spanish–even though he may have had a few words or expressions–while the gentry of eighteenth-century Lima would not have thought of learning English. Upon the return voyage, with Bodega's letter of recommendation, Vancouver and his crew were received with all courtesy by the Spanish authorities at Monterey and allowed to rest there.

It is difficult to imagine more contrasting figures than the two explorers who met on that remote, much-disputed shore, though both were in their middle years and both died a few years later. The text on the Spaniard's portrait reads: "Juan Francisco de Bodega y Quadra, Capitán de Navio de la real Armada. 1743-1793." Born in Lima of Creole parents, Bodega held a high rank in the naval department of the harbor of San Blas, and during his active career, which dates from 1773 to 1793, he outdistanced contemporaries through his excellent qualities. With the exception of one Euro-

*Michael E. Thurman, *The Naval Department of San Blas*. (Arthur H. Clark) Glendale, 1967.

pean tour of service (1783-1789), he served the Royal Navy in American waters, and his name stands high among those who won fame in the short but eventful history of Spain's northwest ventures. Bodega's childhood in Lima coincides with the luxury which prevailed in higher circles there, and his prestige was augmented by his experiences in the Old World. His portrait [7.6] shows an elegant bearing and a sympathetic, open face, clean shaven and youthful. He wears a wig, as was the fashion, and the parade uniform of a naval officer, with gold braid, a lacy stock and ruffled cuffs. On his coat are religious medals and military orders, among them the Cross of Santiago. His tricornered hat has a jeweled cockade. Inkpot and feathered pen are on the table at his side, and his hand rests on a sheet of paper–the Nootka agreement?–to bear out his look of authority, while in the distant harbor awaits his brigantine.

Although the portraits illustrated here are copies and may even be posthumous, they bring out well the contrast in the two historical figures. Vancouver (1758?-1798), clean shaven also and with the obligatory wig, is shown wearing sturdy clothing of a modest color–no gold or decorations [7.5]. His bearing is straightforward, simple and dignified. Even the plain buttons contrast with those on the golden attire of the Spanish officer, whose empire was on the threshold of decline, while the world of the English navigator was in ascendancy. It was Vancouver who disproved any west-east passage between the Pacific and Hudson Bay. The writer was present when the trunks, which Vancouver brought back from his voyages in the 1790's, were being unpacked for the first time at the British Museum, after having been stored in Welsh mines during World War II.

By the Nootka Convention, Spain admitted the rights of other lands to fish and trade in the northern Pacific. France and Russia as well as England were already rivals in that region. For a few more years, Spain also enjoyed a lively trade in furs, and shipped seal, beaver, sea otter and other valuable pelts in comparative safety to Manila and even to Canton.

The situation in Europe was increasingly adverse to Spain's farther expansion. The occupation of Nootka was costly in material and personnel and had little value unless Spain could maintain her monopoly of the northern sea. The importance of San Blas waned as coastal shipping to Upper California gradually declined and that region became more and more independent in both economic and military affairs. There was a serious loss of key naval personnel, and the erosion of the Spanish viceroy's power began to show in the early nineteenth century, as the colony's struggle for independence was breeding.

The distance from San Blas, Mexico, to Nootka Island, Canada, is over 3,000 miles–as far as Cortés sailed to bring a subcontinent under Spanish rule. But while Cortés's feat was colossal in result, the Nootka venture remains a mere episode in history. The efforts of the valiant Spanish officer Bodega came to nought. At war with England once more, the authorities had to realize that their naval capacity was overextended. By 1800, they had relinquished to England their claim to Canadian territory. British, French and American ships, though technically forbidden to enter Californian harbors, were bringing in luxuries and industrial products which were unavailable from Mexico–and carrying home enthusiastic reports of the region. When the Napoleonic wars began to shake all Europe, Spain's hegemony over the Americas tottered to collapse.

As British Columbia developed under British administration, the collection of exotica became the hobby of many English travelers whether by land or sea. Today when totem poles are a rarity–and those in good condition bring high prices and go into museums and parks–we have to recall that in the last century such collections were easier to assemble, though little data was available. When I gathered material for my survey of pre-Columbian art, I considered including an example from the Pacific Northwest. However, at that time (1940) it was not possible to establish whether a sculpture was of pre-Columbian origin or not. Many years later on a lecture tour, we spent some time in Vancouver where I saw two pieces of sculpture in the Museum of the University of British Columbia. One showed no influence of Christian culture; the other was datable.

The stone statue of uncertain date is about 4½ inches high, and is striking not only for the economy of line, but also for evidence of the simple tools that were used to accomplish such a telling piece [7.7]. There is movement in the spiraling drapery and a feeling of belonging, child to mother and mother to child–a rhythmic, enfolding swing to the whole. The piece conforms to the language of the ultramodern sculptor, but it was carved without the intellectualization of art, in the small village of Bella Bella on Denny Island not far from Vancouver.

A different style is manifest in the wooden figure of an angel holding a baptismal font [7.8]. It is 34 inches high with a wing spread of 25 inches. The garments bear traces of blue-grey, black and white coloring. Face and hands were painted a light tan. The statue was carved in 1886 by one Freddie Alexis, an Indian, for the mission church at Fort Simpson, situated less than ten miles south of the Alaskan border and more than five hundred miles

north of the city of Vancouver, then well in the wilderness of Canada. G. H. Kaley, a Methodist minister, active in Fort Simpson between 1882 and 1914, was the first missionary to this wild area, and the carving was the first attempt of one of his Indian converts to depict a Christian subject. It must not have made a particularly appealing impression, for it was removed from the church after a short time "because it frightened the children."

The carving shows skill in the handling of wood. With its unelaborated lines, it has no relation to the friendly angelic figures from the wilderness missions of South America at the other end of the hemisphere. It has great dignity. The right hand is stiffly raised, not so much in a gesture of blessing as in admonition of the solemnity of the baptismal vow. The severity is emphasized in the out-of-proportion round head and the facial expression. The wide, thin-lipped mouth is forbidding in its muteness; the huge staring eyes, set far apart, are not focused but seem all-seeing. Small wonder that it was frightening to children–it has a strong sense of the supernatural. When the wings are taken away, the statue loses its relationship to Christianity and approaches pagan lore, forceful in its aloofness. In some details it recalls a figure on a totem pole.

The Russians were unwilling to relinquish the hold on valuable fishing and trapping grounds on the northwest coast of America that they had gained with persistence. Early in the nineteenth century they landed a party in Bodega Bay, less than a hundred miles north of San Francisco, and, in 1812, they erected a fortress there, naming it Rossiya (Russia). The purpose was the construction of a port from where they could furnish much-needed supplies to their establishment in Alaska. The site was well chosen, on a cliff above an ample sloping beach, with a stream forming a deep gully on the landward side behind the settlement. An engraving from 1828 shows the place viewed from the east [7.9]. A stockade of heavy timber fourteen feet high encloses the main part of the fort, like those of our own early military establishments. Of the two lookout towers, one faces the land, the other the sea, with portholes for cannon. A church catches the eye, with its tall spire and the rounded "onion" dome typical of Russian Orthodox buildings. Inside the enclosure were also the houses of the commandant and officers, the barracks, two warehouses, shops and a jail. Outside clustered the huts of the Aleut hunters whom the Russians had brought with them, the farm buildings and a cannery. A wharf was constructed on the shore below, a workshop for ship repair, a smithy, a bathhouse and storage sheds. The Russian colonists began a thriving trade with the San Francisco presidio,

exchanging their meat, hides and grain for tobacco, sugar and manufactured goods.

The burgeoning Russian settlement worried the Spanish governor of California so much that he urged the establishment of missions to the north to block Russian expansion. And in 1823 the mission Dolores, later called San Francisco Solano, was founded, with the erection of a cross made of three limbs, and an altar of woven willow twigs. Soon its chapel, a low tile-roofed structure of adobe, a house for the priest, a guardhouse and a granary were completed. From the beginning, the mission, which lay close to the Oregon border, throve from its vineyards, orchards and cattle–and soon a lively trade with the Russians developed there also.

By this time the Mexicans had made themselves independent of Spanish rule. Still worried by the Russian menace, the governor ordered a town to be established–the present Sonoma–and named the Mexican general Alfarez Mariano Vallejo, "commandant of the line of the north." He laid out the settlement as a quadrangle in Spanish colonial tradition. By 1839 it had been colonized with 25 Mexican families and a garrison of soldiers from San Francisco. The first Americans in the region were three sailors to whom Vallejo issued large land grants on conditon that they settle at the border of the Russian claims. Vallejo himself lived as a feudal baron with his own military, and having made a treaty with neighboring Indians, he enlisted some of them in his company.

The Russian colony actually brought about its own demise by practically exterminating the sea otter in that area. Unsuccessful as farmers, they tried shipbuilding but failed because of unskilled treatment of the wood. The new missions and colonists were pressing in upon them. In 1841, on order of the Czar, the Russians withdrew from Fort Ross to Alaska whence they had started.

The man into whose hands the Fort Ross property passed was the Swiss, Johann Augustus Sutter, founder of New Helvetia, now Sacramento, and notable in the Gold Rush. The price agreed upon for buildings, chapels, livestock and even a twenty-ton Russian schooner, was $30,000, of which Sutter paid $2,000 in cash and the rest in annual installments, chiefly of wheat. Madame Rotchev, the Russian commander's wife, begged Sutter not to let her garden house be destroyed: she had built it and had spent many happy hours in it amid her flowers. However, Sutter's men having taken it apart to move it, could not put it together again, because they could not fathom the different Russian manner of fitting the wood.

For a time after the Russians had been pushed out, there was not much interest on anyone's part to keep up the place. An engraving from 1843 shows the neglect [7.10]. The buildings have no roofs, the fences of the corral are collapsed. A windmill is visible at the left in this picture; apparently the sketch was made from the edge of the cliff. Today, Fort Ross is in the care of the National Park Service. The watchtower is impressive in its restored state [7.11]–a stalwart wooden structure, pleasing to the eye, with the czarist flag flying above it. A cannon stands at a porthole within the blockhouse; the tablelike construction beside it held the cannonballs and other ammunition [7.12]. The church can be seen in the background, its onion dome now covered with a protective roof. Details are clear in a closer view [7.13]. The children playing around the entrance and the bell on a scaffold at the left give an idea of the dimensions.

Russia's abandonment of Fort Ross coincided with Europe's post-Napoleonic difficulties and adjustment. In spite of Mexico's separation from Spanish rule and the pressure of United States borders expanding toward the Pacific, the harbor cities of the young Mexican republic, Guaymas and Mazatlán, remained of importance. With the growing shipping traffic in the Pacific and the end of Spain's monopoly of the Manila trade, ships of many nationalities plowed the long routes of the capricious ocean. Thus it was that in 1841 the crew of a helplessly drifting Japanese ship reached Mazatlán.

That, however, was not the first historically recorded landing of Japanese on the west coast of Mexico. In the mid-sixteenth century, Francis Xavier, among the first followers of Ignatius Loyola, had spread the Word in India and Japan. In 1585, inspired by the head of the Jesuit mission there, an embassy of five Japanese noblemen, who had learned to speak both Latin and Portuguese, journeyed to Europe via Acapulco with letters of introduction to Phillip II of Spain and to Pope Gregory XIII. They were given the splendid reception accorded those of royal blood and, allegedly, on returning home they were so changed in manner and dress that their own parents hardly recognized them. A number of Japanese works about their experiences were published in Japan shortly thereafter.

The list of contemporary books printed in Europe also reveals what impression these foreigners made there. An Acta Consistorii written in Italian came out in Rome the year of their arrival [7.14]. A Spanish report was printed in Seville in 1586 [7.15]; and a German, in 1587, "with consideration of such visit from the point of view of the Lutheran Church" [7.16]. In

1590, a volume in Latin was published in Macao, then a Portuguese colony in the estuary of Canton, China [7.17]. Other books appeared in French and Portuguese. All of these describe the appearance of the Japanese visitors, their dress, their religious beliefs, the organization of the army, even their foodstuffs, style of living and manner of writing. Seventy-eight volumes are known from before 1600, and still more are believed to exist.*

Little known but of greater importance to the history of the colony is the contact of Japan with Hispanic America, especially Mexico, in the first decades of the seventeenth century. One Rodrigo de Vivero, ex-governor of Luzon in the Philippines, had been shipwrecked off the Japanese coast in 1609. He was cordially received by the first shogun and was furnished with a ship to carry him to New Spain (Mexico). A number of Japanese merchants sailed with him for the purpose of investigating the prospects of trade with the New World. They landed at Acapulco and were presented to the viceroy in Mexico City, but after five months they returned with discouraging reports.

Early in 1614, another Japanese deputation, made up of distinguished political and diplomatic figures as well as merchants, attempted to establish relations with Mexico. They arrived in a Western-style ship that had been built in Japan and was manned by Japanese sailors. Seventy-eight were baptized in the Mexican capital. Although most of the group returned to Japan via Acapulco, six samurai journeyed to Spain from Veracruz. Again they were granted audiences with king and pope and made ceremonial visits elsewhere in Europe. On their way home they spent three years in Mexico before returning to Japan. But they, too, could report only meager results from the seven years of effort, because of the strict monopolistic trade regulations imposed by Spain on her colonies. Less than twenty years later, a widespread rebellion in Japan caused that country to be closed to all foreign contact, and it remained so until the arrival of the Perry Expedition in 1853. A Japanese who returned to his homeland after having lived abroad for any length of time was promptly beheaded so as to keep the land as free from outside influence as possible.

However, no laws could prevent vessels from being blown off course by monsoon or typhoon. Nineteenth-century literature contains numerous true stories of shipwrecked seamen and travelers. For our purpose, the

*Adriana Boscaro, *Sixteenth Century Printed World on the First Japanese Mission to Europe*. Leiden, 1973.

174

experiences of the castaway Japanese sailor, Hatsutaro, is relevant.* In 1841, he and twelve others of the crew of a coastwise vessel were blown off course and drifted helplessly in the Pacific for four months. They were picked up by a Spanish ship and taken to Baja California, eventually to Mazatlán. All thirteen men survived. Three years later, Hatsutaro and a companion made their way back to Japan. Hatsutaro's account of the shipwreck and the rescue was published in a book in Japan, with a unique and perceptive report of life on the Mexican west coast. Illustrations were provided by a painter friend. To be as factual as possible, the artist worked for more than ten days molding rice paste into topographical features of a miniature landscape that corresponded with Hatsutaro's detailed descriptions. He fashioned tiny wooden models of ships with sails of cut paper and rigging of thin cord. Then he made sketches from the model, revising them as the seaman pointed out discrepancies. The resulting work illustrates how one Asian interpreted the Mexican harbor [7.18].

The same book contains also a picture of the port at Canton, China, where Hatsutaro rested on his journey home. It is done in the tradition of Japanese woodcuts and at first sight the two harbors appear much alike. However, on closer inspection the main physical features of Mazatlán are clear to those who know the place. The islands are well indicated: note the batteries of cannon placed at several strategic points. No doubt the Asian painter could work only in the traditions of his land. The picture–indeed the whole book–reveals many misconceptions which an Asian would have, when faced with the problem of depicting life in the Western Hemisphere. Mazatlán, with its crescent-shaped bay, is illustrated in a more or less contemporary American print [7.19]–but we see two different landscapes.

In this chapter, which chiefly concerns adventure, we have come across three art works from widely separated regions. Each of the three examples speaks a different language. The stone carving of mother and child is timeless. In the wooden angel from near the Alaskan border where Christianity came late, the carver's atavism comes through the thin veil of the new religion. In the painting, an American subject, although approximated from a carefully constructed small-scale model, is at once recognizable as Japanese. The craftsmen and artists of the Indies also, with roots in ancestral pagan centuries, may have absorbed influences from the Old World, but the end product is full of invention and fascinating originality.

Kaigai Ibun, translated by Richard Zumwiukle. Los Angeles, 1970.

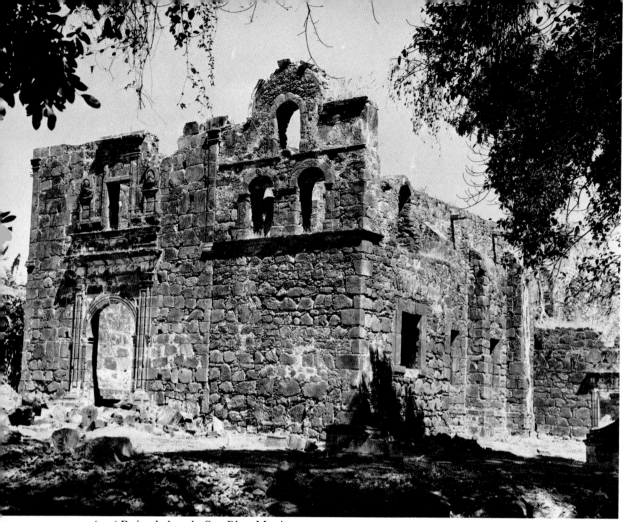

[7.1] Ruined church. San Blas, Mexico.

[7.2] Fortress.

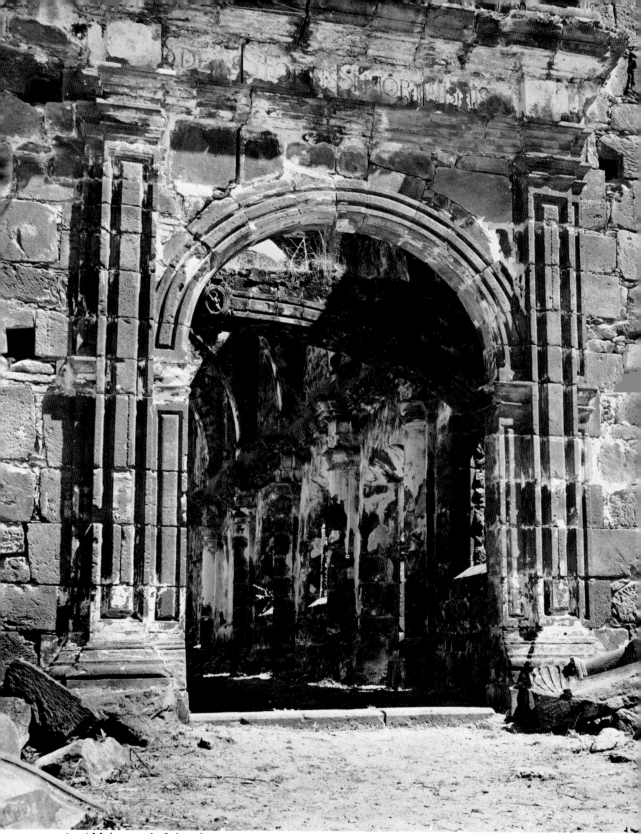

[7.3] Main portal of church.

[7.4] Friendly Cove, Nootka Sound,
British Columbia. Engraving.

D. J. F.ᶜᵒ DE LA BODEGA Y QUADRA
Capitan de Navio de la R.Armada
1745-1793

[7.6] Captain de la Bodega y Quadra.

[7.5] George Vancouver.

[7.7] Mother and Child. Stone. Bella Bella, British Columbia.

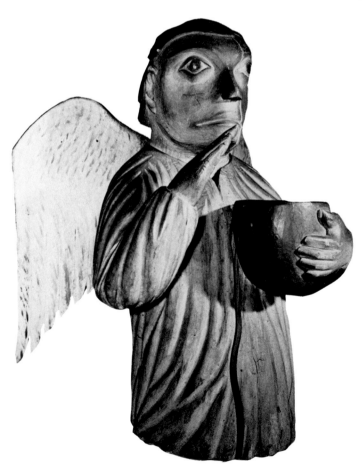

[7.8] Baptismal font. Wood. Fort Simpson, British Columbia.

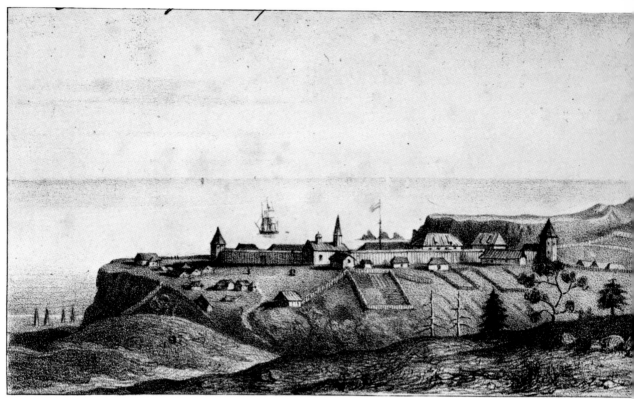

[7.9] As a Russian outpost in 1828. Engraving.

FORT ROSS, CALIFORNIA.

[7.10] In 1843. Engraving.

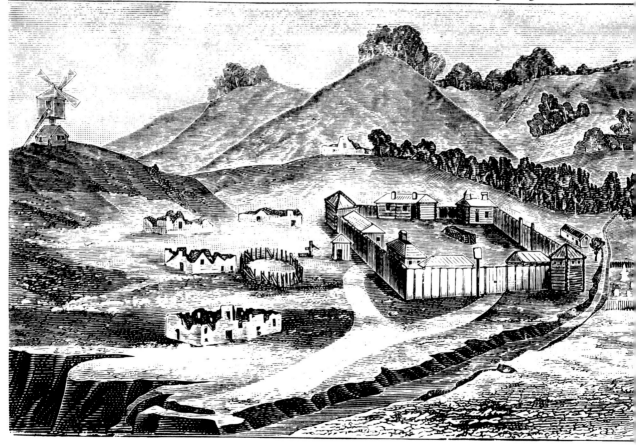

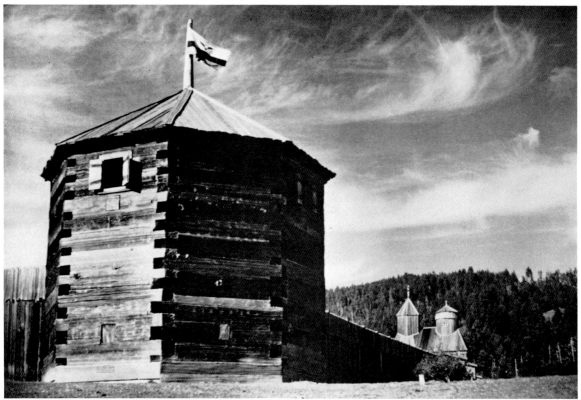

[7.11] Restored.

[7.12] Blockhouse interior.

[7.13] Russian chapel at Fort Ross.

BREVE RILATIONE
DEL CONSISTORO
PVBLICO,
Dato a gli Ambaſciadori Giaponeſi
dalla Santita di Papa Gregorio.
xiij. in Roma, il di 23.
di Marzo 1585.

CON LICENZA DE SVPERIORI.
IN ROMA,
Appreſſo Franceſco Zannetti, alla Sapienza.
M. D. LXXXV.

[7.14] In Italian.

BREVE RELACION DEL
recibimiento que en toda ytalia, y Eſpaña
ſue hecho a tres embaxadores de los Rey
nos de Bungo, y Arima, y Omura, de Iapõ
de nueuo conuertidos a la fee Catolica q̃
fuerõ embiados a dar la deuida obediencia
al ſummo pontifice y ſe la dieron
como conuenia.

¶Impreſſo en Seuilla por Fernando Maldorado

[7.15] In Spanish.

Warhaffte
vnerhörte Zeitung einer Bott,
ſchafft ſo etliche König vnd Fürſten auß Ja
ponia/ deß Catholiſchen Römiſchen
Apoſtoliſchen Glaubens halben/
vnlangſt gen Rom ge,
ſchickt haben.

Mit kurßer Beſchreibung der,
ſelben Lande vnd Inſeln.

Sampt eines Lutheriſchen Vr,
theil vnd Bedencken/ was von ſolcher
ſchickung zu halten ſey.

Darauß augenſcheinlich abzu,
nemen/ das der allein ſeligmachende Catho
liſche Apoſtoliſche Glaub/ den Heyden durch
die Lehrer der Römiſchen Kirchen verkün,
digt/ vnd den alten Chriſten durch
die Keßeriſche Predicanten
abgenommen wirdt.

Alles auffs new mit fleiß gebeſ,
ſert vnd gemehret/in dieſen gefährlichen leßten
zeiten/zur warnung gar nußbarlich/ auch
kurßweilich vnd nötig zu leſen.

Regnum Dei auferetur à vobis, & dabitur
genti facienti fructum.

Gedruckt im Jar. 1587.

[7.16] In German.

DEMISSIONE
LEGATORVM IAPONEN
ſium ad Romanam curiam, rebuſq; in
Europa, ac toto itinere animaduerſis
DIALOGVS
EX EPHEMERIDE IPSORVM LEGATORVM COL-
LECTVS, & IN SERMONEM LATINVM VERSVS
ab Eduardo de Sande Sacerdote Societatis
IESV.

In Macaenſi portu Sinici regni in domo
Societatis IESV cum facultate
Ordinarij, & Superiorum.
Anno 1590.

Scripſit Valignanus. Vere Eduardus de Sande, comitae ex locis
Valignani ipſius et P.N. Generali aeſtimatione. GB.

[7.17] In Latin.

TEXTS ON THE VISIT OF JAPANESE AMBASSADORS.

[7.18] Japanese print.

[7.19] From a railroad album.

MAZATLAN HARBOR, MEXICO.

Folk Textiles

At his first meeting with Hernan Cortés, the great Moctezuma descended from a litter carried by four caciques, in which he sat beneath the marvelously rich canopy of green-colored feathers, with much gold and silver embroidery and with pearls and jades suspended from the borders. He was magnificently attired, and the soles of his sandals were platforms of gold and the upper parts adorned with precious stones. Fine colored cloths were spread on the ground before him so that his feet should not tread on the earth. The Inca Atahualpa and the other unfortunate chieftains likewise arrived to greet the Spaniards in richly decorated palanquins, dressed in colorful garments.

We have ample proof that the dazzled Europeans did not exaggerate. At least from one area of America, textiles from the time before Columbus are on hand to speak for themselves. The bodies of important personages lie mummified in the exceptionally dry sandy soil of coastal Peru, wrapped in gorgeous apparel. They come to light in our present century in a miraculous state of preservation and reveal a variety of weaving techniques that astonish the onlooker.

In Mexico and Central America, the damp, often tropical climate is not so favorable for the excavator. But there, stone stelae, painted and sculptured pottery record in wide variety the lavish accoutrements of the pre-Columbian people. Murals that cover the interior of entire buildings have been found in the Maya area, depicting chiefs, splendidly attired, each with marked individuality. According to the Codex Mendocina and the tribute roles of Moctezuma, subjugated nations paid the Aztec empire an annual tribute of over a million pieces of cloth. The picture-writing of these early documents shows specific patterns from the separate regions, some motifs of which still survive.

Archeology has found hints of the weaver's high art also in the south-western United States (New Mexico, Colorado, Arizona)–fragments of pre-Columbian fabrics, subtle in design and technique, and blankets fashioned of turkey feathers or strips of rabbit skin.

The main raw material of pre-Columbian textiles was fine native cotton. In Peru, the silky wool of the llama, guanaco, alpaca and vicuña was also employed. The feathers of brilliant tropical birds were skillfully applied to the cloth, and the skins of jaguars and other wild animals were put to decorative use.

At the time of the Conquest Europe was just beginning to revel in trade with the Orient. The costume of the wealthy European blossomed with silks from China and printed cottons from India. Paintings of the period show these together with colorful rugs from the Near East.

In the New World, the Spaniard soon realized that the Indian, and later the mestizo, had considerable artistic capability. From the world of imagination, heritage of the pagan past, and from models imported from Spain, a cultural mixture developed that marked many facets of daily life as well as of the arts and crafts. New materials were introduced, such as sheep's wool and silk. Linen was scarce, as it could not be grown satisfactorily in the colony and had to be imported. The introduction of the treadle loom made possible the production of larger-size fabrics than were made before. In many instances, workhouses for weaving–*obrajes*–were constructed where the craftsmen led the life of prisoners.

Although the Spaniard in general cared little to record the work of the humble, Baltasar Martínez, bishop of Trujillo, Peru, in the last third of the eighteenth century, fortunately left six volumes about the life of his diocese for posterity. Some of the illustrations show steps in the manufacture of textiles. In one, the warp is being prepared [8.1]. Various colors seem to be

188

indicated by shading on the spools. In the next figure, an Indian works a rustic treadle loom [8.2]. Another illustration [8.3] shows a tapestry with angular pattern for which a lacy fringe is being fashioned with bobbins. And in the fourth, a group of barefoot mestizo women, seated on long benches, are embroidering a long cloth with flowers. Doubtless the model showed a uniform pattern, but the fact that six people worked on one piece would lend individual touches to the whole [8.4].

As the manner of dress was prescribed according to social rank, the hidalgo, the medico, the lawyer, the university student, even the merchant could be recognized by what he wore. The mestizo living in the towns and cities also wore European-type clothing, but there were regulations as to how far he could go with cut and color. The Indian was at the bottom of the social scale, and his garb remained unchanged for a long time. Thus much of the weaving for his personal use went on in the villages by traditional methods.

The weaver had a broad repertory from which to draw. Models set before him comprised not only fabrics from Europe and the Far East but also patterns out of books. In the process of "copying," however, a transformation took place. The weaver's inspiration was fed also on tradition formed in his village. A new style came into being, and a strongly American flavor gave the pieces originality. The tapestries from Peru, with their Chinese motifs, have a touch of fairy-tale atmosphere. Armorial hangings present Spanish heraldry in naively garbled interpretation. Favorite local motifs appear in an otherwise imported scheme. The folklore products of the nineteenth and twentieth centuries can best be understood with reference to these earlier periods.

As might be expected, weaving both in colonial and contemporary times reached its highest level in just those areas where it flourished in the pre-Columbian epoch–that is, in the American Southwest and the Mexican, Maya, and Andean areas. Certain characteristics of the pre-Columbian craft survive into the present; other favorite motifs of folk art are obviously imported, and some derive from present-day experience. Human, animal and bird forms appear in stylized versions in the textiles of a number of pre-Columbian cultures. The horse, which the Spaniards brought with them into the New World, was soon adopted as a subject. The double-headed eagle of the Habsburgs also entered the New World with the Conquest–an awe-inspiring symbol with its two crowned heads and menacing, outstretched claws. Small wonder that this decorative and technically inviting

189

motif entered the fantasy of the native weaver and remains a favorite. On the other hand, the cross occurred in pre-Conquest times, and, again, it is used more as a convenient textile motif than as a religious symbol.

It is not the intention here to present typical examples from the various regions of Spanish America–a work which has already occupied many volumes–but rather to show interesting and often unusual pieces, some from this writer's collection which was given to the Textile Museum of Washington some years ago in memory of its founders, Louise Chase and George Hewitt Myers.

The native population of the American Southwest comprises older, sedentary peoples, such as the Hopi and other Pueblo tribes, and a relatively new nation, the Navajo, who are still nomads and who have learned much from the older tribes and from the white man, without losing their individuality.

The Hopi women's ceremonial dress is of fine white cotton [8.5]. The embroidered design, subtly distributed in black with touches of red and green, can be found on painted pottery as well. Thin lines of the basic fabric lighten the weight of the colored border. Especially effective are the inverted triangles on the lower edge, tying the embroidered section into the white area which is planned as part of the composition. Tassels are white at the top, orange and brown at the lower edge. It is interesting to note that practically all design elements in modern Hopi weaving are pre-Columbian.

The Navajo count their wealth in sheep and horses, imports of the Spaniards. They apparently learned to weave from the Pueblo people. From them also, the Navajo learned sand painting which they brought to a high flourish, and from the Mexicans, silver work employing the Spanish colonial peso. Though using the stripes, zigzag, step designs and other nonfigural motifs of their neighbors, Navajo weaving shows more variety in pattern and a lively interest in color. Certain types of work made up trade goods to the Spanish colonies farther south. Sheep's wool is the Navajo's raw material, and the upright loom is used; it can be folded up and carried along conveniently in their nomadic life.

In Figure 8.7 the loom is set up at the foot of the great red cliffs of Canyon de Chelly. Sheep graze nearby; from the natural wool of different breeds, the weaver derives her various tones of black, gray, brown and white. Present-day colors are taken also from commercial dyes–and sometimes cloth is unraveled and respun by hand to obtain a finer quality for their work. The loom is lowered as the weaver proceeds with her tapestry. In front of

the loom, one girl can be seen carding the wool. Another is spinning thread. An old woman at the right wears a finished blanket with a serrated pattern.

A saddle blanket some 30 x 30 inches, dating from the last third of the nineteenth century [8.6], shows an unusual use of the stripes and the diamond motif typical of a "chief blanket." The piece is kept from buckling by a clever application of the "pulled-warp weave," by which the wefts are put on in wedge-shaped sections, pulling the warps out of line. Here, the colors are chiefly natural brownish black, gray and white with an edging of red in the center which has faded to orange.

Another piece of about the same age, which might be a double saddle blanket, is more brilliant [8.8]. Borders and center stripe are red with black crosses. The serrated wedge shapes are gray, outlined in red, and red crosses with black tips extend into the white background.

The folk art of Mexico is very colorful, and shows a great variety of techniques. Notable is the lost art of finger-pleating, the shaping with an iron of a heavily starched, delicate handkerchief, perhaps used at a wedding or confirmation, into some significant form—a flower, a dove, a chalice. Only a few samples survive.

In the state of Coahuila, just south of the Texas border, a type of wool sarape or cloak, with or without neck-slit, has been woven for some time. It is named a Saltillo after the state's capital city. Some of these pieces belong to the finest tapestry weaving which Hispanic America has produced. The ground is comprised of a solid color broken with small patterns or stripes and always edged with a proportionate, darker contrasting frame and border. Harsh tones are never used and the colors are combined to produce a glowing central medallion, usually serrated. The possibilities within this scheme are endless.

In Figure 8.9 the predominant tone is a rich rose color with evenly spaced dark and turquoise blue stripes as contrast. The general effect of the other [8.10] is golden beige, again set off by blue and turquoise stripes. Here there is a great variety of motifs in the stripes and edging. A brilliant display of harmonizing colors is worked out at random in the lozenges that border the central diamond.

A type of wool fabric from Guadalajara, farther to the south, reflects the cheerful nature of the weavers' environment. The ground is always white, the edges bordered with roses in bright tones of red within serrated bands [8.11]; bluebirds frame the sides, and, in the center, all the motifs are

brought together in a brilliant wreath. In the 1930's, this writer saw youthful Indians in blue jeans wearing sarapes woven in this ingratiating pattern, with the roses encircling their necks. With prosperity, hand-weaving of this type, so time-consuming, was more or less discontinued as the skilled workers were drawn into the textile mills.

A boy's small sarape from the Tarascan region, state of Michoacan, is woven in one piece with a neck-slit, of dark brown wool [8.12]. It relates to the Guadalajara type of work in its rich reds and in the use of birds, although here they are highly conventionalized, flowerlike, with only touches of blue. With the free-flowing lines of the coral-colored central medallion, the whole composition is remarkably balanced.

Forty-five years ago, we bought two embroidered panels [8.13] for one peso each from an Indian woman who was sitting on the curb near our hotel in Mexico City. Each piece is quite different from the other, although they harmonize in effect. The work is done on unbleached muslin in thick black floss which is drawn clear across the piece as in weaving, so that the figures show up on the other side in white against a black ground. In the samplerlike design, one sees a row of men and women holding hands as if in a dance, double-headed eagles in various interpretations, birds alone and with floral medallions, rabbits and stylized flowers, as well as a variety of dividing bands with purely geometric patterns. There is subtle artistry in placement and execution.

Another famous center of sarape and rug weaving was Oaxaca, where the traditional design was a great central "sun" in brilliant red on a black field edged with tassel-like motifs–very powerful in its simplicity and proportions. In the last decades, a continuous deterioration in the quality of the weaving has been noticeable, worsened by the placement of the human figure, often a couple, in shrill colors in the middle of the piece–as a local merchant explained cheerfully, "Idols for the tourists . . ."

On the other hand, matters of everyday life are occasionally incorporated effectively into the work. In one of her tapestries, a Navajo weaver pictured the train that crossed the horizon of the high plateau. On a blue-and-white tablecloth, a Mexican woman embroidered Charlie Chaplin, the Little Tramp, probably as he appeared on the crude poster pasted to a flaking adobe wall in her village [8.15]. In the 1930's, a Guatemaltecan used the motorcycle police of General Ubico's regime to enliven her composition. The observant weaver placed the legs of the riders on the front wheel of the vehicle, making it evident that it was motor-powered, while the driver's crouching position gave a sense of speed.

192

A napkin, one of a set of two collected in Ocuilapa, Chiapas, Mexico, in 1895, carries an interesting fluid design in red and blue on a plaid textured weave [8.14]. The working of the thick tassels as well as the whole scheme reflects this region's proximity to Guatemala; both were once provinces of the viceroyalty of New Spain.

The countries of Central America were long isolated from modern technology–a blessing for the collector of folk art. The women of Guatemala still weave on the ancient backstrap loom in a number of complex techniques that go back to pre-Columbian times. When her more arduous chores are done, the housewife can be seen sitting at her loom in the afternoon shadow, relaxed and content [8.16]. The loom appears remarkably simple. The warp threads, already laid out in place, are bound to two end bars, one of which can be hung on a wall, a tree or any stable upright. The other end is attached to a strap of woven sisal or leather that the weaver passes around her hips, so that she can tighten the work at will merely by leaning back. Though the fabric is necessarily narrow, the weavers are experts in tapestry and gauze, as well as other supplementary weft techniques, notably a type of loom embroidery or brocading in which colored figures scattered through the piece are formed with the fingers during weaving. Into the 1930's, the costume gave a clue to the village from which the wearer came. Today, however, there is a borrowing of designs that are considered attractive to buyers.

One finds frequent use in Guatemala's weaving of the human figure and a variety of fancifully stylized creatures: birds, horses, monkeys, rabbits, heraldic animals. A stunning example can be seen in a woman's blouse from San Pedro Sacatepéquez [8.17]. At first glance, the central decoration, brocaded on a loose, light weave, seems to be an intricate geometric design. However, closer inspection reveals three versions of stylized birds alternating with zigzag bands. The predominant color is a mild blue, with fire-red borders and touches of pink.

Yard goods for women's skirts and various household needs are woven by the Guatemaltecan men on foot-looms much like those the Spaniards brought from Europe. The menfolk of the region are skilled also in knitting. One could see them doing this work as they sat on the earth before a village shop, leaned against the walls of their shacks, or made their way to the weekly market. The man from Sololá wears a tight-woven red cotton shirt with small, bright, hand-brocaded figures [8.18]. A tweed jacket is tied around his shoulder by its sleeves. His kiltlike, wool knee blanket serves as warmth in the cold morning air, and as apron for work in the fields. The

carrying cloth draped around his hat will be unfolded to wrap his smaller purchases.

A woman's towel or *servilleta* from Chichicastenango was bought nearly 40 years ago [8.19]. It is somewhat more than a yard long, not including the loose fringes, and was probably made for the market, but the pattern is highly original. Three fiery horses are brocaded in black wool on the cotton ground. A negative pattern of diamond shapes, and stripes in orange and yellow with touches of red, animate the figures. The tails, worked up from the right edge in the same rich decoration, fill the surface and close the composition. The empty spaces are enriched with the figures of two small humans at the top, alligatorlike dragons at the sides, and a scattering of birds of different types.

Unique to the region around San Francisco en Alto is a type of large, slit tapestry blanket of which it is said that no two are alike. The one shown here measures 1⅞ yards wide by 2⅔ yards long without fringes and is done in natural black and white wools, in a pattern of pine trees and corn stalks [8.20]. It was fashioned by an old man in the vicinity who brought his work into town from time to time as an offering to the church. Highly effective are the shadings in deep black or in gray where motifs overlap.

The cotton gauze of pre-Columbian times, which amazes the experts, continued to be produced into the twentieth century. A section of a bolt, said to have been woven in Cobán, Guatemala, shows five rows of different motifs before the repeat, following ancient custom [8.21]. In spite of the stylization, those familiar with Guatemalan colonial textiles will easily find the key to the motifs' identification. We see horses, a row of women, the Tree of Life as a vase with a bird perched on top, highly conventionalized double-headed eagles, and a series of colonial gentlemen in wide breeches and round hats, holding hands. Some of the figures have the playfulness of cut-outs made in white paper for children. In each section, which runs to over two yards long, the separating geometric bands also are varied, and their repeat comes after every four rows, giving even more fluidity to the sequence. Such gauzes, depending on their thickness, were used as veils, rebozos, even mosquito nets.

The rebozo or woman's long shawl probably stems from pre-Columbian times. An edict of 1583, issued by the *Real Audiencia* of New Spain *prohibiendo a mestizas, mulattas, y negras el uso de la indumentaria nativa* suggests that the women of those new population groups had adopted it. By the early eighteenth century, the colonial woman's costume had lost much

of its genuinely Spanish character and the rebozo had become a favorite garment of all classes. A Guatemalan woman's shawl from near Panajachel on the shore of Lake Atitlán is done in tie-dye work on heavy cotton [8.22]. The negative pattern in light tones on an indigo blue base shows stylized cornstalks and kernels alternating with the figures of women. The warp ends are knotted into triangular scallops.

A shawl of very fine white cotton, called a *macana* in that region, was bought in the market at Cuenca, Ecuador [8.23]. Its technique and the elements of its design are practically those of the tie-dye shawl from Guatemala. The difference in effect reveals the contrast of taste between the two regions. Here the ground is white, the minute stylized maize motifs are in blue, and the figures of the women holding hands can be recognized in the negative pattern across the borders. Notable are the long lace fringes woven from the warp threads, with bands of flowers and birds in open work.

The Cordillera of Colombia and Ecuador abounds in *paramos*, high plateaux that sometimes lie at an altitude of eight to nine thousand feet, and the cloud-shrouded climate necessitates heavy clothing. In southern Colombia, the Indians and mestizos wear plain gray or checked wool apparel. Likewise, the Otavalo Indians who dwell in northern Ecuador, only a few degrees south of the equator, have kept their own style of dress, durable and warm, exlusively somber in color. The women of one village wear long black robes over white that are strongly reminiscent of the habit of Dominican nuns. The Otavalo market is held at dawn, for the sun at the equator is oppressive even at an altitude of around 10,000 feet. There is such a demand for the tweedlike woolen fabrics that their section of the market is often sold out at an early hour [8.24]. The men in the picture stand tall, with little movement. Their gaze is fixed–stolid and stoic. They are wearing wide homespun trousers, shirts covered by a long poncho of dark red or blue. Some still have their hair in braids. Their broad felt hats are locally made and very heavy. All the men are standing; the women are seated close to a high earthen bank that radiates the rays of the early sun and gives them back the warmth the night has taken away. An almost animal passivity characterizes the scene, which is seldom viewed by travelers, because by seven o'clock most of the Indians, burdened with their goods and purchases, are en route to their villages, so as not to have to plod the way in burning heat.

While a majority of the pre-Columbian textiles of Peru come from the coast, the examples of Peruvian folk art available are almost entirely from the Andean highlands. It is Cuzco, with its influences reaching into what is

today Ecuador and Bolivia, that remains the living laboratory of folk culture. The high altitude and gigantic landscape have put their stamp on the folk art of this region. Patterns were small and involved in ancient times, and recent products show the same tendencies. They have not the gay colors of Mexico or the expansive patterns of Maya Central America. The stylization is rectilinear, the motifs are subordinate to the general effect. Inca holy flowers appear together with symbols of Christianity.

Both men and women weave on the horizontal loom; here the supports are bound fast by plaited woolen cords [8.25]. The Quechua weaver wears more or less modern clothing but with the characteristic knitted Quechua cap and a heavy woven belt with geometric pattern. His carrying cloth with small accessories lies knotted at his side. A child is bound to the young girl's back in a striped manta, perhaps somewhat like that which is being made on the loom.

Tightly composed, strongly conventionalized decorative units appear also in the four knitted Quechua caps [8.26]. The ear flaps serve as protection against the cutting wind of the Andes, at altitudes up to 14,000 feet. It is an ingenious and utilitarian type of headgear that has been adopted by skiers and members of mountain expeditions all over the world. Yet during World War II, the children of a high-ranking American official of the U.S. Embassy were ridiculed in the streets of Lima because they were wearing Indian apparel. Though like in form, the caps show individuality in tone and pattern. One, of brushed wool, has an hourglass pattern blending cerise, blue and yellow. Another shows stylized flowers with a band of yellow cats amid elements in shocking pink, green, orange and black. A third presents a pattern of diamond in diamond predominantly Chinese yellow and blue, while the fourth is made up of alternating bands of birds and cats. Many of the motifs, whether animal or conventionalized, are remarkably like those encountered in pre-Columbian work.

A *manta* or cloak, bought in Cuzco more than a quarter-century ago, was even then an old piece [8.27]. It is woven, in two parts, of wool on a small loom. The main field is a smoky sky blue, with red edges and decorations in red and gold. Among the tiny submerged motifs are cat figures and interlocking frets–hark-backs to ancient times. Through wear and tear and frequent washing, the colors have taken on beguiling tones.

Much skill went into the fashioning of the small carrying cloth or coca bag of wool from the Peruvian highlands, only 15½ x 16 inches [8.28], which is gathered and tied by its tassels, and then may be thrust into the belt. Coca,

196

the dried leaves of a shrub native to the region (from which cocaine is derived), is chewed for its effect, at once soothing and stimulating. Notable is the varied striping of the ground fabric which is overlaid with different floral designs in red, unsymmetrically arranged but forming a balanced whole. The pre-Columbian craftsman seldom cared for perfect symmetry. Each tassel has a different color, and the central stripe of deep blue and tiny bright stripes at the edges further enliven the effect.

It was a colorful custom, still practiced to a certain degree, for the *alcaldes*, or head men, of various villages to gather at the church on Sundays, with their silverbound staves of rank. The great variety in color and pattern of their ponchos can be seen in the group before the church in Pisac [8.29]. Some wear the characteristic red and blue flat hat over their knitted caps, and a number carry conch shells which this writer has heard blown with arresting and lugubrious sound during Mass at the elevation of the Host.

Although the Quechua Indians of southern Peru and the Aymara of the Bolivian high plateau lived for centuries side by side and in some regions intermarried, Bolivian work is quite separate in character from that of Peru. The Aymara have different color preferences, using considerable black or deep green for contrast. The wool is often alpaca. The small manta illustrated [8.30] was bought in a hole in the wall, in the Indian quarter of La Paz, from a mestizo woman wearing a little round derby and a silver fish pendant. Upon repeated urging to show us the oldest pieces she had, out came this manta from a lower shelf where it lay folded between a keg of kerosene and a bag of salt. After friendly bargaining, she patted my wife on the shoulder, saying: "And, Señora, this one will wash." It is woven in two pieces. The usually subordinate decorative stripes are so expanded as to emphasize the many colors used and to crowd the conventionally dominant plain field into narrow dark bands, here of brownish red and dark green. The weaving is very fine. More than forty ornamental bands comprise each half of the piece, using red, dark blue, cerise, green, beige, golden yellow. Stylized corn tassels and Inca flowers predominate, with more than one type of interlocking design. Here vibrating life and a certain dignified restraint are successfully merged.

In a Bolivian shoulder bag, hand-loomed in crimson, the stripes are featured and carry bold decorative motifs [8.31]. In this case, two men on horseback occupy the central panel in purple, cerise and yellow, while two women in flaring skirts are placed in each of the side panels, mainly orange

and green, reminding one of the figures on playing cards. Human figures also appear on the wide shoulder strap, together with a monkey and a bird. Five flamboyant red tassels heighten the verve of this piece.

All of these pieces from the Andean Highlands are executed in such sophisticated technique that both sides are artistically effective.

From the tombs of pre-Columbian Peru, mummies come to light hung with gold and silver ornaments. The colonials displayed their wealth in gold and pearls. At the shrine of Copacabana on Lake Titicaca, a favorite pilgrim place in Alto Peru, the object of veneration is a painting of the Virgin. The picture is covered with pearls, golden chains, enameled watches, jeweled rings and earrings, fixed to the fabric in sign of devotion. The Aymara bride also follows the century-old custom in the display of a part of her dowry [8.32]. Her intricately dressed hair is crowned with a cap of gold coins. Spanish silver pesos make up stomacher and belt. And huge silver pins in the shape of spoons and filigree flowers hold her elaborately patterned mantle. While the entire appearance has, from a visual point of view, an amazing harmony, each motif holds its own.

All the illustrations in this chapter were taken at least three to four decades ago, if not earlier. And one suspects that nowhere in any country can such purity of folk art now be found.

Latin Americans call their folk art *arte popular*, meaning the art which the populace has created. Up to the 1920's, the appreciation of folk culture was limited to a very small circle. In Mexico, it was not until 1940 that the Instituto Nacional Indigenista had its first publicized meeting in Patzcuaro. Now poets, writers and scholars with the ability to express themselves clearly have taken up the subject. The monumental new Museo Nacional de Antropología in Mexico City is devoting more than 40 percent of its ample space to the folklore of their land, and even small republics in South America have established museums for their folk art, in the realization that we are in the twelfth hour for collecting and preservation.

In a world in which mass production supplies nearly all of our needs, it is refreshing to contemplate the work of the individual. The armchair traveler and the globe-flying tourist are familiar with the primitive arts of other continents. In the folk art of the Americas he can view a very different art, the distillate of a civilization many centuries in the making. These textiles were not produced on the assembly line but on a high plateau where a smoking volcano loomed above the weaver, or on the edge of a dark jungle valley abounding with brilliant tropical birds.

Folk art has in it the pulse beat of the human hand. Like folk music, it might be likened to a poem made by an illiterate person who intuitively offers a microcosm.

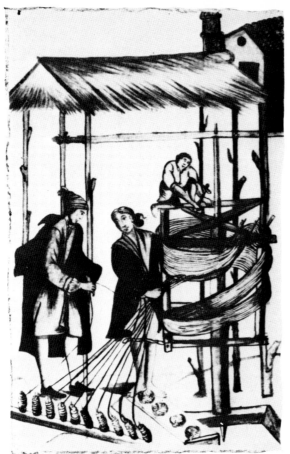

[8.1] Setting up the warp.

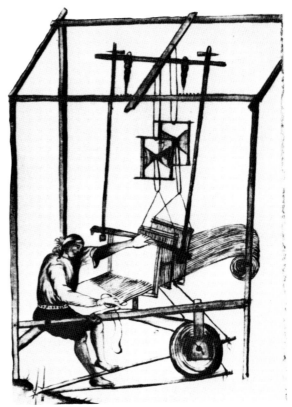

[8.2] Weaving.

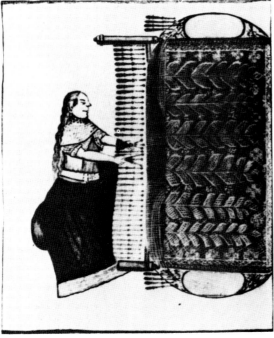

[8.3] Fashioning fringes.

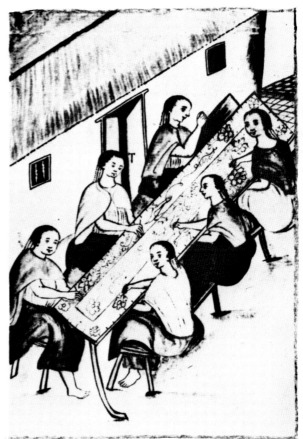

[8.4] Embroidering.

FROM BISHOP MARTÍNEZ'S BOOK ON DIOCESAN LIFE.

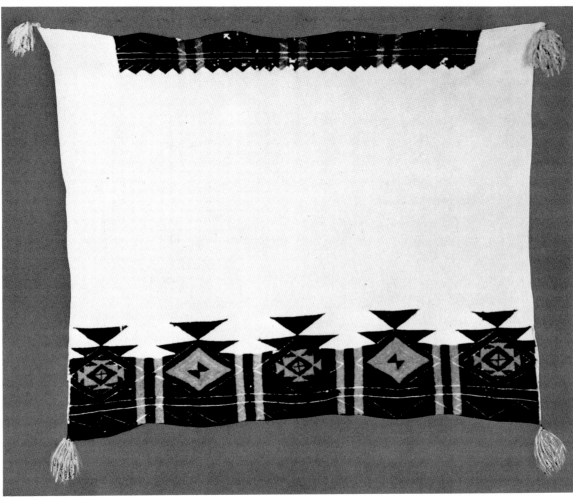

[8.5] Hopi blouse.

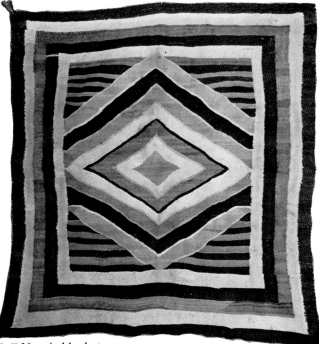

[8.6] Navajo blanket.

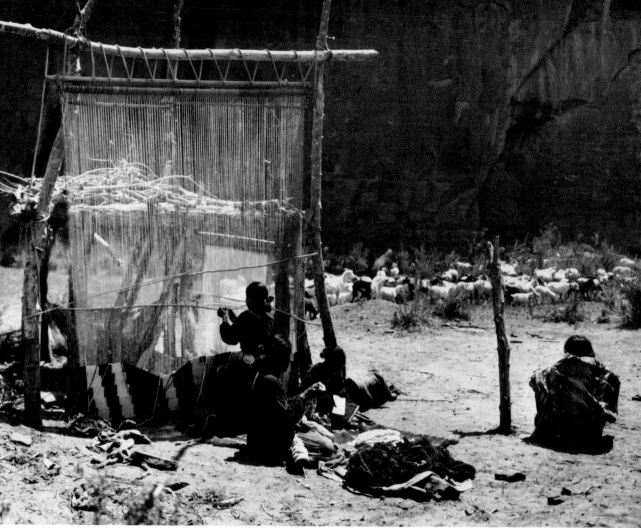

[8.7] Making a Navajo blanket.

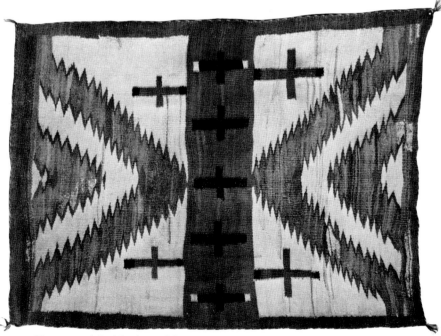

[8.8] Navajo saddle blanket with crosses.

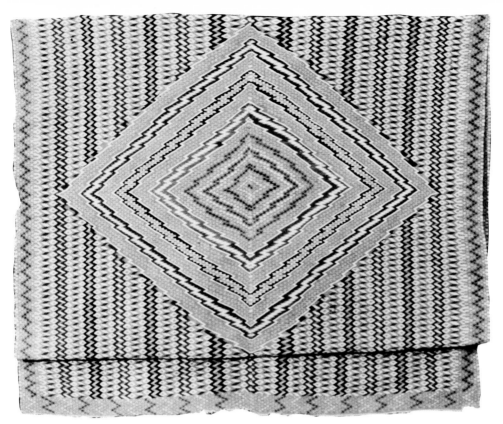

[8.9] Saltillo sarape in tones of pink. Mexico.

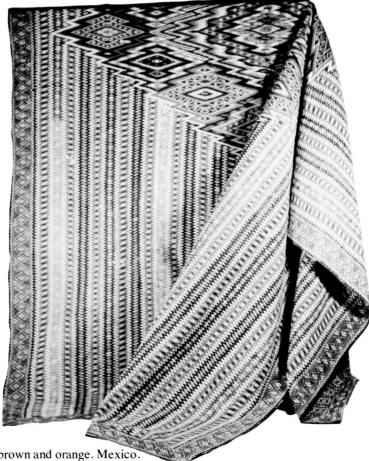

[8.10] Saltillo sarape in tones of brown and orange. Mexico.

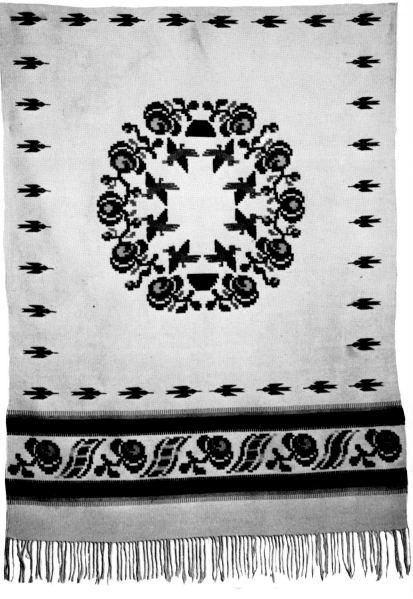

[8.11] Sarape. Guadalajara, Mexico.

[8.12] Child's sarape.
Patzcuaro, Mexico.

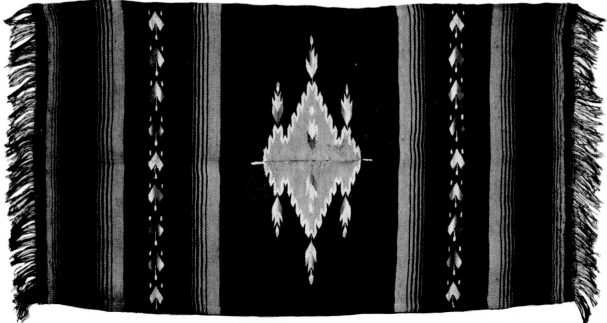

[8.13] Two embroidered cloths. Mexico City, Mexico.

[8.14] Napkin. Ocuilapa, Mexico.

[8.15] Embroidered tablecloth with Chaplin figure. Mexico.

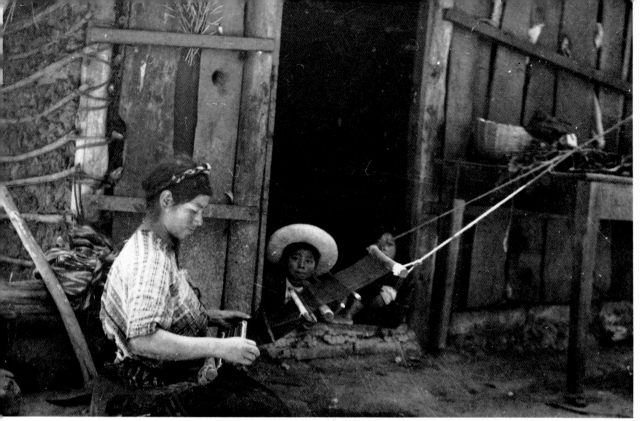

[8.16] Woman weaving on girdle-back loom. Santiago Atitlán, Guatemala.

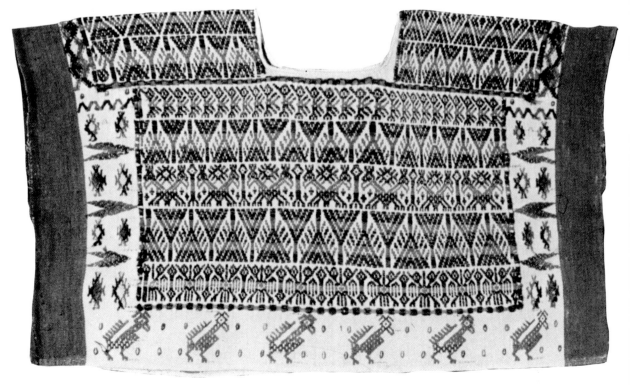

[8.17] Woman's blouse. San Pedro Sacatepéquez, Guatemala.

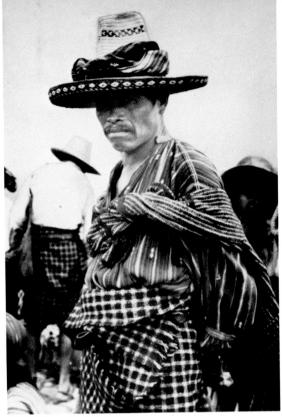

[8.18] Man from Sololá, Guatemala.

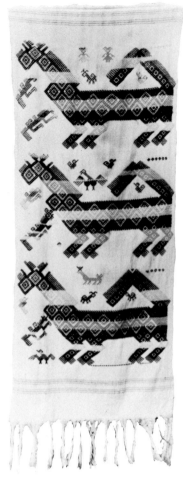

[8.19] Woman's napkin. Chichicastenango, Guatemala.

[8.20] Slit tapestry blanket. San Francisco en Alto, Guatemala.

[8.21] Gauze piece. Coban, Guatemala.

[8.22] Woman's tie-dye shawl. Panajachel, Guatemala. [8.23] Tie-dye rebozo. Cuenca, Ecuador.

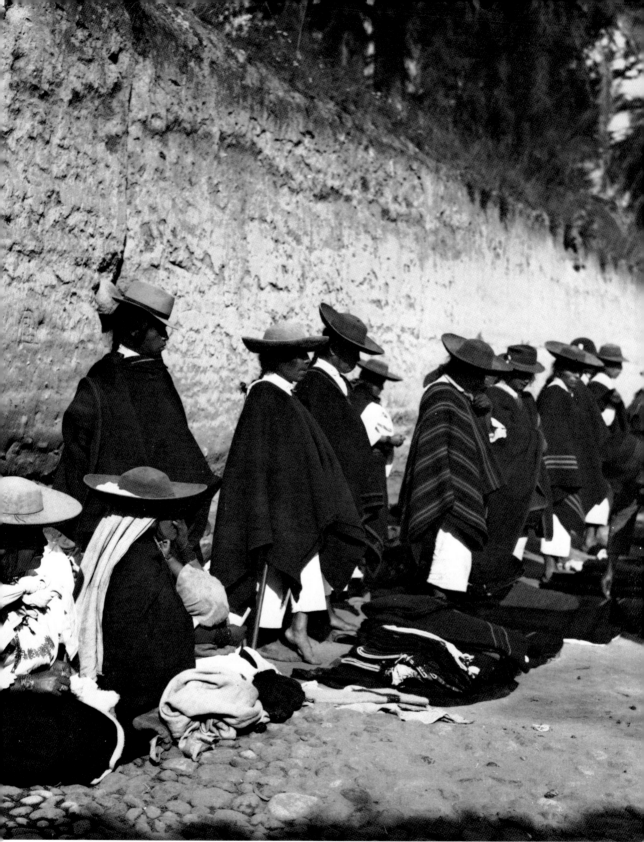

[8.24] Tweed market. Otavalo, Ecuador.

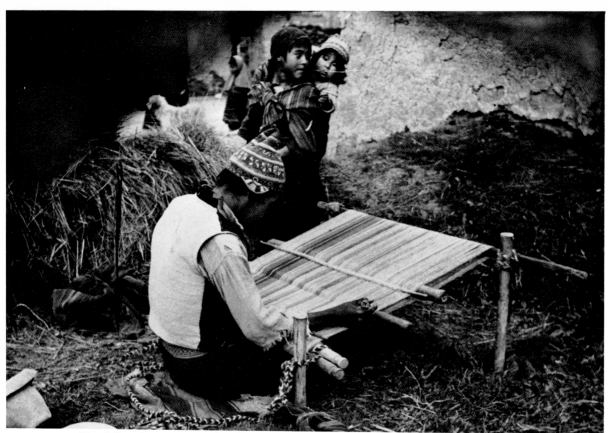

[8.25] Quechua man weaving. Peru.

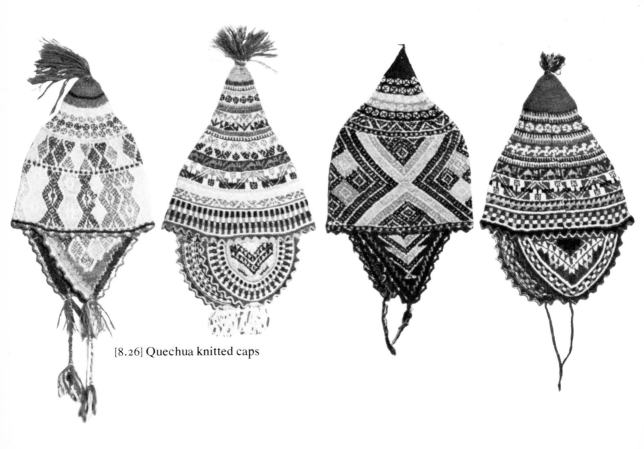

[8.26] Quechua knitted caps

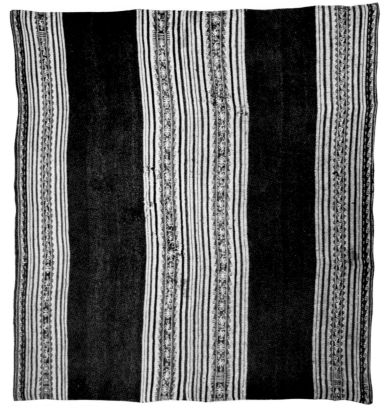

[8.27] Cloak. Cuzco, Peru.

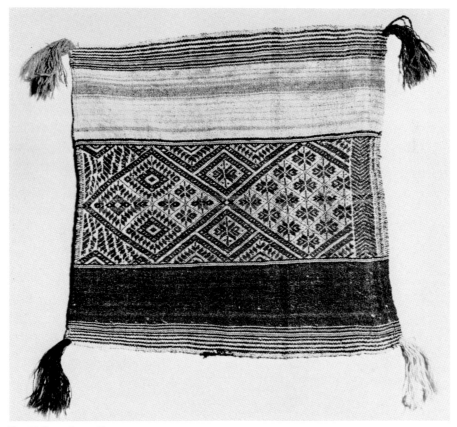

[8.28] Coca bag. Cuzco.

[8.29] Selectmen. Pisac, Peru.

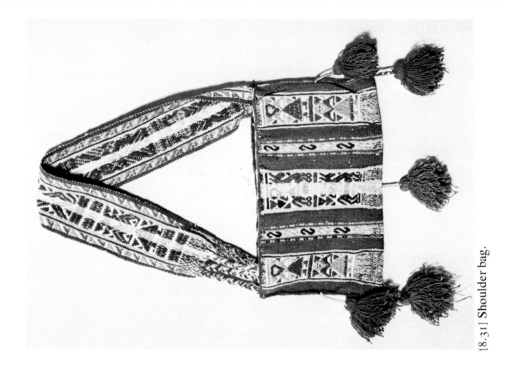

[8.31] Shoulder bag.

[8.30] Aymara *manta*. Bolivia.

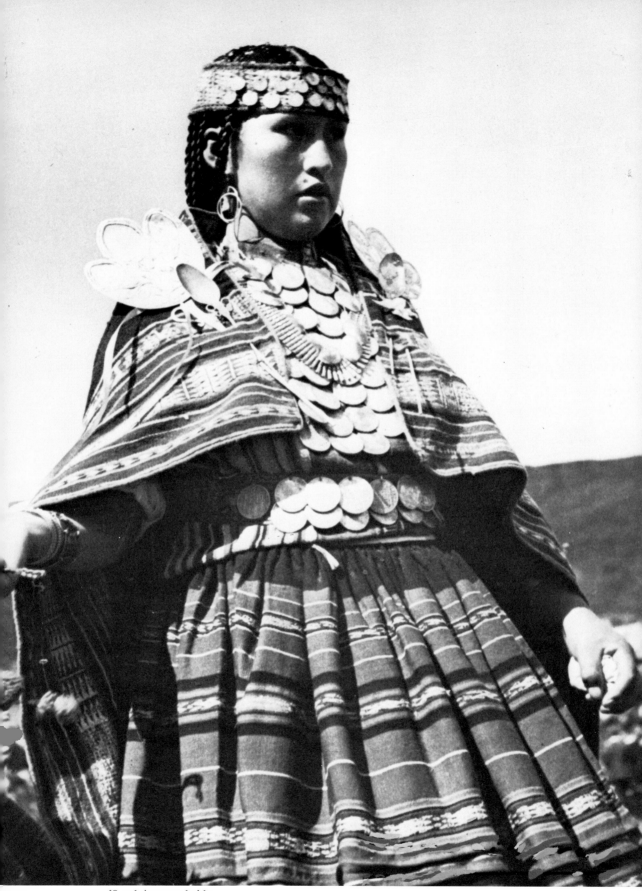

[8.32] Aymara bride.

9

Lightning over a Shrine [1933]

Our farewell excursion. Early May. Our car leaves the capital and we ride on the uneven stone pavement of the causeway which in ancient times led across shallow Lake Texcoco. The stone parapet is still intact in places and at the end, on a weather-beaten stone pillar, is a small shrine. Some tired flowers laid at the edge and a blind taper in a cracked container collect the dust which rises in spirals from the dry lake bed. Turning off the highway, the old road narrows. The car mounts slowly from the floor of the plateau towards the villages in the mountains. Luckily there is little traffic; only a few lurching trucks that threaten to force us off the shoulder. Each mile seems to carry us back another decade into the past.

It is market day in Amecameca. The main plaza is crowded with stalls and shaded with many awnings [9.1]. Traffic grows lively as the afternoon wanes. We stop for a moment in front of the church with its high white gate

*This trip to Amecameca, made on our first visit to Mexico in 1933, was published in my *Battlefield of the Gods*. The place was revisited thirty years later, and some text and photographs were added.

[9.2]. Several old Indian women are jogging across the dry, trodden grass to Vespers. In the church tower brown boys are ringing the bells riotously, pushing the swinging metal with their hands. Beyond, the ground slopes upward to peaks of everlasting snow. Ixtacchihuatl, long-silent volcano, dominates the landscape; the tapering summit of Popocatepetl is farther away, half lost in haze.

We drive on slowly to the foot of the Sacro Monte, which lies within the boundaries of the village. No other road leads up the hill except the Via Crucis, the path of pilgrims. Groups of men and women are coming down the broad sloping steps of the way, children skipping before them [9.3]. They give us shy greetings from under the brims of their wide straw hats.

The fourteen Stations of the Cross, symbolic of the halts made by the procession to Golgotha, are narrow and low, humbly built of plain brick. The yellow stucco of their surface is scratched with the names of pilgrims and fissured with time. In deep niches in the upper part of the monuments panels of glazed tile are set, with religious exhortations in elaborate blue lettering. Sombreros, old bits of clothing, and colored rags hang on the mossy branches of the trees beside the road, tokens of those for whom the Indian pilgrims have come to beg blessing. The line of steps describes a great curve and beyond the fourteenth station we see the chapel of the shrine.

The twelve friars who were the first missionaries to Mexico came over from Spain in 1523. One of them, the pious Father Martín de Valencia, worked, died and was buried on this spot. At his tomb miracles of healing began to occur, and the place rose to great fame among the Indians, as if the ancient name Amecameca held for them the seeds of an Indian Mecca. Until the beginning of the twentieth century Indian pilgrims thronged to the place from great distances, particularly for the celebration of Ash Wednesday, and dragged themselves up the four hundred-foot height on their knees, confident that their devotion would result in benefits for themselves or their loved ones.

The tomb of the "Apostle" Father Martín is covered by a squat oriental dome stained a rust red, with a flight of outdoor steps leading up to an encircling porch [9.4]. The left balustrade has an ingratiating Baroque curve. It would appear that the right side was straightened later, to give space for the open-air altar dedicated to the Virgin. A simple rectory leans against one side of the chapel. Hollow sapling logs, serving as waterspouts, jut from its flat roof far out over a dry garden patch.

Underneath the porch a wide door leads into the chapel of the shrine, a

low barren room with walls and vaulting painted icy blue. There are several votive pictures hung in one corner, and some figures of saints stand on whitewashed pedestals. The paintings, executed on wooden plaques with primitive technique but startling power of expression, represent the miracles performed for the benefit of one or another grateful pilgrim. Their subjects range from the healing of serious illness by prayer to the prevention of murder by the intervention of the Holy Ghost, and are pictured with such sincerity and devotion that even the skeptic can hardly find it in his heart to doubt the facts of the case.

On a platform before the altar, in a casket of carved wood and glass, lies a life-size figure of the dead Christ, called by the natives El Señor de Sacro Monte. According to legend this Lord of the Sacred Hill was made by Father Martín de Valencia himself out of the pith of the maize. Due to its special material the relic is very light of weight and has a shimmering aspect which is particularly pleasing to the Indian fantasy.

The Christ who lies here is an emaciated, broken man. It is a Christ born of this soil, of the same substance as the Indian maize god. One can understand why the Indians feel that this place is their own. Even today, after four hundred years of Christianity, they prefer to kneel before saints with Indian faces, sprung from the local past; they light hundreds of candles before their altars, and leave neglected the figures of Saint Francis and Saint Anthony–beloved in Europe–whose actions and motives remain strange to them.

An Indian woman who came up the hill with her two boys just ahead of us is praying at the shrine. One child kneels at her side, his bare heels pressed together, his hands devoutly folded. The other is so young that he sits and plays idly on the floor. The mother takes a bouquet of bright flowers from her basket and gives it to the older boy. Timid in the mystic atmosphere, he tiptoes up to the casket and lays the flowers before it, arranging them prettily with deft fingers. He crosses himself, kisses the altar, and returns to his mother. The scene is enacted with so much youthful charm that a strange woman nearby beckons the boy and gives him her offering of flowers also.

At the time when the Church was held in greater esteem than today, the reliquary was carried about the town once a year at the head of an immense procession, and fires were lighted along the hill, their glowing visible for miles around in the clear mountain air. This custom of lighting fires has evidently lasted until today, and we have to step around heaps of smoking embers when we approach the edge of the hill for a better sight of the snow-volcano. The view from within the chapel is shut off by a rain-beaten

wooden partition, evidently erected to protect the pilgrims in the church from the driving winds from the snow fields.

Around the chapel are the sunken graves of an abandoned cemetery. The landscape, flooded with the rusty rays of the setting sun, brings to mind the thought of that ancient epoch when a large and prosperous community dwelt around this hill. It was from here that Cortés is said to have had his first view of the Valley of Mexico. In those days the natives offered sacrifices in elevated temples decorated with the figure of the Plumed Serpent. Holy fires burned continually in his honor and could be seen from far off. The population came out with music and standards to greet the first white men; priests perfumed the air with fragrant censers, and the way was strewn with flowers.

The adobe huts, with their thatched roofs and glassless windows, are today almost as they were at the time of the Conquest. The jars and pots of flowering plants set out around the houses, the circular storehouses for corn in the ear, the mud-plastered granaries, like huge clay bowls with roofs of straw, the squat stone sweat-houses for steambaths, the chicken run, the *metate* for grinding corn have not been changed by time. The snow-volcano, the fields of maize and maguey, the web of irrigation ditches of the plateau remain untouched by Christian centuries. The Sacro Monte, with its crucifix and chapels and its Calvary, could not much affect this scene, where ancient vegetation, the enormous trees bearded with hanging moss, the enveloping strength of nature absorb the Christian architecture. In Italy, in Western Europe and in Spain, ecclesiastical buildings dominate the landscape. But here, the Christian centuries have merely built into a landscape the features of which were formed and fixed ages ago.

Lowering clouds portend the rain to come, and in the suddenly darkening evening we go down the hill [9.5]. In the little garden of the town's only inn, a shaggy dog bounds toward us and his barking brings out the owner of the place. There are evidently no other guests. A table is laid for us under an arbor of passion flower. Lights flare in the kitchen. A little boy runs out and down the street, returning after a while with beer. The bright flowers around us nod in the rising wind and seem to breathe in the cool air from the snow fields. Rain is near. There will be no moon tonight. The storm covers the stars and we hurry with our supper.

The Indian girl, her long braid swinging, has just carried away the dishes when the storm breaks with a heavy downpour. The tympani of the thunder roll on the glacier, and as if the ancient gods protest that they still live, a brilliant streak of lightning zigzags across the heavens above the shrine.

218

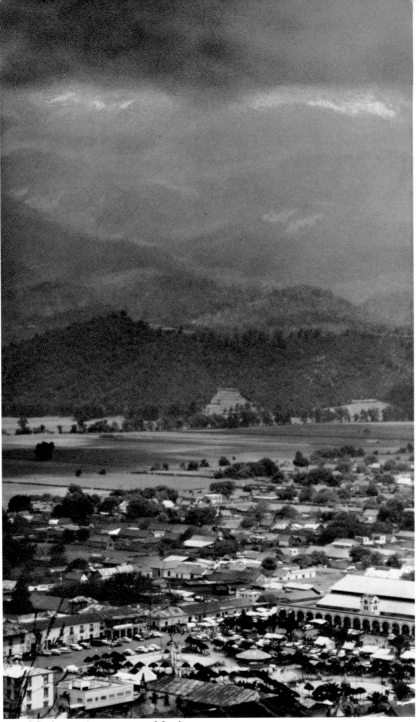

[9.1] Market at Amecameca, Mexico.

[9.2] Parish church. 1933.

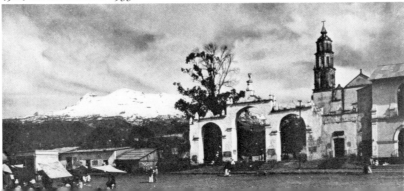

[9.3] Via Crucis. Amecameca, Mexico.

[9.4] Shrine at the Sacro Monte.

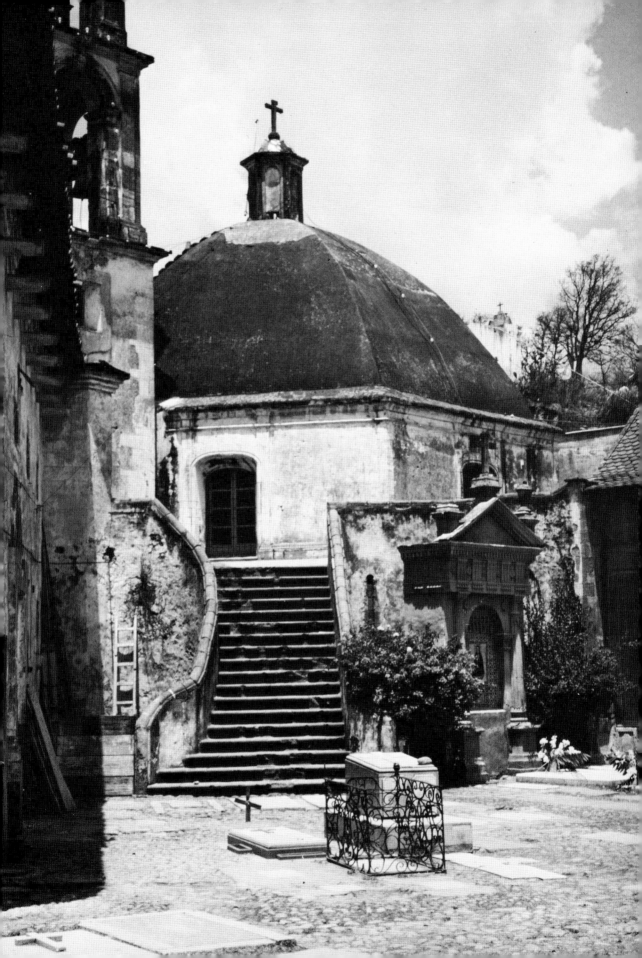

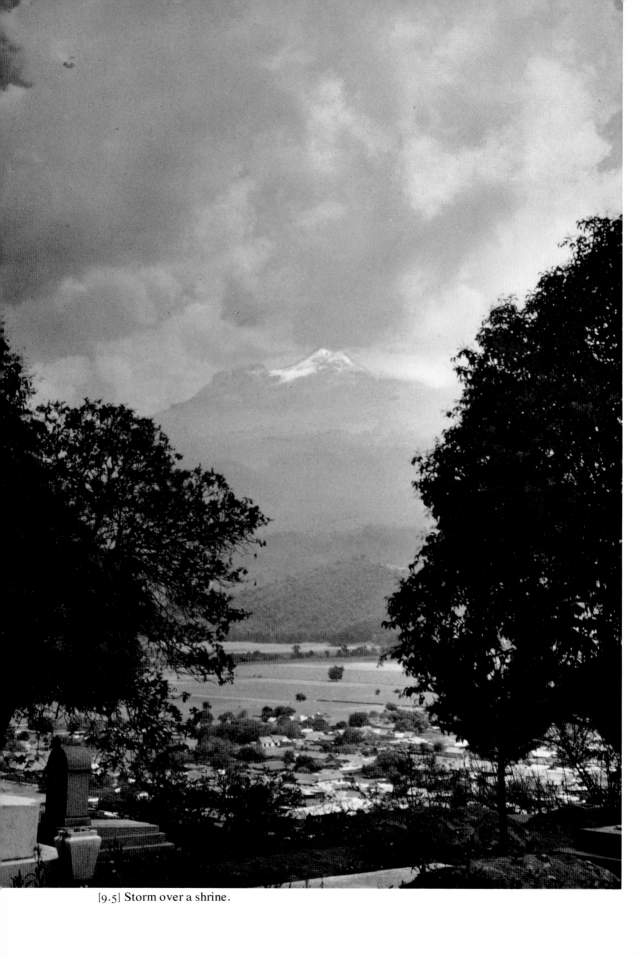

[9.5] Storm over a shrine.

Acknowledgments

In the four and a half decades of activity in the field and the nineteen extended trips which we made into Spanish America, we received suggestions and help from so many people in various ways of life, that to enumerate them all would make a volume–and a good part of my autobiography. They were colored with warm human episodes, some unforgettable.

The first place of credit should go to those who are no more here: Sir Eric Thompson, England; Mario J. Buschiazzo and Paul Dony, Argentina; Francisco de la Maza, Mexico; Ralph L. Linton, A. V. Kidder and E. Boyd, the United States–colleagues who were real humanists, with whom the contact was always enriching and memorable.

Among the living, mention should be made of Henry Berlin, Mexico, who gave unsparingly advice and data with rare generosity; Irving A. Leonard, who in fine literary style illuminated the intellectual climate of that colonial empire whose Baroque and Rococo art I presented in my works. They had the sensitivity which makes friendship an inspiration.

In the preparation of this book, Judith Woracek Mullen contributed, as art director, her experience and rare good taste; Miklós Pinthér, chief cartographer of the American Geographic Society, made the attractive map; and, besides the finished manuscript, Marilyn A. Ross typed difficult pages more than once, sometimes from tape.

Illustration Credits

© copyright
EZK Elisabeth Zulauf Kelemen
K.A Kelemen Archive
K.E Kelemen–Eagle Collection
M Museum or Museo

1/ 1.5, 1.18–Cisneros, Cuzco; 1.6, 1.17, 1.19–K.E; *all others*–EZK

2/ 2.3, 2.4–Textile M; *all others*–K.A (Ruiz, Toluca)

3/ 3.1–K.A; 3.2,3.7–© Laura Gilpin; 3.4–© Taylor M, Colorado Springs; 3.8–M de Americas, Madrid; 3.1, 3.6, 3.11, 3.14–K.A; *all others*–EZK

4/ 4.1, 4.2, 4.9–K.A; 4.3–K.E; 4.4–Textile M; 4.5–Brooklyn M; 4.6-7-8–© de Menil Coll.; 4.10–EZK; 4.11, 4.12–courtesy Blelloch and Bolivian Embassy, Washington; 4.13–© M von Völkerkunde, Leipzig; 4.14–© Hans Ertl

5/ 5.2, 5.4, 5.13, 5.18, 5.23–K.A; 5.27–© Juanita Ruiz; 5.28–Lippencott, Eckhart Archive; 5.31–A. Cohn, Eckhart Archive; 5.33–© Bancroft Library; *all others*–EZK

6/ 6.1–K.E; 6.2, 6.7-8, 6.10–K.A; 6.3, 6.6–EZK; 6.4, 6.12, 6.18–M, La Paz; 6.5–courtesy, Harten, Düsseldorf; 6.9–M, New Orleans; 6.11–after De Jonge ''Delfter Keramik,'' 1969; 6.13–© Paul Dresse de Lebioles Coll., Brussels; 6.14–© Mesa y Gisbert, La Paz; 6.15, 6.19–Friedemann Coll., Bloomfield Hills, Mich.; 6.16–private coll., West Germany; 6.17–James F. Adams Coll., Philadelphia

7/ 7.1, 7.2, 7.3–© Auto. Club of Southern California; 7.4-5-6–courtesy Capt. A. K. Cameron, Maritime M, Vancouver B.C.; 7.7-8–University British Columbia, Vancouver; 7.9-10–© Bancroft Library; 7.11–© Tom Myers, Sacramento; 7.12-13–Natl. Park Service, Sacramento; 7.14-15-16-17–K.A; 7.18–© Dawson's Book Shop, Los Angeles, 1970; 7.19–Courtesy Miklós Pinthér

8/ 8.9, 8.17–Textile M; 8.10, 8.14–Smithsonian Inst.; 8.16, 8.20, 8.21, 8.24–EZK; 8.18–© Eichendorf, 1940; *all others*–K.A

9/ 9.2–K.A; *all others*–EZK

225

Index

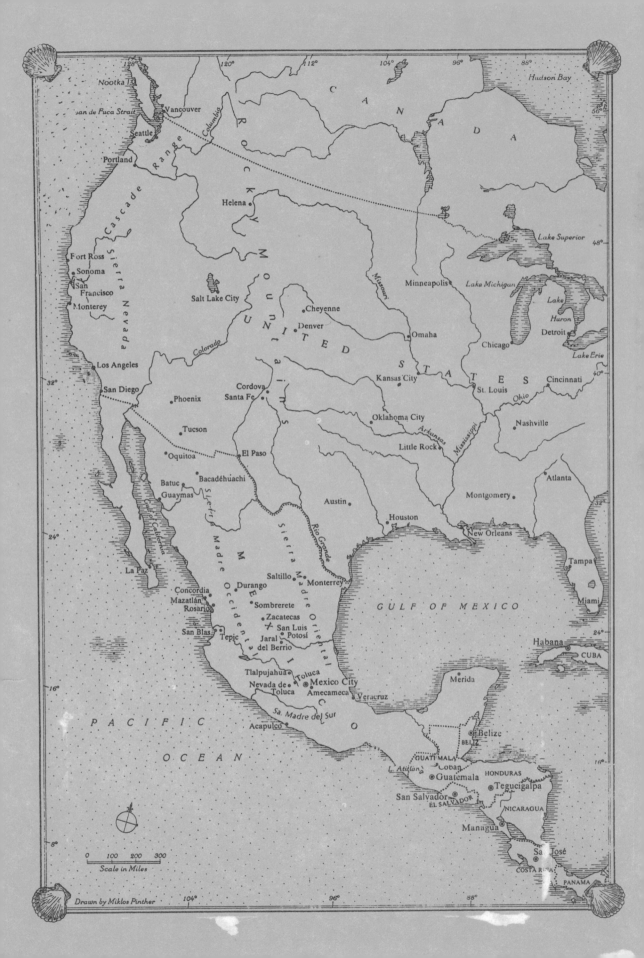

Drawn by Miklos Pinther

Scale in Miles
0 100 200 300